100 Years of
Motorcycles
Twentieth Century in Pictures

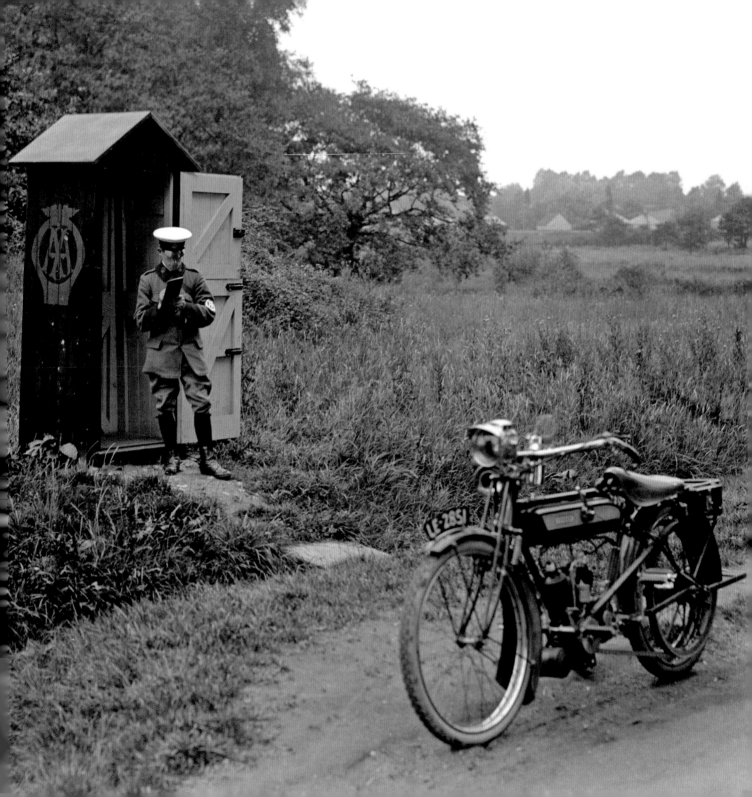

100 Years of
Motorcycles
Twentieth Century in Pictures

AMMONITE
PRESS

PRESS
ASSOCIATION
Images

First Published 2010 by
Ammonite Press
an imprint of AE Publications Ltd,
166 High Street, Lewes, East Sussex, BN7 1XU

ISBN 978-1-906672-53-9

British Cataloguing in Publication Data. A catalogue
record of this book is available from the British Library.

Editor: Ian Penberthy
Series Editor: Richard Wiles
Picture research: Press Association Images
Design: Gravemaker + Scott

Colour reproduction by GMC Reprographics
Printed by Hung Hing Printing Company

Page 2: The Automobile
Association was formed
by motoring enthusiasts in
1905 with the aim of helping
motorists avoid speed traps.
Subsequently, it expanded its
activities to provide emergency
assistance, signposting, legal
assistance and many other
services to its members. Here
a motorcycle patrolman uses
an AA roadside telephone box
on Epsom Road in Surrey.
His bike, a recent introduction
to the AA, is a 1912 Triumph
Hub Clutch.
January, 1912

Page 5: John Surtees passes
Kate's Cottage on his 500cc
Manx Norton during the Isle
of Man TT. That year, Norton's
team boss, Joe Craig, had
given Surtees his first factory
sponsored ride. Kate's Cottage
is one of the most iconic sights
of the TT; originally it was
known as The Keppel.
11th June, 1955

Page 6: With the air full of
flying debris, the USA's James
Stewart (R) leads a jostling
mêlée of riders around the
first corner during the MX1
qualifying session ahead of the
Red Bull Motocross of Nations
race at Donington Park, Derby.
27th September, 2008

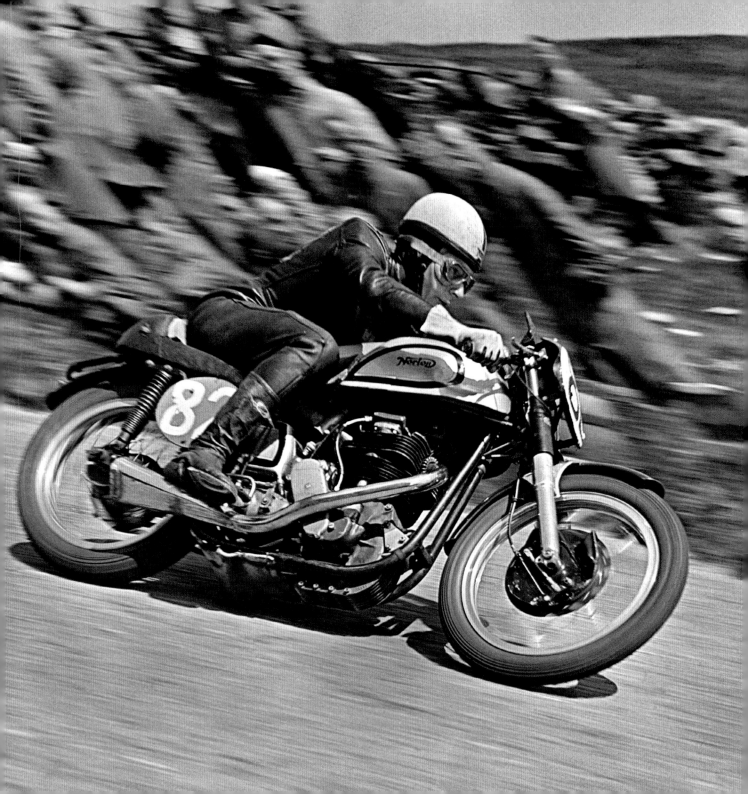

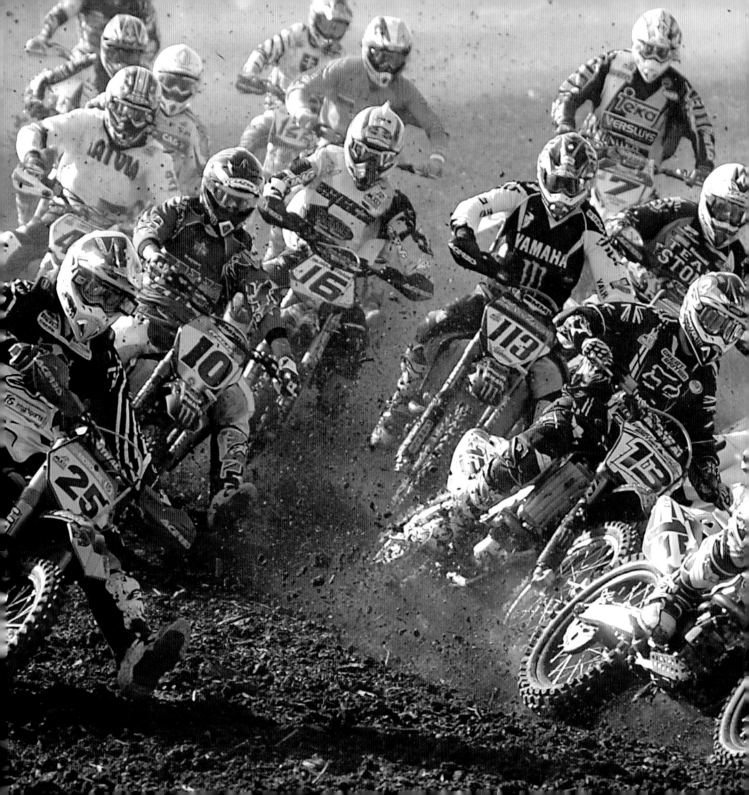

Introduction

Today the motorcycle is seen as a machine for enthusiasts, a big boy's toy or an economic form of urban transport. During the 'golden age' from the end of the First World War to the late 1950s, however, motorcycles and motor scooters provided affordable personal transport for a large number of people in the UK. Britain's motorcycle industry boomed during this time, but as the second half of the 20th century progressed, cars became less expensive and many riders came in from the cold, swapping two wheels for four. A complacent British motorcycle industry went into decline, hastened by the dynamic rise of the Japanese makers.

The earliest motorcycles appeared toward the end of the 19th century, when inventors began strapping small engines to bicycle frames. This was a time of experimentation, with different power units being chosen, before the petrol engine was settled upon. Soon it was realized that as more powerful engines were developed, machines would require stronger frames and components, and although the powered bicycle, and later moped, continued to be popular as a ride-to-work machine, it soon became a small part of the overall picture.

For the family man, however, the motorcycle had limited use, since it could carry only two people, unless attached to a sidecar. Having one, two or even three seats, a sidecar provided transport for the entire family. During the First and Second World Wars, the sidecar played a major role when attached to a military motorcycle, since it provided a platform for a machine gun or mortar.

Given man's competitive nature, it is not surprising that shortly after the arrival of the motorcycle, races and similar events were devised so that riders could pit their machines against each other. In time, this led to a variety of motorcycle sports, including time trials, road racing, off-road racing and speedway. The legendary Isle of Man TT first took place in 1907, the same year in which the first purpose-built racing circuit was opened at Brooklands in Surrey.

In the 1950s, young riders clad in leather jackets and jeans, known as Rockers, would frequent coffee bars, playing rock 'n' roll music on the juke boxes and racing their machines from one café to another. As the 1960s dawned, however, a new group emerged. Interested in fashion and with a more cosmopolitan interest in music, they eschewed grubby denim and oily bikes in favour of smart clothes and neatly panelled scooters. They called themselves Mods, and it wasn't long before the two groups were at loggerheads, often clashing in long-running battles at seaside resorts.

Another modern role for the motorcycle is as exotic prop in celebrity photo shoots. Big machines, such as Harley-Davidsons with their acres of chrome, are commonly seen with someone famous draped over them.

The photographers of the Press Association have recorded the various roles played by the motorcycle throughout the 20th century. Their work is reflected in the pages of this book, evoking all aspects of the two-wheeled lifestyle.

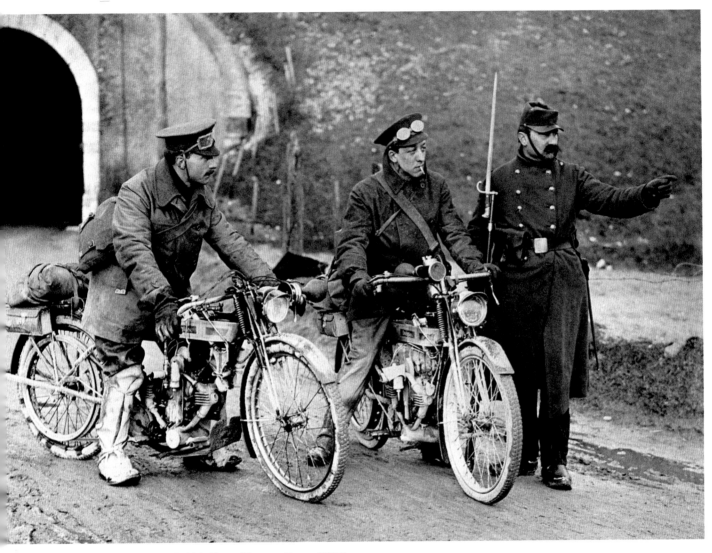

Dispatch riders of the British Expeditionary Force (BEF), on Douglas 348cc motorcycles, are given directions by a French sentry in northern France. A large number of Douglas machines was supplied for military use during the First World War, the factory turning out 300 a week.

1st October, 1914

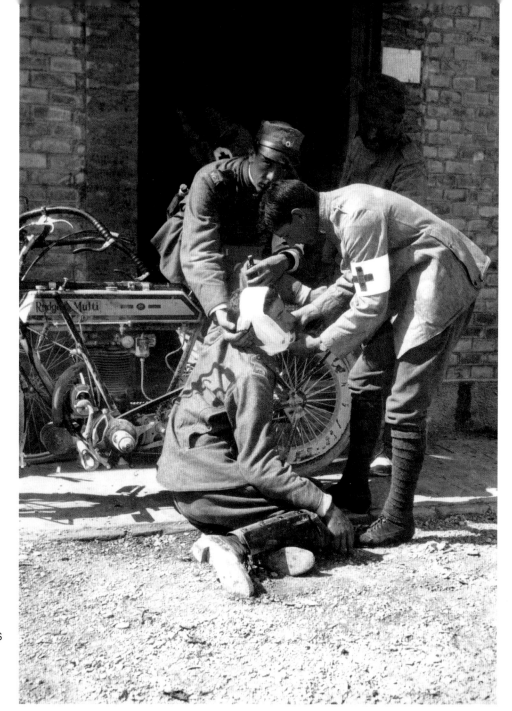

An injured soldier, probably a dispatch rider, is tended by French Army medical personnel. The motorcycle is a British-made 1914 Rudge Multi, so called because of its multi-gear transmission.

1st November, 1914

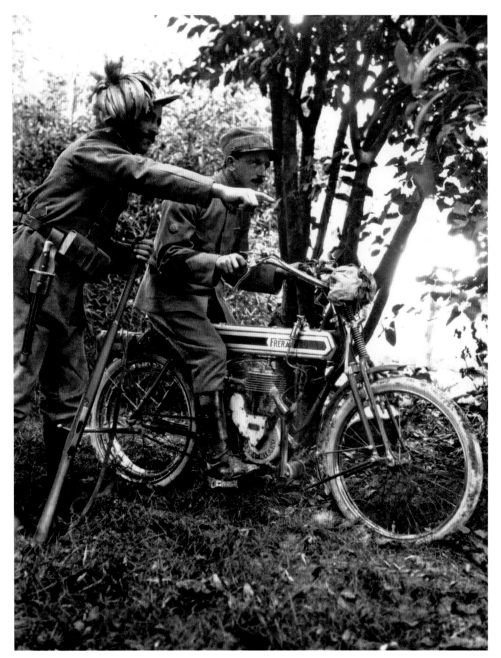

Facing page: Signor Davide Cislaghi with his one-wheel motorcycle called the Monowheel, which was capable of speeds of up to 40mph. Although the trials proved a success, the machine never caught on.
January, 1923

An Italian Bersaglieri soldier points out an enemy position to his officer, who is mounted on a 1915 Italian-made Frera motorcycle. The machine has a civilian paint scheme.
1st August, 1916

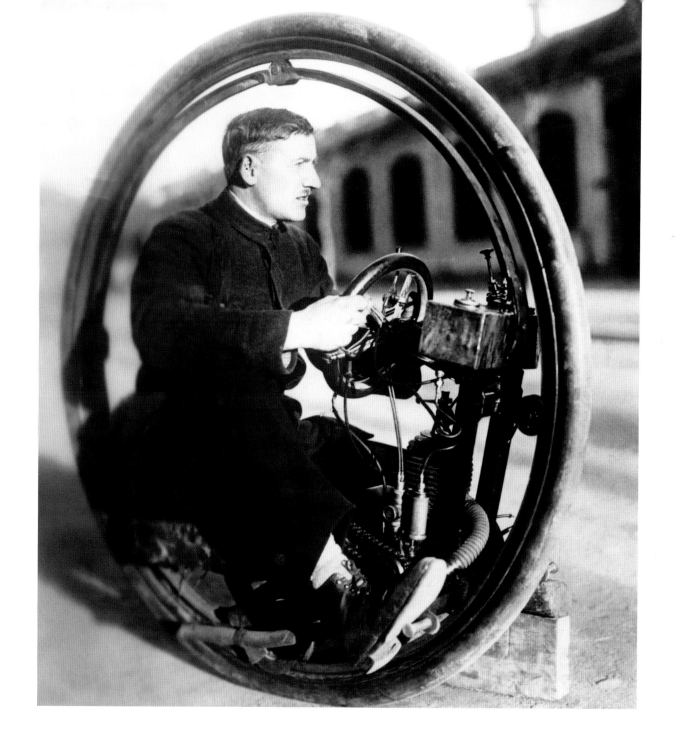

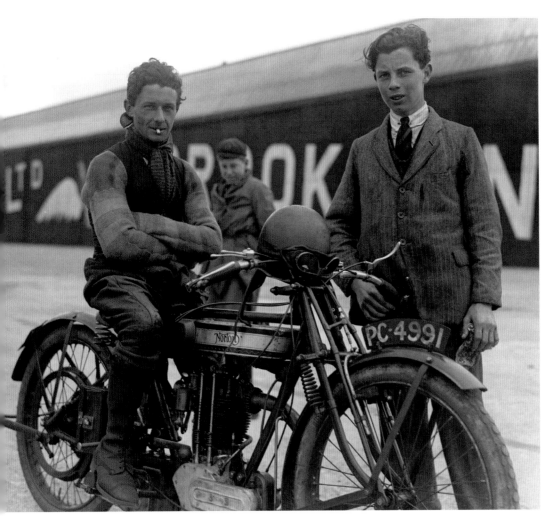

Famed motorcycle racer of the 1920s and 1930s, Bert Denly takes a break during a practice session at the Brooklands circuit on his Model 18 Norton. The Model 18 was an overhead-valve, 500cc machine that had been introduced in 1922.

6th April, 1925

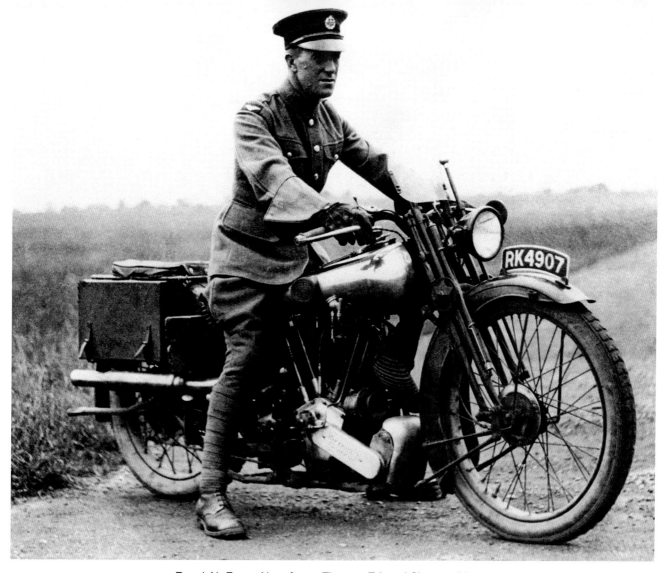

Royal Air Force Aircraftman Thomas Edward Shaw on his motorcycle, a Brough Superior SS100. Shaw was better known as Lieutenant Colonel TE Lawrence or 'Lawrence of Arabia'. He was a keen motorcyclist and owned a succession of Brough machines, on one of which he would be fatally injured in May 1935.

26th March, 1927

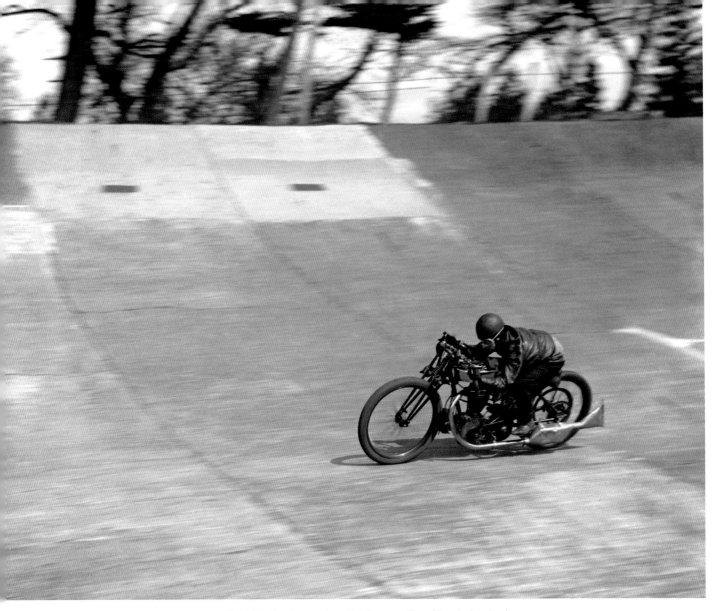

Bert Denly at speed on the famous Brooklands banked
circuit in Surrey. His machine is a 1927 Norton Model 18.
The overhead-valve 500cc bike was a very successful racer
for the British manufacturer.
1st May, 1928

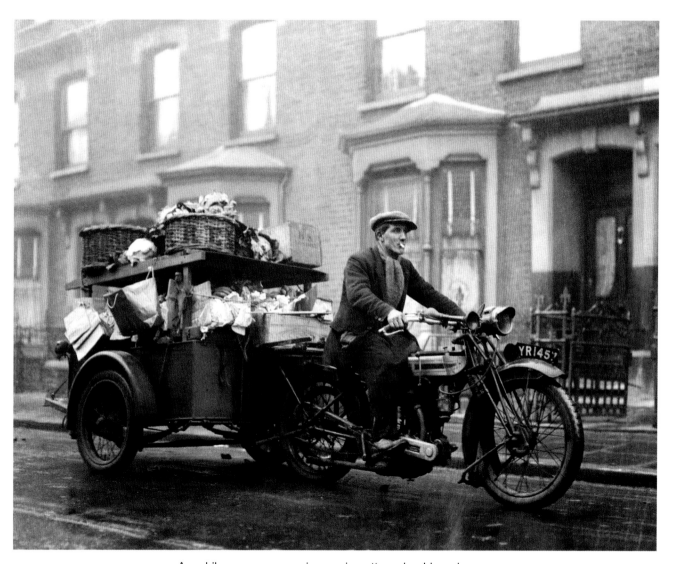

A mobile greengrocer enjoys a cigarette as he drives down the street with his 'shop'. Because of the relative high price and rarity of cars and small vans in the 1920s and 1930s, motorcycles, often fitted with sidecars, were pressed into service instead.

2nd February, 1929

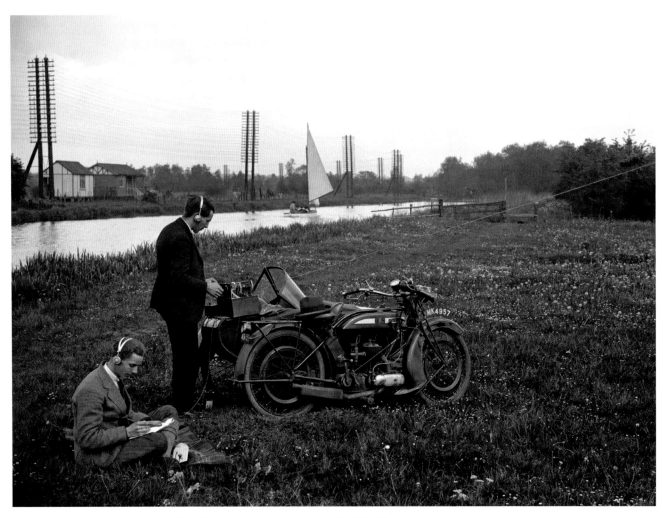

A motorcycle and sidecar provided the ideal means of carrying out early experiments in mobile radio communications.
9th April, 1929

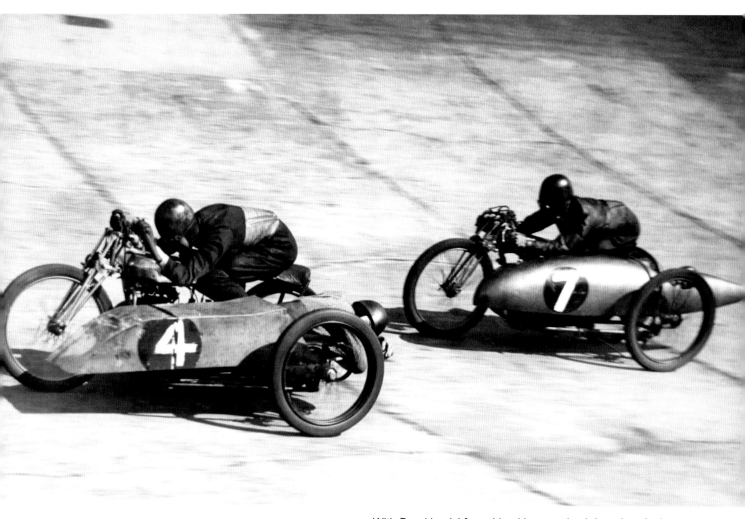

With Brooklands' famed banking as a backdrop, Les Archer leads from Ben Bickell in the Championship Scratch Race. Their sidecar passengers can barely be seen as they lie flat to cheat the wind.

5th October, 1929

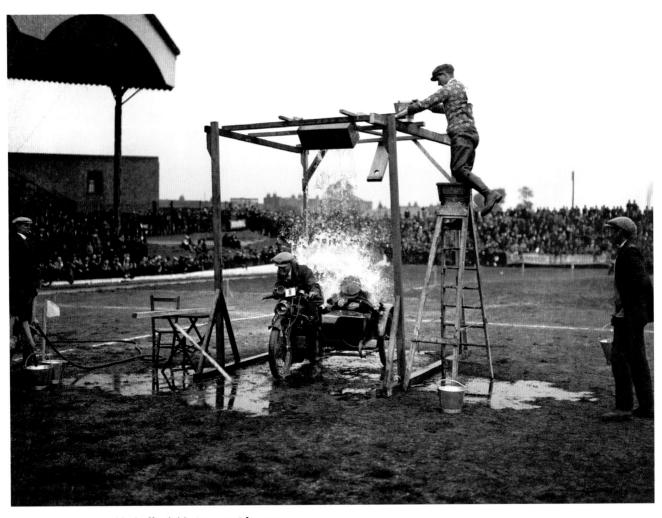

The motorcycle provided affordable transport for many during the 1930s, and this popularity led to the advent of local riders' clubs and a variety of competitive events. This motorcyclist and his sidecar passenger receive a soaking during a 'tilting the bucket' competition.

22nd February, 1930

Facing page: Motorcycle trials became a very popular pastime, pitting rider and machine against a variety of terrain and against the clock. This motorcyclist tackles a hill in Surrey as the judges look on.

22nd February, 1930

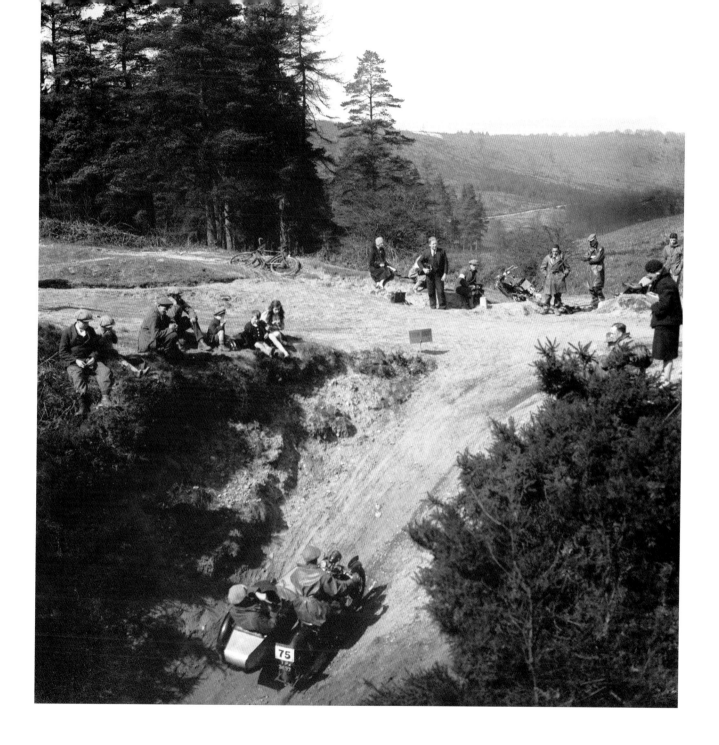

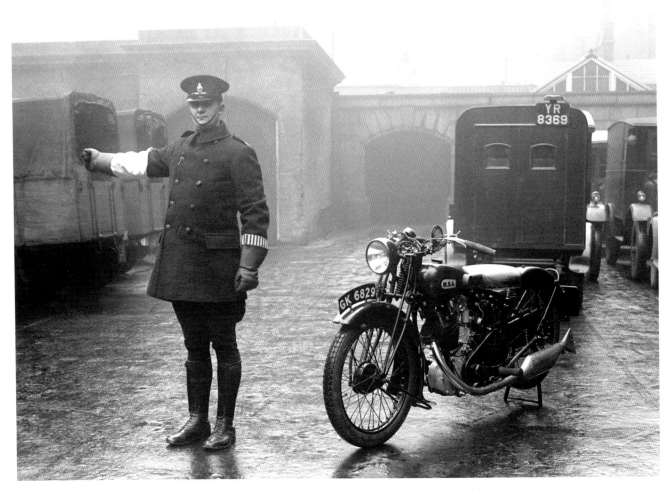

Police forces around the world soon realized the value of the mobile motorcycle-mounted patrol, the first official introduction being in 1911 in the USA. On a murky day, this British officer stands beside his 1930 BSA B30-4 overhead-valve machine.

21st January, 1931

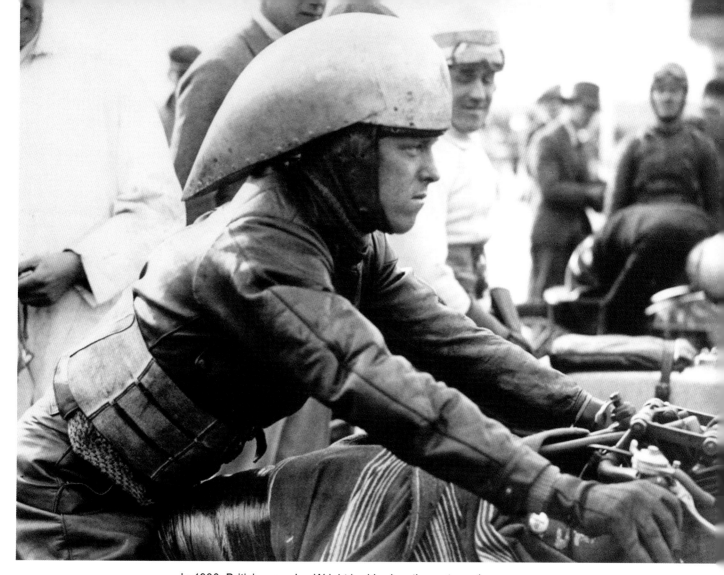

In 1930, British racer Joe Wright had broken the motorcycle world speed record twice, pushing it to over 150mph. Aware of the importance of aerodynamics even during that early period, he developed a streamlined helmet, which bears a striking resemblance to modern racing bicycle helmets.
19th April, 1931

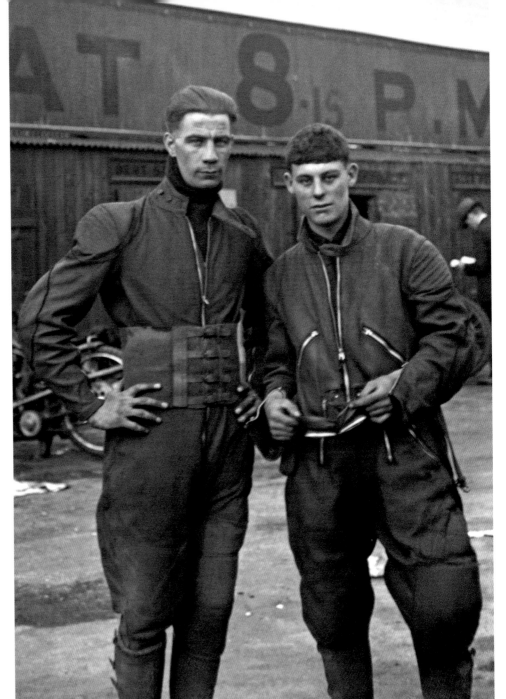

Speedway riders Sid
Edmonds (L) and Phil Bishop
at the High Beech track in
Loughton, Essex. Their
one-piece leather suits
complete with padding
were the forerunners of
modern racing 'leathers'.
Later in the year, both riders
would compete in the Star
Riders' Championship,
a nine-heat event held
at Wembley Stadium,
but without success.
10th June, 1931

In the 1930s, the motorcycle and sidecar were the equivalent of today's family car, providing transport for two or more. Motorcycle touring holidays were common, giving access to many, previously inaccessible parts of the country. This 500cc side-valve Norton 16H and Watsonian GP have carried their riders to the cliffs at Ilfracombe in Devon.

4th August, 1931

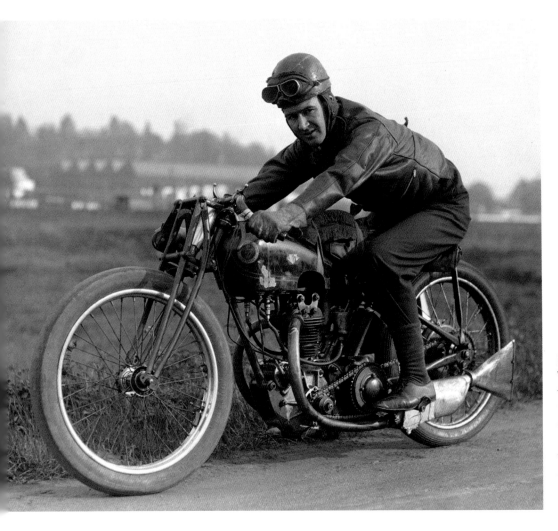

PK Anderson on a Rudge-Whitworth overhead-valve, twin-cylinder machine at a British Motorcycle Racing Club meeting at Brooklands. Rudge motorcycles were well made, but expensive, and the company ceased production in 1940.
1932

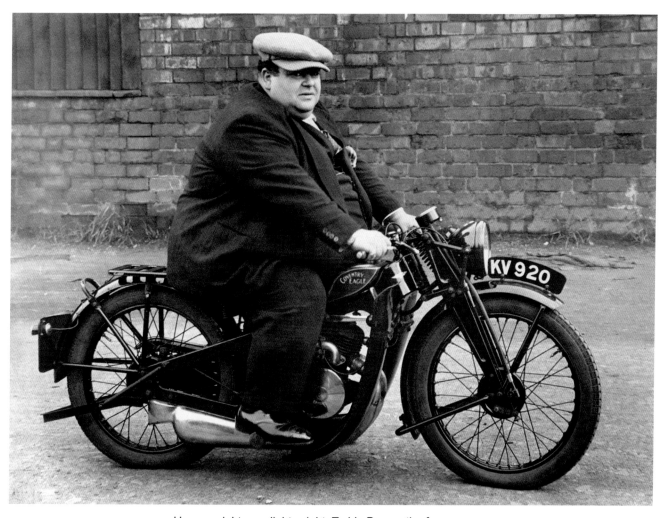

Heavyweight on a lightweight. Teddy Brown, the famous 23-stone xylophone player, whose career spanned the 1920s and 1940s, astride a two-stroke 147cc Coventry Eagle Silent Superb motorcycle. Although Coventry Eagle had made its name with V-twin racing machines, the Depression years forced it to concentrate on affordable lightweights, which had novel pressed-steel frames.

3rd June, 1932

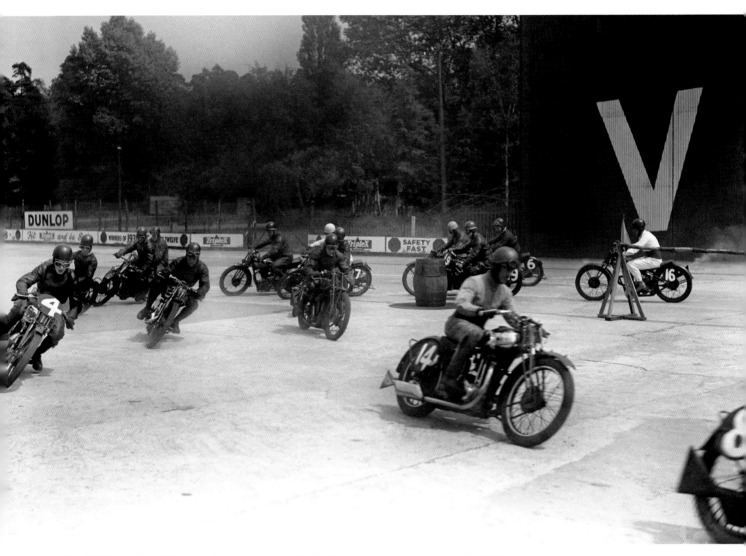

The 2.75-mile Brooklands racing circuit near Weybridge in Surrey was opened in 1907 and was the world's first purpose-built motorsport venue, hosting both car and motorcycle events until the Second World War intervened in 1939. Here riders round one of the hairpin bends at the start of the 100-mile (36-lap) Junior Grand Prix. The building in the background is a hangar belonging to the aircraft manufacturer Vickers; there was an airfield in the centre of the track.

23rd July, 1932

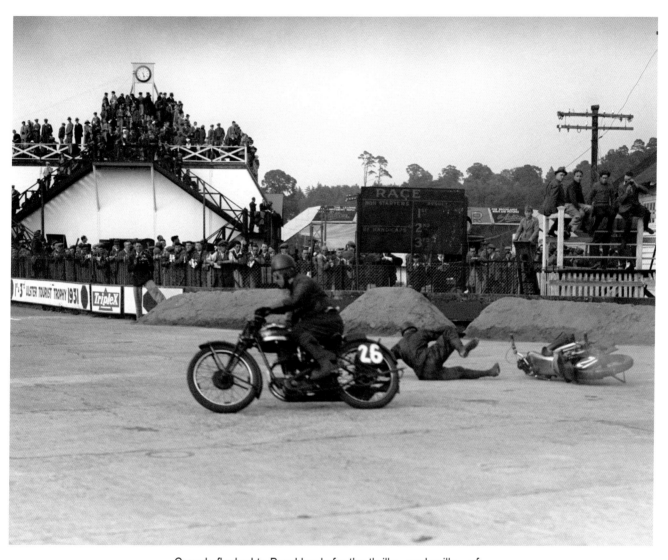

Crowds flocked to Brooklands for the thrills – and spills – of racing. Jack Pierre gave them what they wanted when he took a tumble from his Norton motorcycle in the 100-mile (36-lap) Senior Grand Prix.

23rd July, 1932

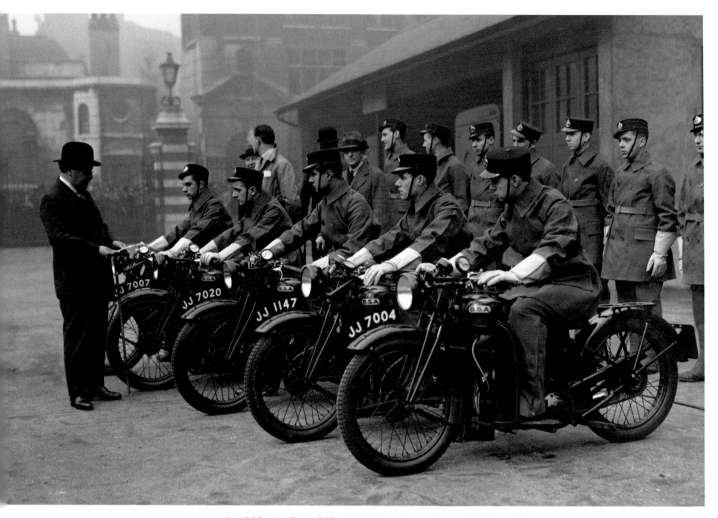

In 1933, the Post Office introduced a motorcycle telegraph delivery service, starting with a dozen 249cc BSA side-valve machines ridden by young lads of seventeen or eighteen in Leeds. The service quickly spread to other cities, and here the Post Master General inspects the first team of boys in London, at the GPO Yard in Giltspur Street, Smithfield.

13th March, 1933

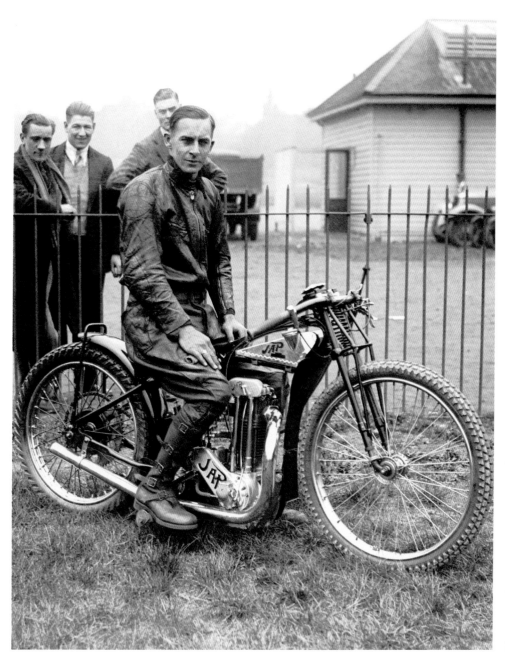

Australian speedway star Vic Huxley, one of the greatest exponents of broadsiding around the track, sitting astride his Rudge/JAP machine. Huxley won the Star Riders' Championship (forerunner of the Speedway World Championship) in 1930, and was runner-up in 1931 and 1932.

24th April, 1933

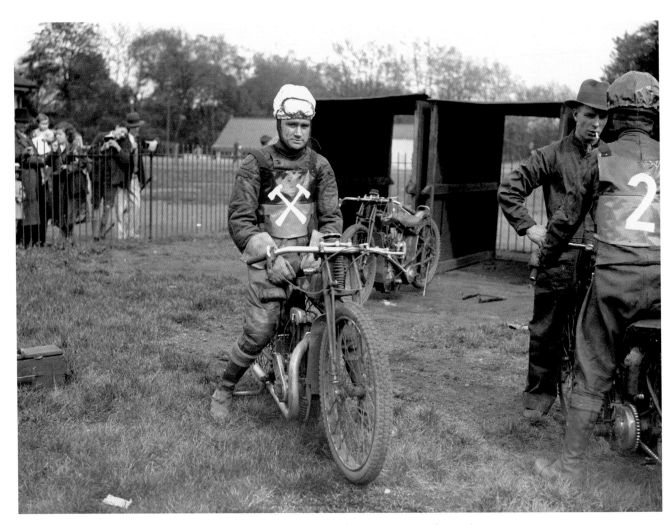

Harold 'Tiger' Stevenson, one of the early stars of speedway,
who captained the West Ham Hammers club between 1929
and 1939, sitting on his Rudge-Whitworth/JAP machine.
9th May, 1933

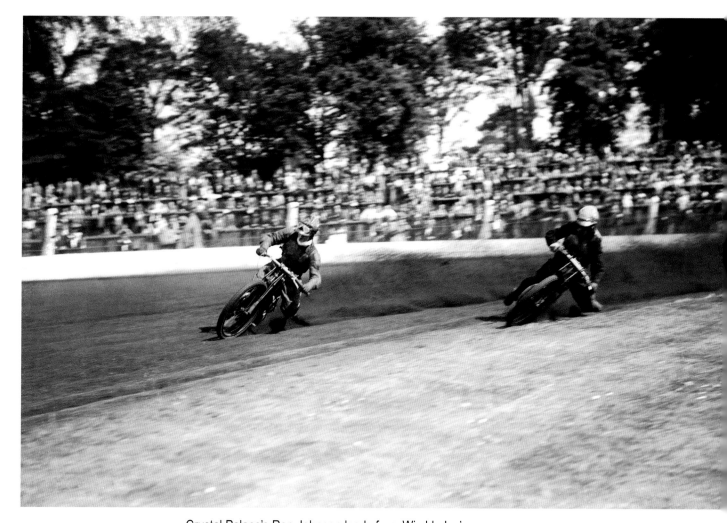

Crystal Palace's Ron Johnson leads from Wimbledon's
Claude Rye during the teams' battle for the Speedway
National Trophy at the Crystal Palace track. In the end, the
Belle Vue team from Manchester won the trophy.

22nd May, 1933

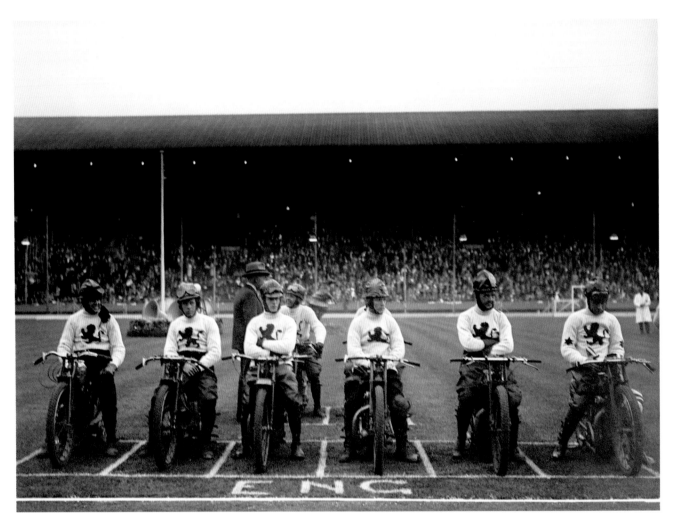

The England team who faced the outstanding Australian squad in the first Speedway Test Series at Wembley. The stadium was packed with 55,000 fans who saw England defeat Australia 76–47 points. The England team was led by Harold 'Tiger' Stevenson, while Australia was captained by Vic Huxley.

26th June, 1933

Facing page: Jessie Hole (L) receives some assistance to negotiate the mud during a motorcycle and sidecar trial event. Jessie had been riding motorcycles since 1925 and was about to become a competitive female speedway rider in 1930 when an accident during a pre-race parade led to another female rider being injured. Immediately, all women were banned from riding in speedway events, the ban remaining in force for 50 years.

22nd July, 1933

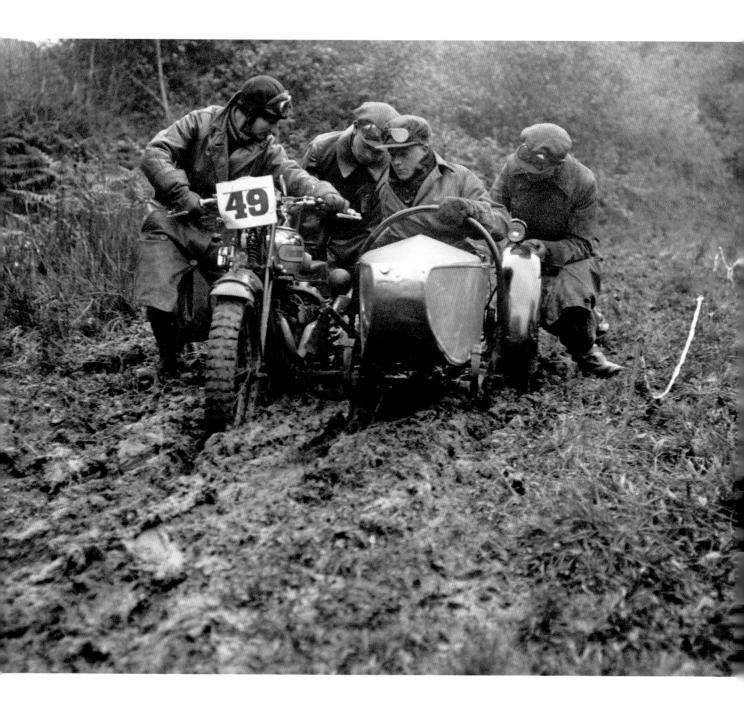

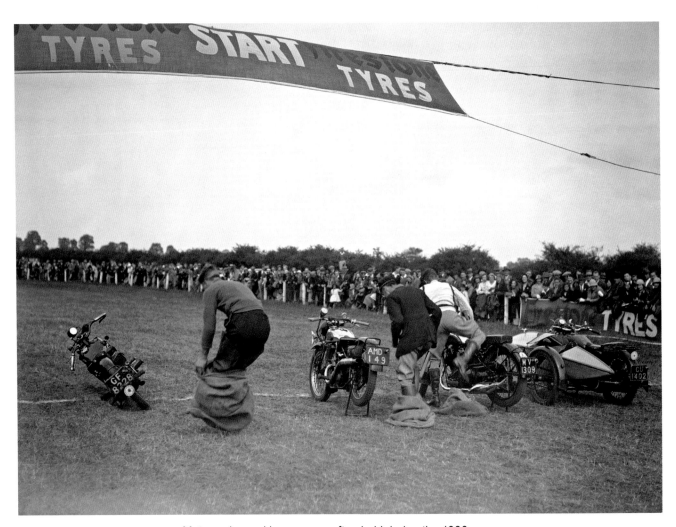

Motorcycle gymkhanas were often held during the 1930s
as a means of giving riders an opportunity to have some fun
with their machines. These riders have just taken part in
a sack race prior to mounting their bikes for the next stage
of the competition.

31st July, 1933

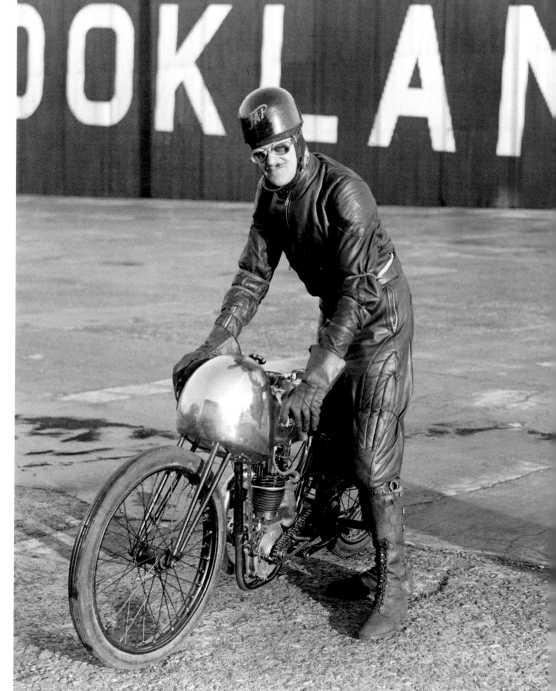

British motorcycling champion Eric Fernihough with his Excelsior/JAP 175cc motorcycle at Brooklands. Fernihough raced a variety of machines, and in 1933 he managed to gain a gold star at the Surrey track by lapping at over 100mph on a 350cc bike. He went on to break a number of motorcycle speed records during the 1930s.

31st October, 1933

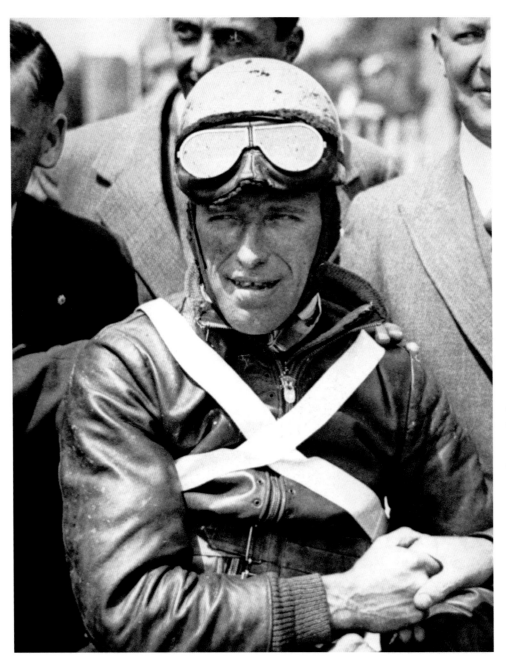

Jimmy Simpson, winner of the 1934 Isle of Man Lightweight TT. Simpson rode a 250cc Rudge-Whitworth machine to complete the race at an average speed of 70.81mph. His victory, the only TT win of his career, gave Rudge a 1-2-3, second and third places being taken by Ernie Nott and Graham Walker. Simpson was also second in that year's Senior and Junior TTs, riding Nortons.

13th June, 1934

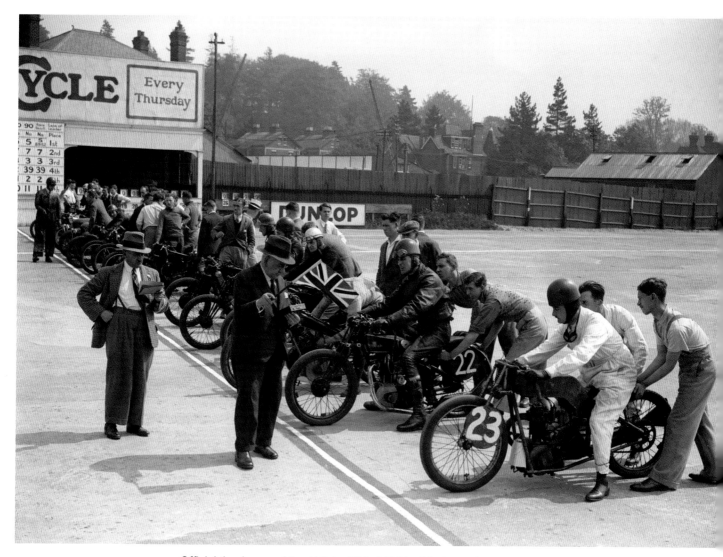

Official timekeeper Albert Victor 'Ebby' Ebblewhite inspects
the bikes before another motorcycle race at the Brooklands
track in Surrey.
5th August, 1934

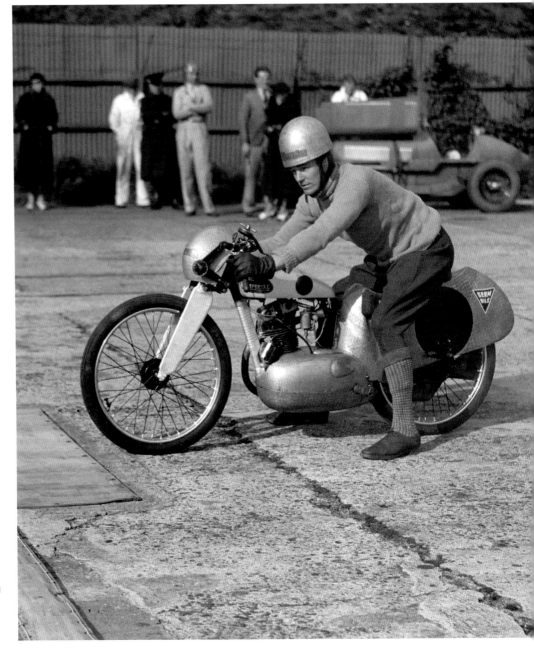

Harry Nash on a New Imperial motorcycle prior to making an attempt on the one-kilometre and one-mile standing-start records at Brooklands. In an attempt to cheat the wind, the machine has been fitted with streamlined panels over the handlebars and rear wheel.
1st October, 1934

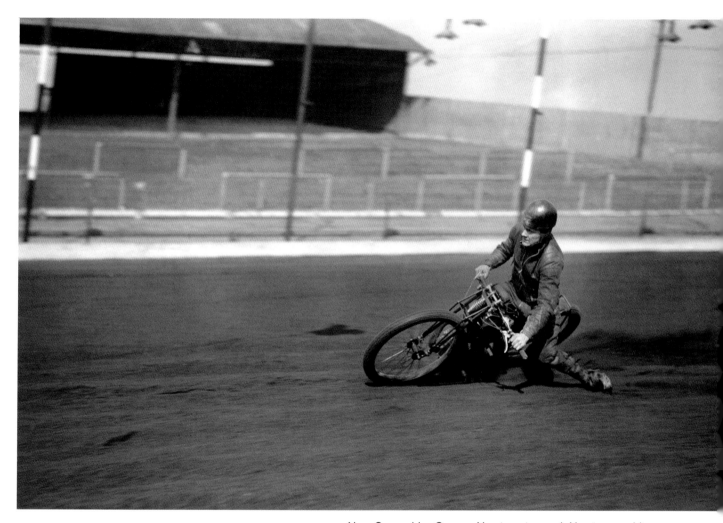

New Cross rider George Newton at speed. Newton would
qualify for the world championship three times during the
1930s, but would be forced to retire in 1938 due to ill health.
He would return to speedway riding ten years later, however,
eventually becoming manager of St Austell Gulls.
28th March, 1935

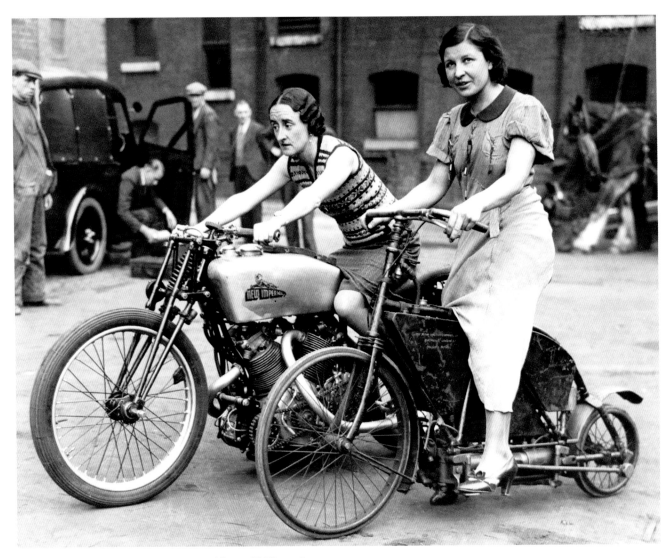

Decades of progress. Two women astride an 1895 crank-
drive motorcycle (R) and a 500cc New Imperial V-twin,
which reached a speed of 114mph at Brooklands.
29th November, 1935

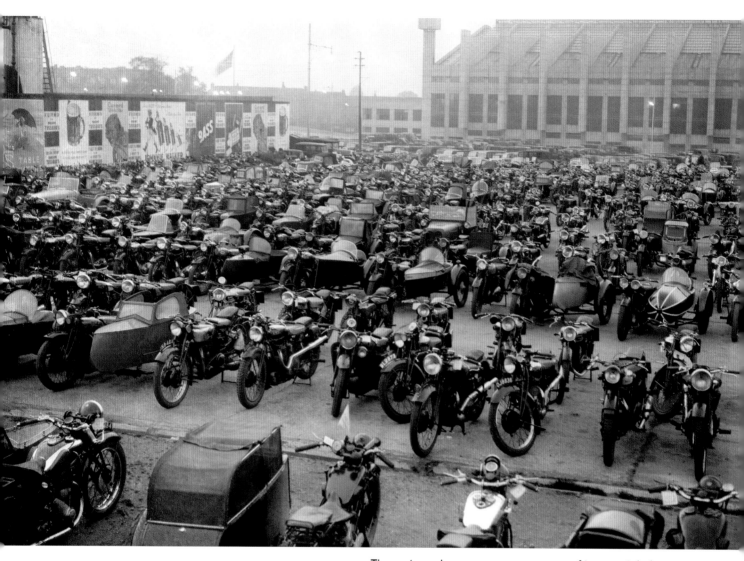

The motorcycle was a common means of transport during the 1930s through to the 1950s, as shown by this sea of machines parked outside Wembley Stadium.
January, 1936

Lionel Van Praag, the young Australian rider who would win the inaugural World Speedway Championship at Wembley on the 10th September, 1936. Controversially, the championship would be decided by bonus points accrued during previous rounds, excluding the winner of the final round. Tied on points, Van Praag and another rider, Eric Langton, would take part in a run-off to decide the winner. Later, Van Praag would be awarded the George Medal for bravery while flying during the Second World War.

9th May, 1936

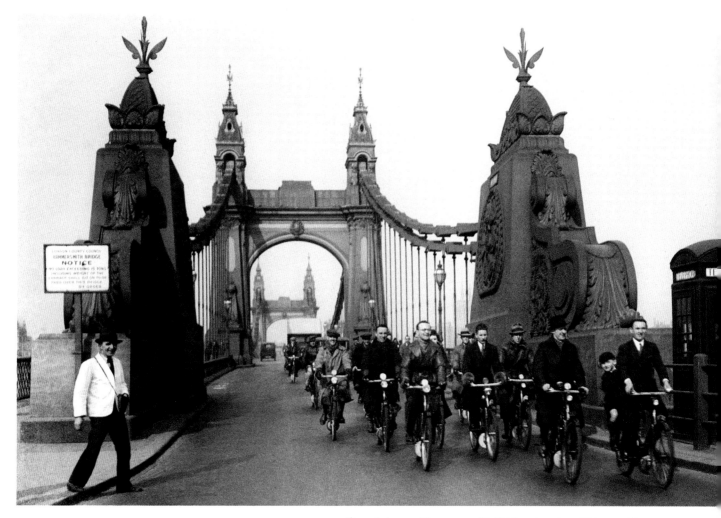

Cyc-Autos on Hammersmith Bridge, London. This machine was a lightweight 98cc bike that was developed from a standard bicycle frame. It started an autocycle boom in the mid-1930s that continued into the 1950s and led to the popular moped. In 1938, Cyc-Auto was taken over by the Scott Motorcycle Company of Shipley, Yorkshire.
16th June, 1936

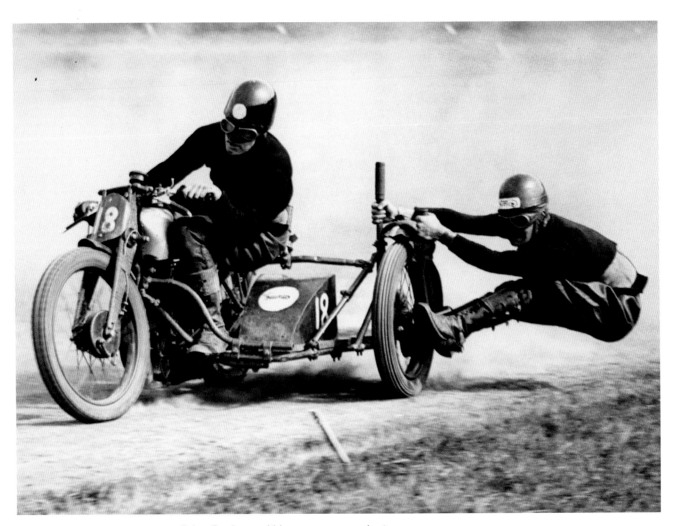

Brian Ducker and his passenger navigate a corner
in spectacular style to win a sidecar grass-track race.
Although allied to speedway, grass-track events take
place in fields in rural locations.
22nd June, 1936

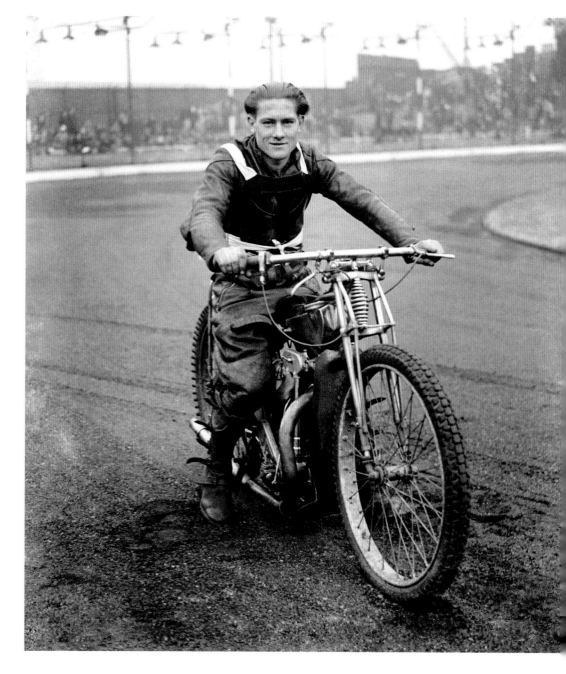

George 'Wee Georgie' Newton. His best pre-war season was 1938, when he set a track record of 58 seconds that stood for ten years. At the end of 1938, however, a lung infection forced the New Cross rider to retire.

22nd May, 1937

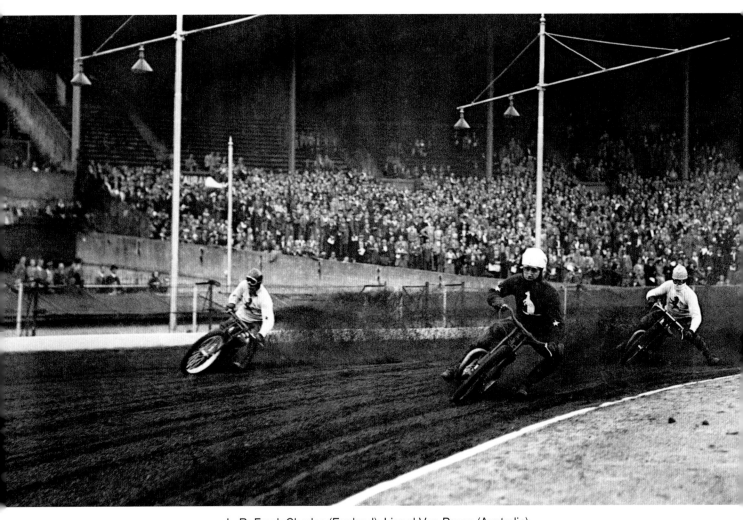

L–R: Frank Charles (England), Lionel Van Praag (Australia) and Jack Ormston (England) power-sliding through a turn at Wembley during the Speedway Test of 1937.
24th May, 1937

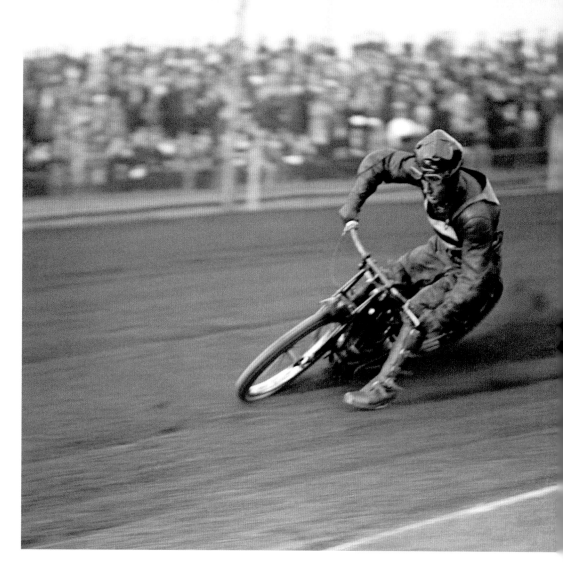

Morian Hansen
demonstrating classic
speedway style. The rider
had recently moved to
Hackney Wick Wolves from
the West Ham Hammers.
31st May, 1937

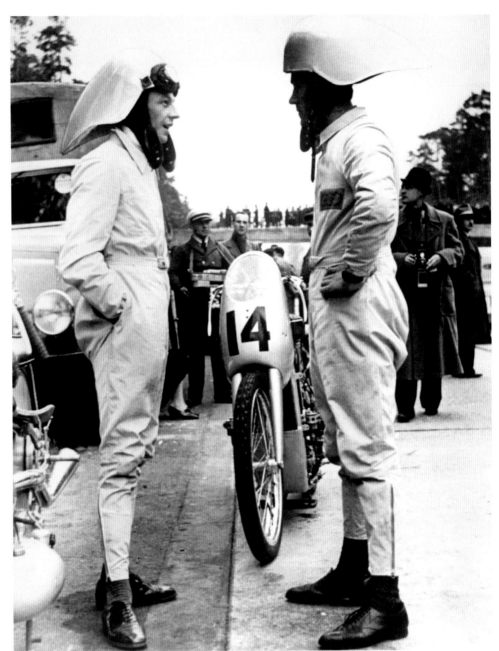

If you want to get ahead, get a hat. DKW (Dampf-Kraft-Wagen) riders Walfried Winkler (L) and Ewald Kluge in conversation at the Reichs Track, Frankfurt. They are wearing the streamlined helmets that helped them set new track records. During the 1930s, the German company DKW was the world's largest manufacturer of motorcycles.

28th October, 1937

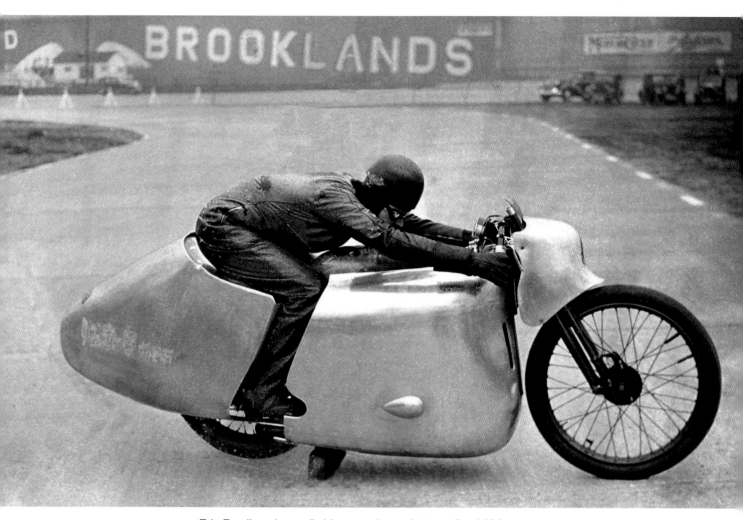

Eric Fernihough unveils his supercharged, streamlined 996cc
Brough Superior at Brooklands, where he was due to make a
demonstration run at the first meeting of the 1938 season. The
machine had been built to attack the world's motorcycle record,
and on the following day he achieved the highest official speed
by a motorcycle at the Surrey track, 143.39mph.
11th March, 1938

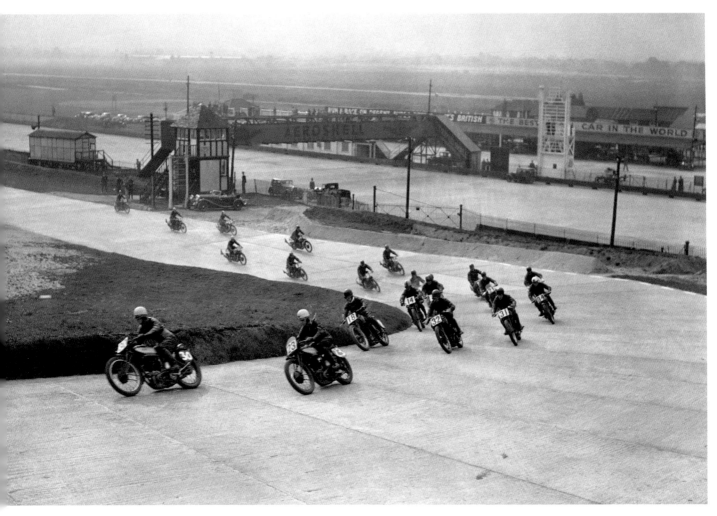

Motorcyclists racing on the Campbell circuit at Brooklands. The Campbell circuit was a track within a track, a flat road course snaking across the centre of the outer circuit to join sections of the banking. It provided a course that was about half the length of the full banked circuit.

8th May, 1938

Facing page: Although motorcycles were commonly used by military dispatch riders during the Second World War, they also played a more aggressive role. Here the 1st Canadian Reconnaissance Squadron, armed with motorcycle-mounted Bren and Lewis machine guns, takes a tea break during an exercise in an English wood. Their job was to scout ahead of the main force and locate the enemy, bringing back information.

January, 1940

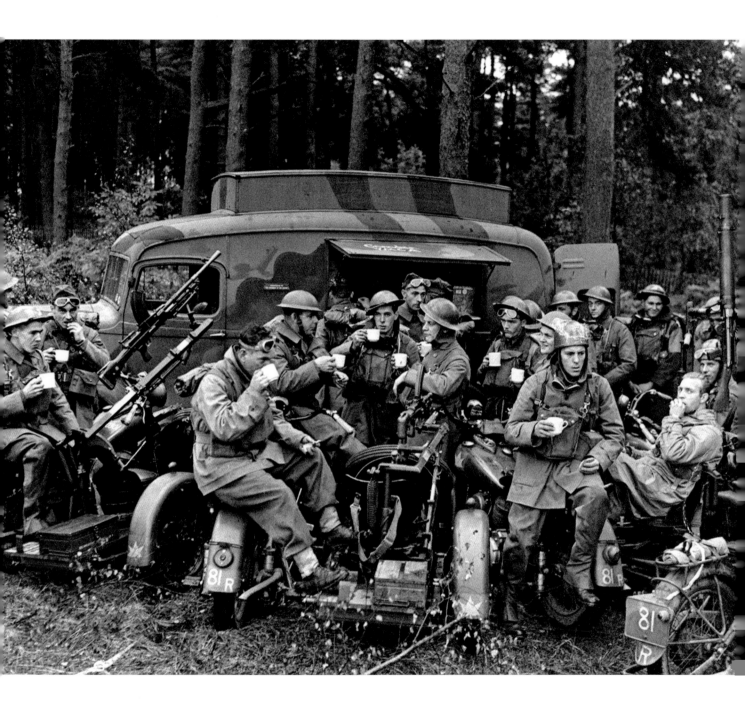

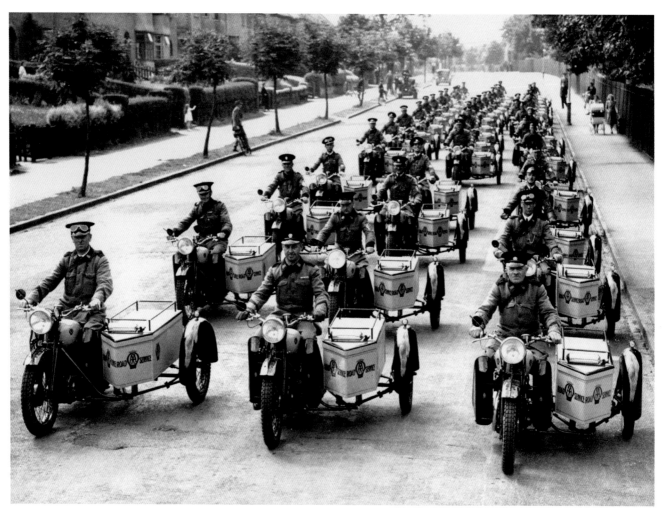

A convoy of Automobile Association Scouts (patrolmen),
mounted on BSA motorcycle combinations, leaves an
assembly point in the Midlands. At that time, the AA had 400
motorcycle patrols, whose job was to provide members with
emergency roadside assistance. On passing a car displaying
an AA member's badge, the Scout would salute smartly.
4th July, 1946

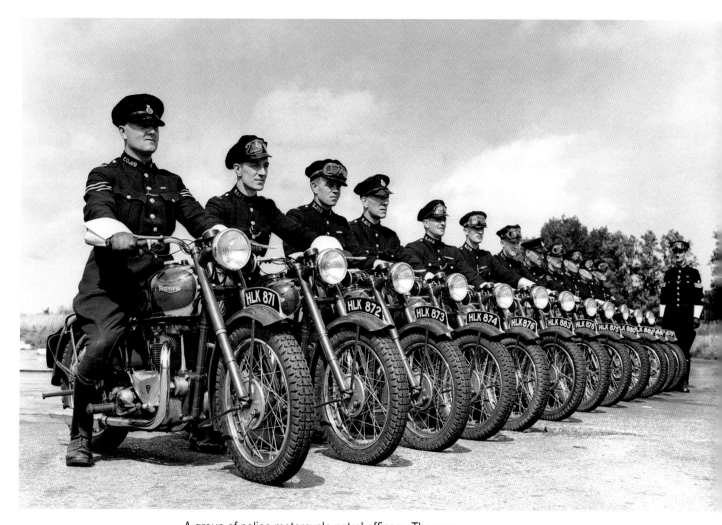

A group of police motorcycle patrol officers. They are mounted on 500cc Triumph Speed Twins, a popular bike with police forces in the UK. The lightweight twin-cylinder machine had been introduced in 1938.

28th September, 1946

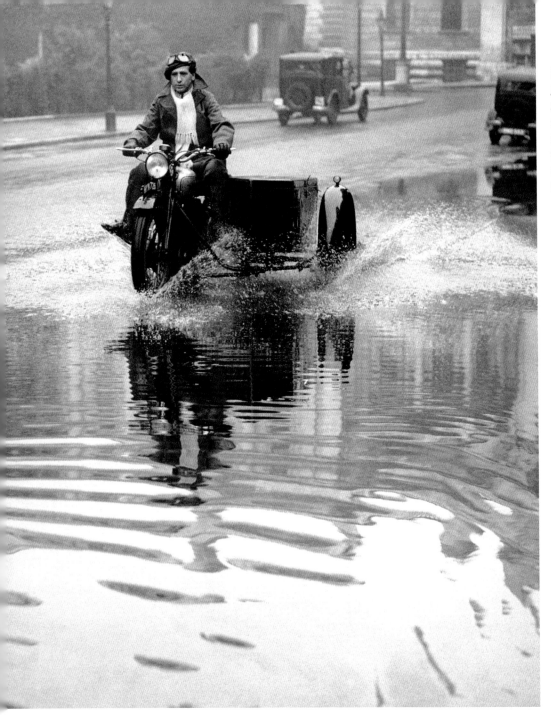

Facing page: An Automobile Association Scout renders assistance to several stranded motorists and a bus at the height of a snowstorm that swept between London and Maidstone.
21st February, 1948

An adventurous rider pilots his motorcycle and sidecar through the swamped roadway on Birdcage Walk, London, where a huge deluge of water had caused flooding. He has lifted his feet clear of the footrests to keep them dry.
27th June, 1947

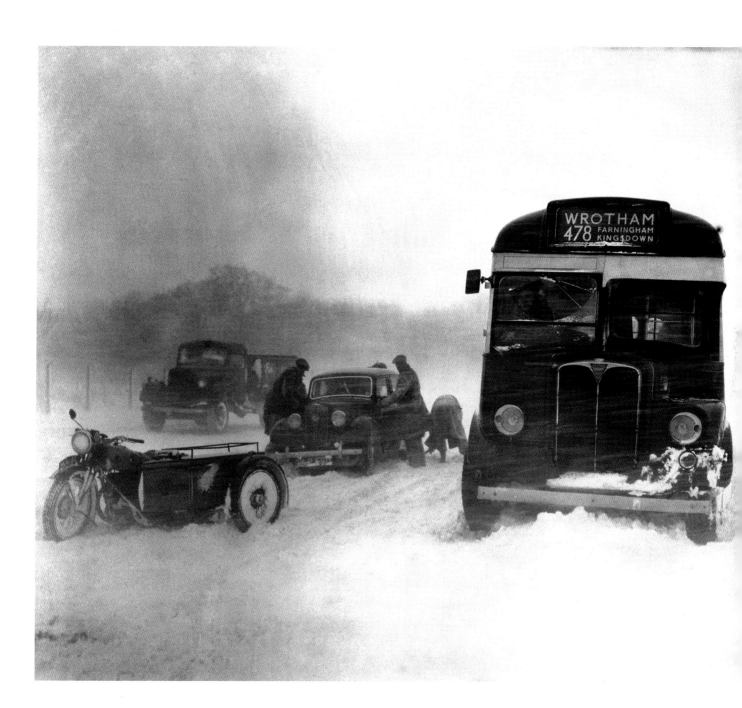

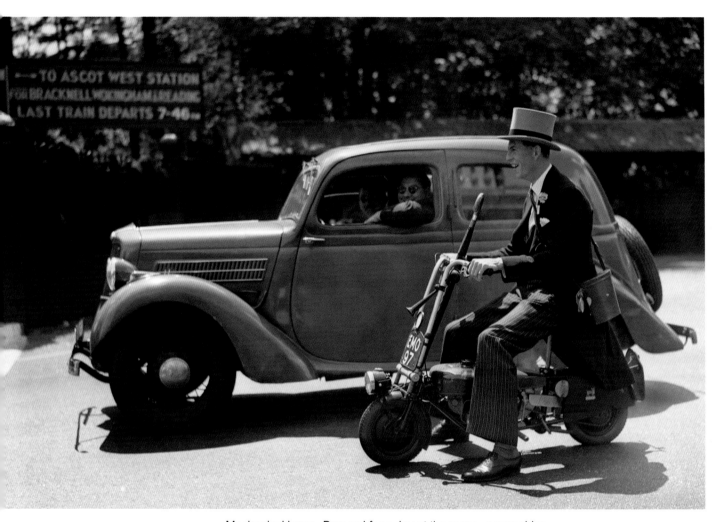

Mechanical horse. Dressed for a day at the races, a man rides a Brockhouse Corgi motorcycle at Ascot racecourse. The Corgi had been developed from the Welbike, a lightweight machine with folding handlebars used by British airborne forces during the Second World War. It was exported to the USA, where it was sold as the Indian Papoose.
5th June, 1948

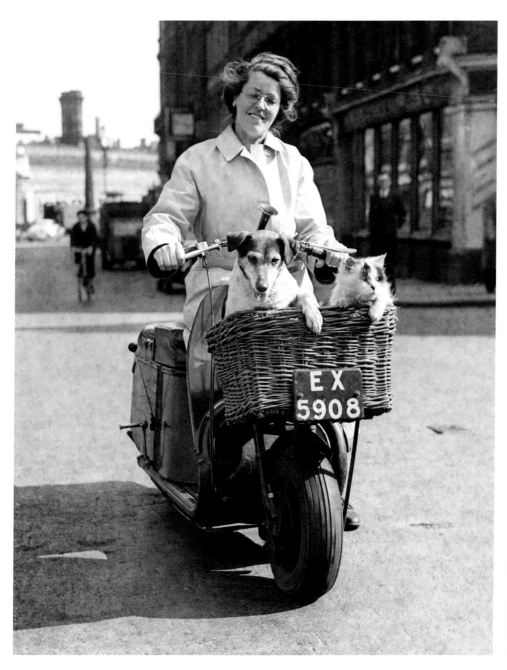

Ms FA Clarke aboard a
Phillips Gadabout scooter
with her dog Pip and cat
Squeak enjoying the ride
from the front basket.
Post-war, scooters became
popular because their
enclosed engines made
for a cleaner ride.
12th April, 1949

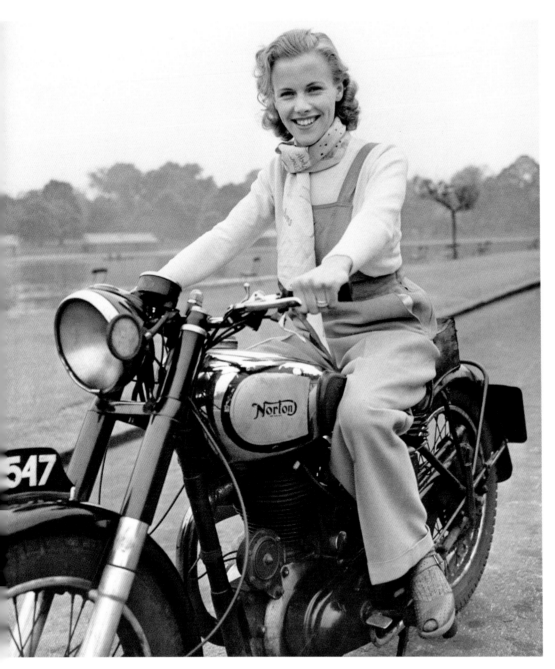

Honor Blackman, 23-year-old London-born film actress, riding her Norton Big Four motorcycle through Hyde Park in London. The machine had a side-valve single-cylinder engine of 600cc. Ms Blackman became well known for playing Cathy Gale in the 1960s TV series *The Avengers* and Pussy Galore in the James Bond movie *Goldfinger*.

9th May, 1949

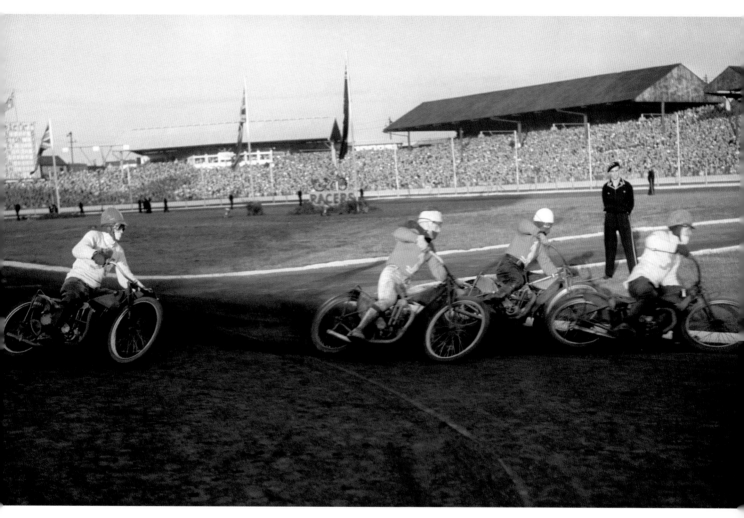

Australians Ken le Breton (third R) and Graham Warren
(second R) battle it out with England's Jack Parker (R) during
the Speedway World Championship. Parker would come
second in the race, while Warren and le Breton placed
12th and 13th respectively.

6th August, 1949

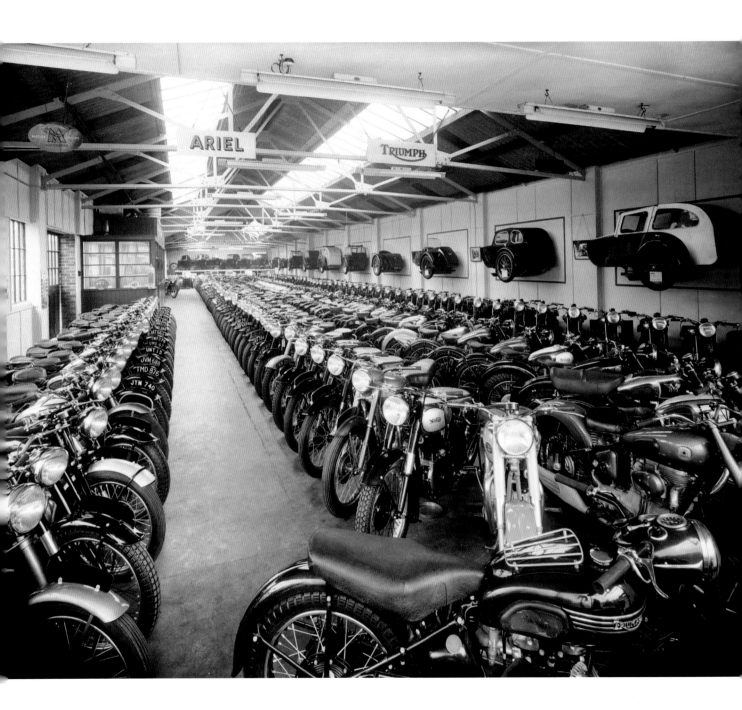

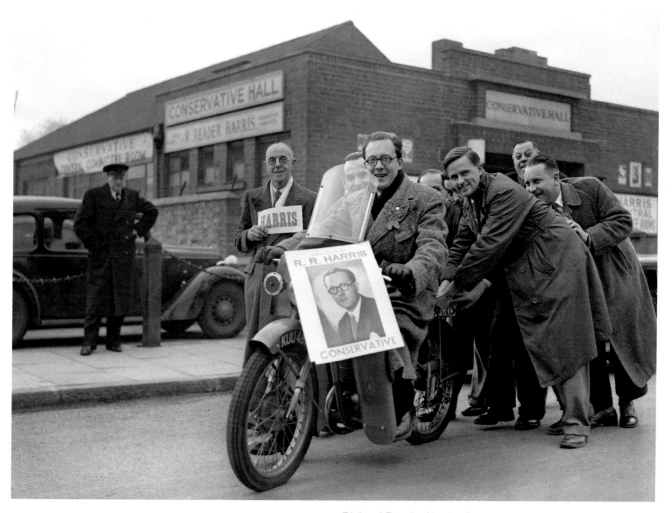

Facing page: The massive interior of Pinks motorcycle showroom in Harrow, Middlesex, where buyers could take their choice of traditional British motorcycles from all the well-known manufacturers, as well as a selection of sidecars. The size of the showroom is an indication of the popularity of the motorcycle as a means of personal transport, which would remain the case until the end of the decade.
January, 1950

Richard Reader Harris, Conservative candidate for Heston and Isleworth, being given a helping hand by his supporters. Harris won the election and held the seat until 1970, when he was deselected following fraud allegations concerning his washing-machine company, Rolls Razor.
23rd February, 1950

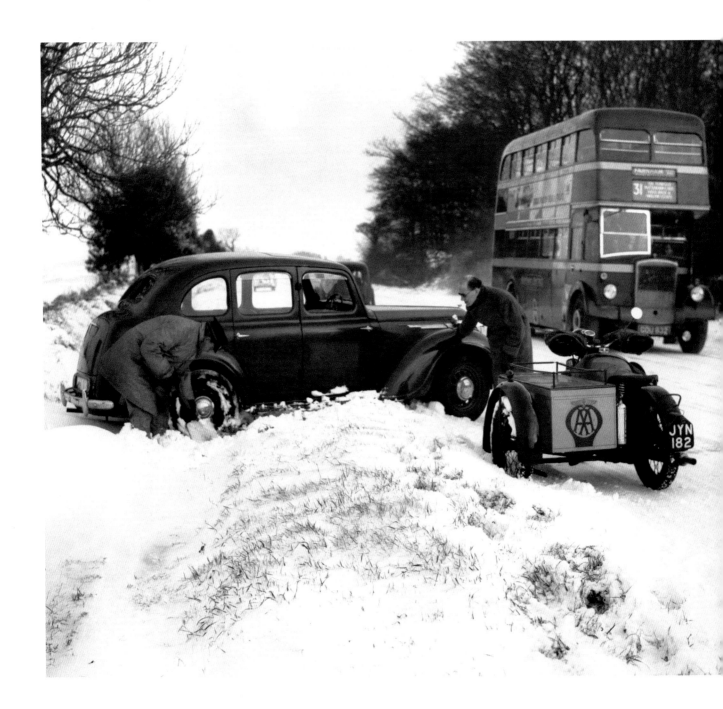

Facing page: Automobile Association patrolman AJ Wilson digs out a car that had skidded into a ditch on the ice-bound, snow-covered road on the Hog's Back, near Guildford in Surrey.
15th December, 1950

Noted motorcycle sidecar racer Eric Oliver (L) and his passenger, Italian Lorenzo Dobelli, celebrate a victory with their Manx Norton/ Watsonian combination. They would take the world championship that year, a third for Oliver.
8th April, 1951

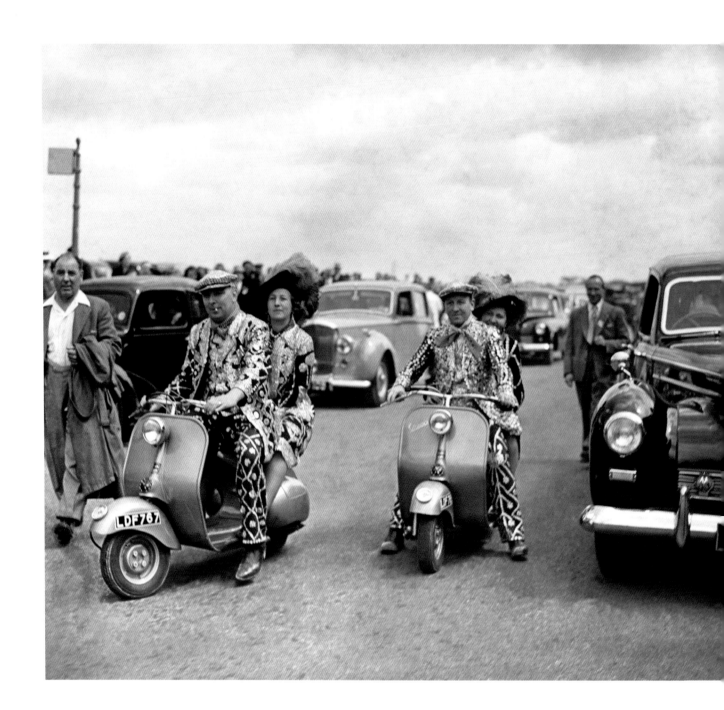

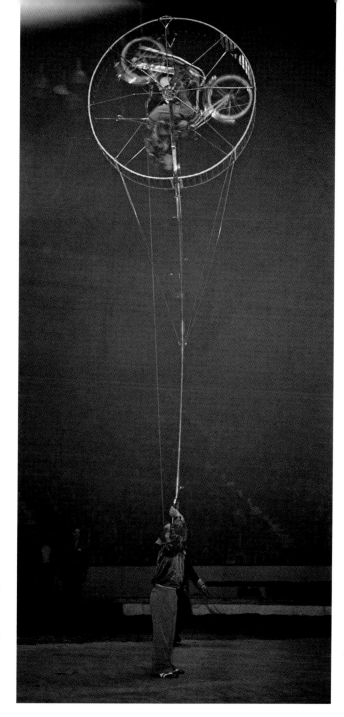

Motorcycle acrobats Les Rockleys thrill the crowd with their exciting performance. In the days when motorcycles were commonly used as personal transport, there were several such acts.
23rd December, 1952

Facing page: Pearly Kings and Queens arrive on Vespa PX scooters for Derby Day at Epsom racecourse. The stylish Italian machines were ideal for those who wanted to maintain their sartorial appearance.
28th May, 1952

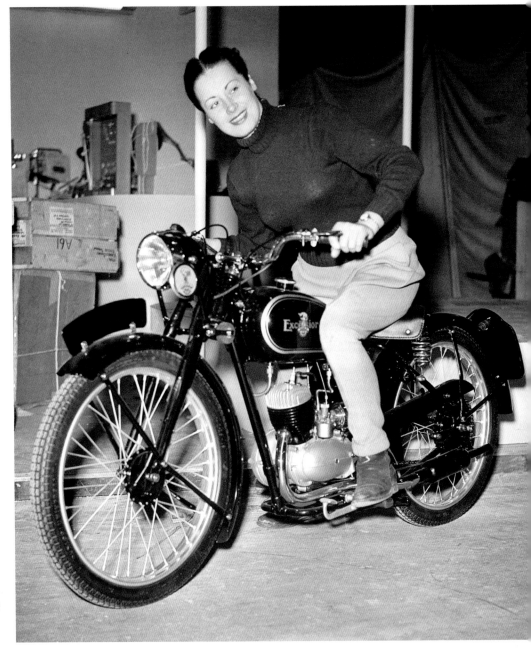

An Excelsior Consort lightweight motorcycle being tried out at the Motorcycle Show. The 99cc two-stroke machine had been introduced that year and was ideal as a ride-to-work bike.
13th November, 1953

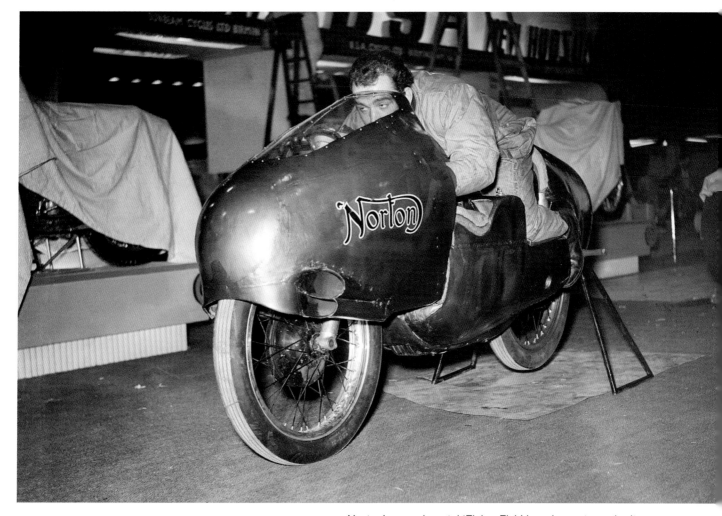

Norton's experimental 'Flying Fish' kneeler motorcycle. It was ridden by Rhodesian Ray Amm in the Northwest 200, but retired after only three laps. Subsequently, Amm piloted the machine to a one-hour speed record of 133.71mph, the last time it was held by a British bike.

13th November, 1953

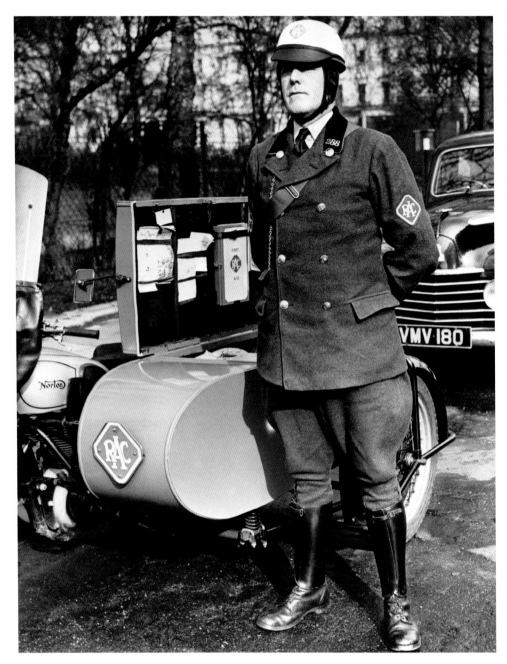

Like the Automobile Association, the Royal Automobile Club employed motorcycle patrolmen, whose duty was to assist members in difficulty. Standing next to his Norton combination, this patrolman wears a safety helmet, unlike many motorcyclists of the time.

25th March, 1954

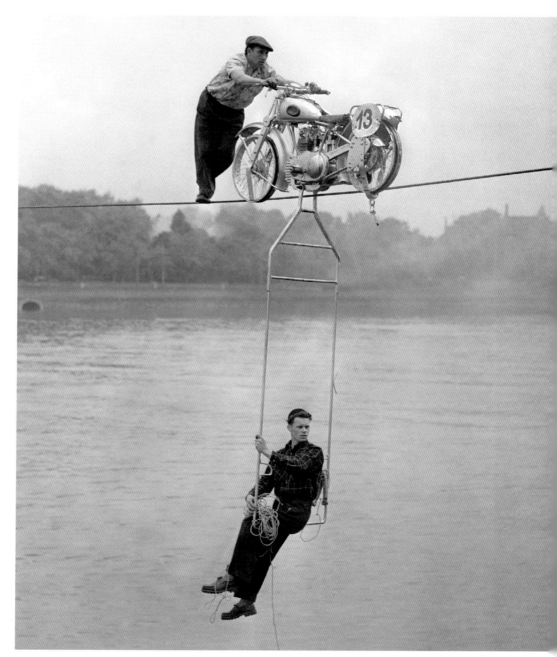

Bike on a wire. Motorcycle high-wire act the Bugler Brothers in trouble during a crossing of the River Thames at Battersea. When their machine broke down, Alphonse was forced to push it back along the wire, while Charles could only sit it out on the swing below.
31st May, 1954

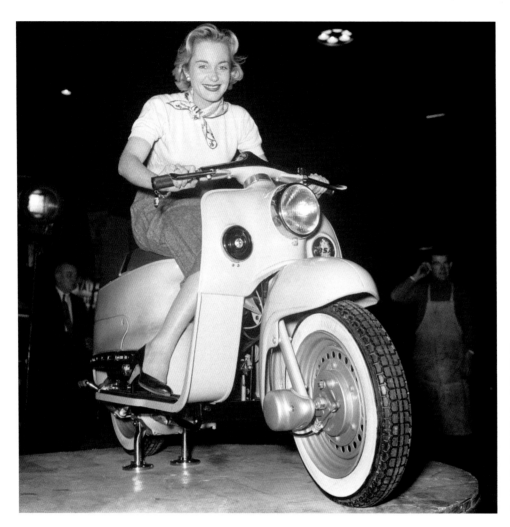

British actress Josephine Griffin tries a scooter for size at the Motorcycle Show. The enclosed design of these machines made them ideal for riders who wanted to wear smart clothes without the fear of them becoming greasy through contact with the engine.

11th November, 1955

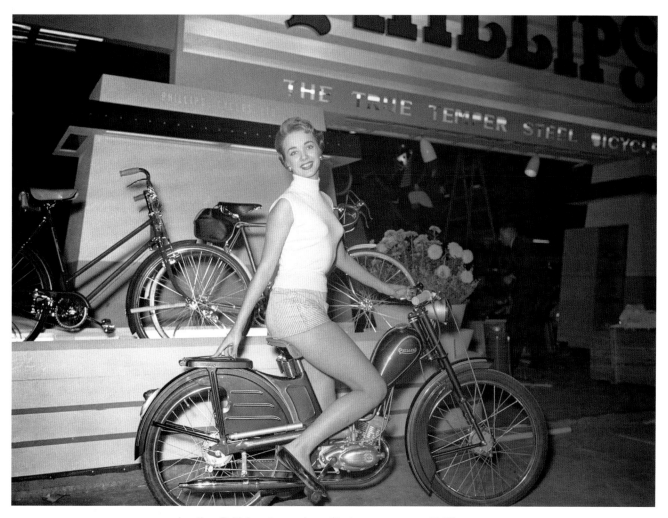

Another British actress, Jean Clarke, poses on a Phillips Gadabout moped. These machines were a step up from the humble bicycle and were ideal for commuting to work.
11th November, 1955

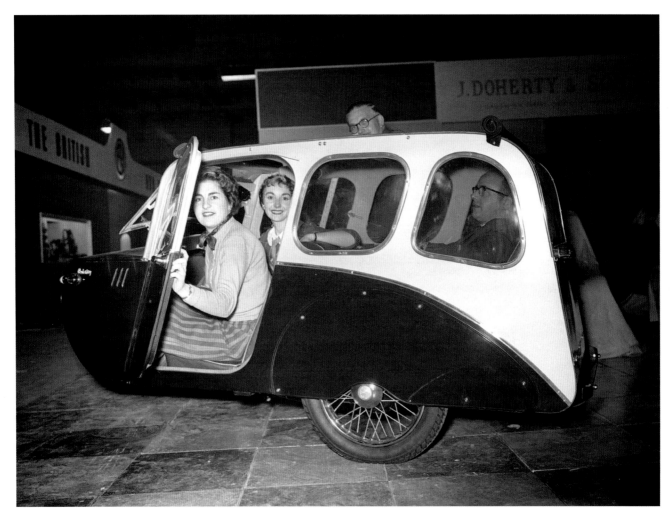

With the addition of a sidecar, a motorcycle could have the same passenger capacity as a small car. The Canterbury Carmobile provided seating for three; it needed a powerful machine to pull it.

11th November, 1955

The Manx Nortons were
a series of racers built
between 1946 and 1963,
and are considered by
many to have been the most
effective racing motorcycles
ever. They were equipped
with 500cc, double-
overhead-camshaft twin-
cylinder engines.
30th October, 1956

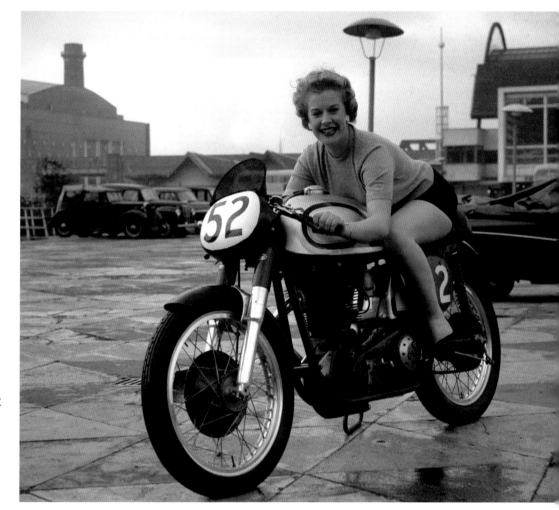

Brenda Lewis-Evans, 17-year-old sister of 1950s Formula One racing driver Stewart Lewis-Evans, tries out the James Commodore L25 250cc motorcycle, which was due for release in 1957.
8th November, 1956

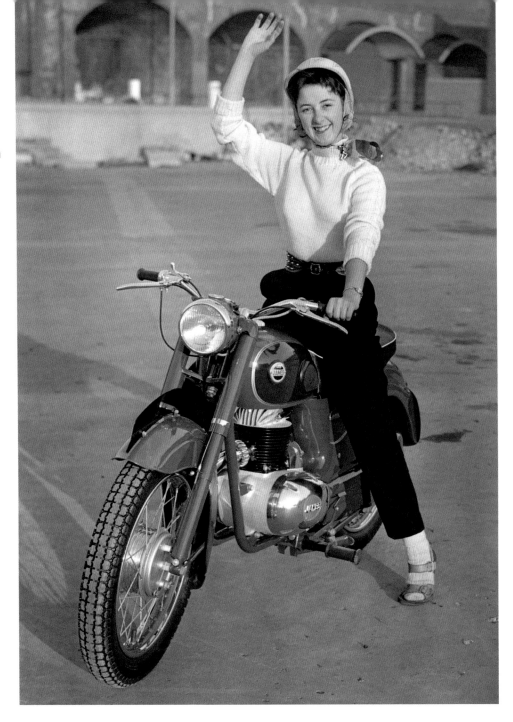

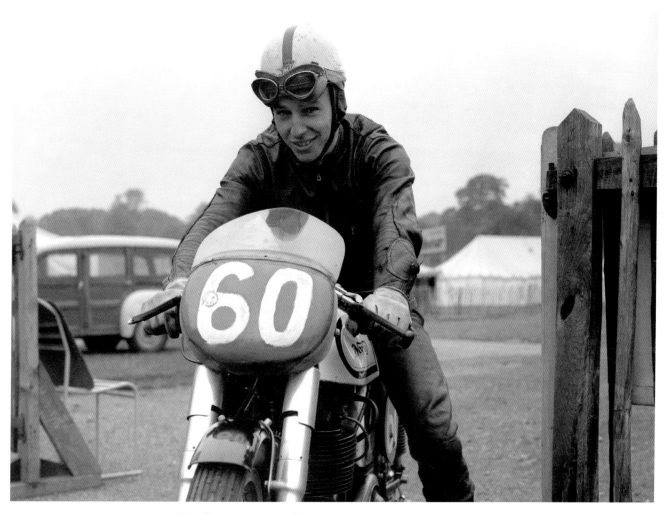

John Surtees on one of his own Norton bikes, which he raced independently at the Crystal Palace circuit, despite being contracted to ride for MV Agusta. He would win in the 250cc, 350cc and 500cc classes, breaking the existing speed record in each.

14th August, 1957

Manchester Belle Vue rider Peter Craven during the Speedway World Championship. Although he would place only third, he had won the championship in 1955 and would do so again in 1962, as well as gaining many other titles, cups and trophies. He would die after a freak accident while racing at Edinburgh's Meadowbank Stadium in September, 1963

16th September, 1957

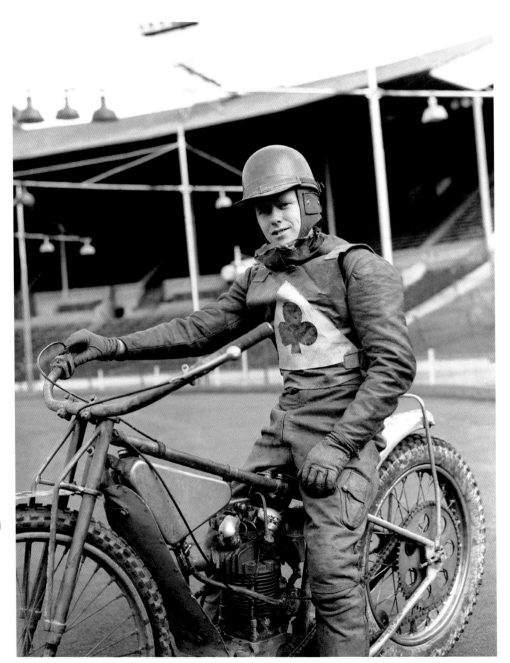

Famous runner and sub-four-minute miler Dr Roger Bannister riding an Army Matchless G3/L 348cc motorcycle while acting as an instructor on the Army Cadet leadership course at West Tofts Camp, Braindon, Norfolk. Large numbers of G3/Ls were built for the Army during the Second World War. After the war, a civilian version of the tough machine was introduced.
16th April, 1958

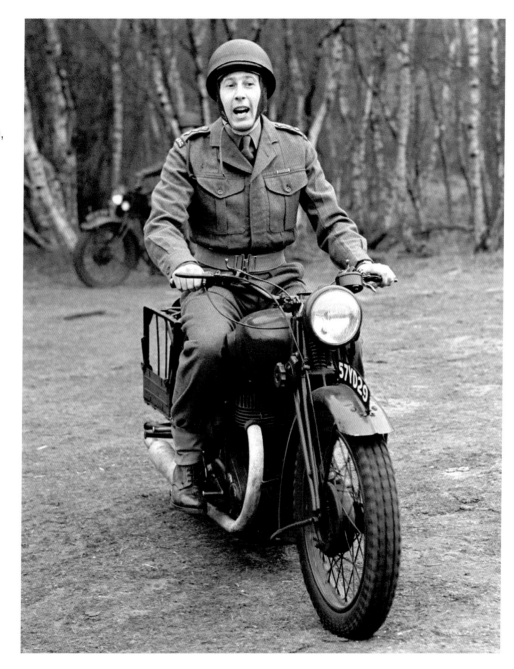

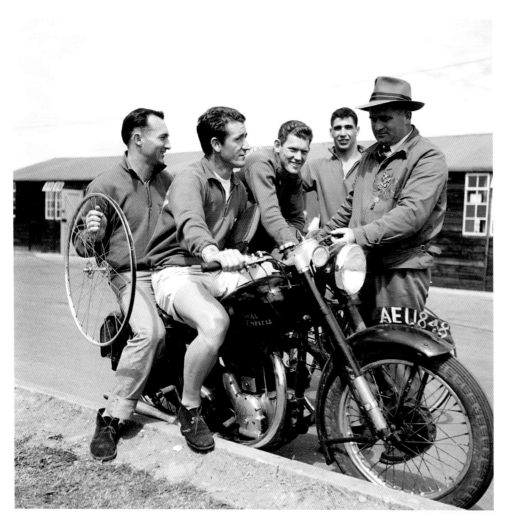

Australia's cycling team
at the British Empire and
Commonwealth Games
in Cardiff used a Royal
Enfield 500cc J2 twin to
travel between their camp
and the cycle track. L–R:
Dick Ploog, Barry Coster,
Con Bambacas, Ian Brown
and team manager Ron
O'Donnell.
23rd July, 1958

Two young women demonstrate a 75cc two-stroke Manurhin scooter at London's Motorcycle and Cycle Show. The Manurhin was the French-made version of the German DKW Hobby.

14th November, 1958

The Minister of Transport and Civil Aviation, Harold Watkinson (second R), examines a deluxe Watsonian Oxford sidecar during his visit to the Motorcycle and Cycle Show at Earls Court, London. Whereas earlier sidecars had tended to be boxy affairs, the use of modern composite materials allowed a much more attractive shape to be moulded.

14th November, 1958

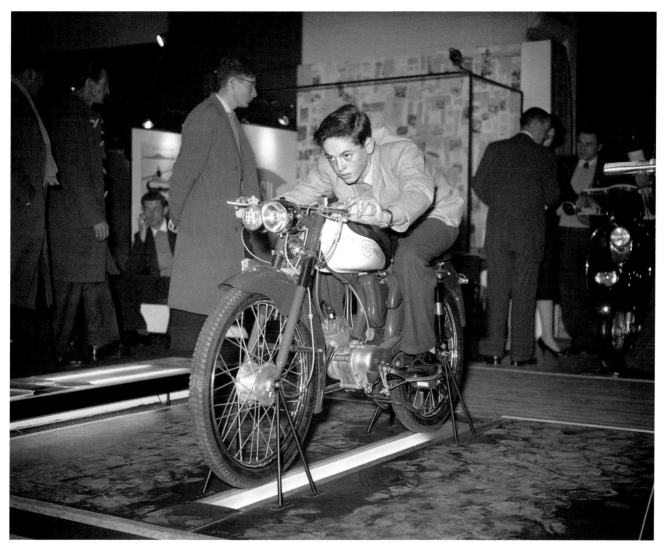

During the 1950s, most teenage boys dreamt of owning a motorcycle. This 14-year-old lets his imagination loose on an NSU Quickly Cavallino sports moped, which, unlike most mopeds with their bicycle heritage, displayed true motorcycle styling. Even so, it was still necessary to pedal the machine to start it.

14th November, 1958

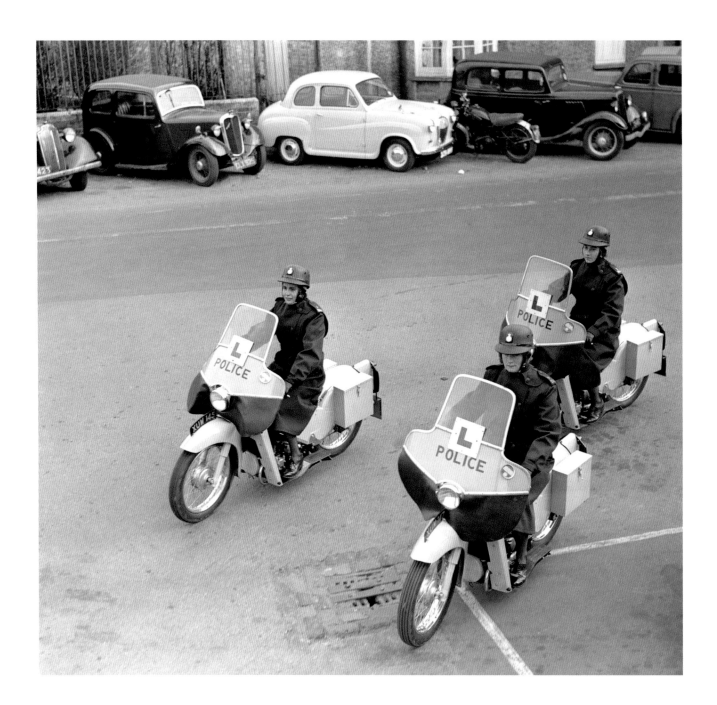

Facing page: Women police officers training on Velocette LE police motorcycles. The LE was unusual in that it had a 192cc water-cooled engine. Over 50 British police forces adopted it for mobile patrols. When riding the machine, police constables were required to nod to senior officers instead of saluting, which led to them being called 'Noddies', while the LE became known as the 'Noddy bike'.
8th March, 1960

An instructor points out the controls of a Velocette LE motorcycle to three women police officers. The machine was expensive, leading to poor sales. However, a massive order for the Mark II version from British police forces kept it in production.
8th March, 1960

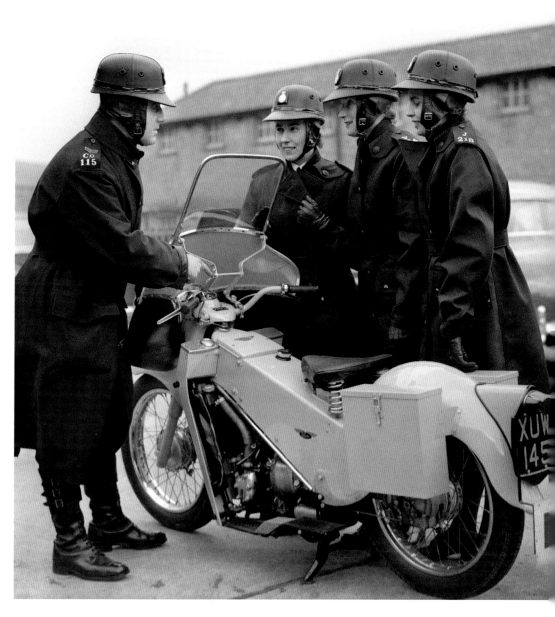

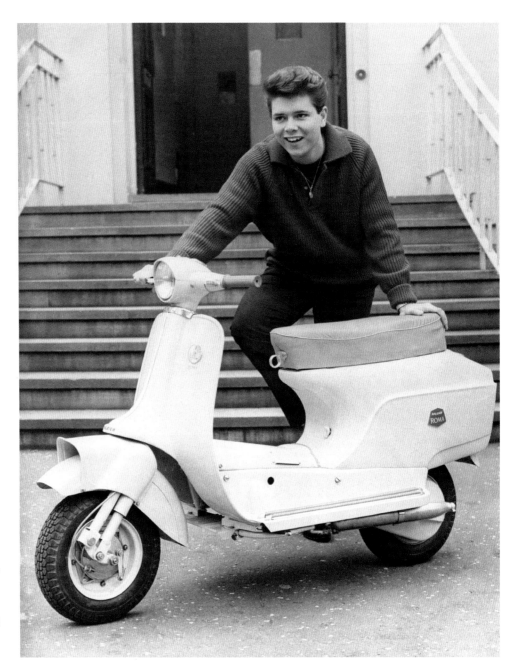

Perennial bachelor boy Cliff Richard gets ready to move it on a Raleigh Roma scooter. Although better known for its bicycles, Raleigh produced a number of powered machines from the earliest days of the motorcycle. The 78cc Roma was introduced for 1961.

21st November, 1960

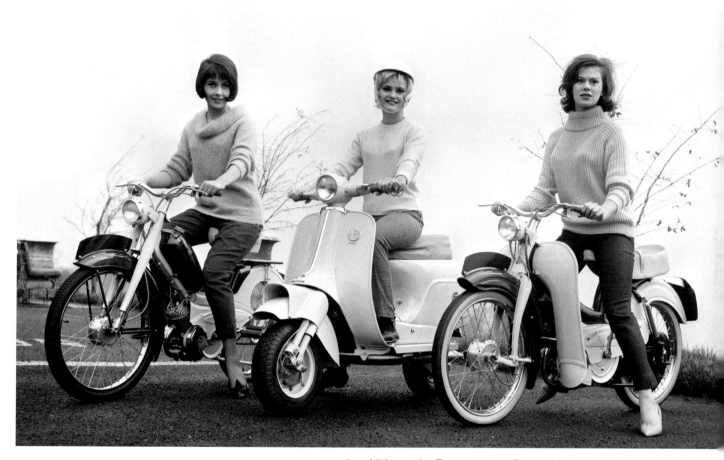

In addition to the Roma scooter, Raleigh's range on display at the Earls Court Motorcycle and Cycle Show of 1960 included two new mopeds. Here they are demonstrated by (L–R) Cynthia Cassidy on the Automatic, Sally Foot on the Roma and Vicky Ward on the Supermatic.

9th December, 1960

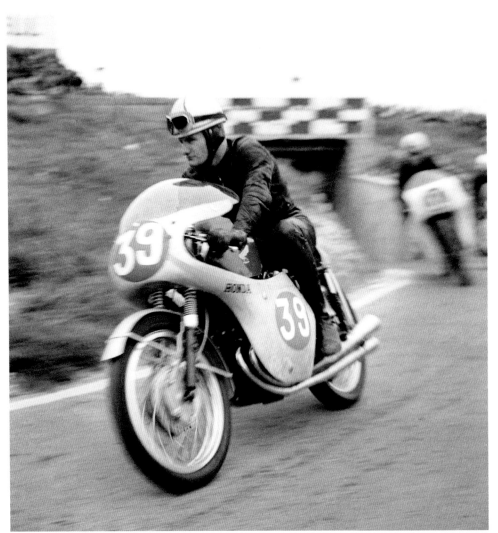

Facing page: Mud-splattered P Bogehoj of Odense, Denmark, returns to Llandrindod Wells, Wales after spending a gruelling 12 hours in the saddle on the first day of the 36th International Six Days Trial. Conceived in 1913, the ISDT is often referred to as the Olympics of motorcycling and is a true test of rider and machine.
3rd October, 1961

Mike Hailwood, considered by many to be one of the greatest motorcycle racers ever, racing a 250cc, four-stroke four-cylinder Honda RC162. He would go on to win the 250cc World Championship for the Japanese manufacturer that year.
29th April, 1961

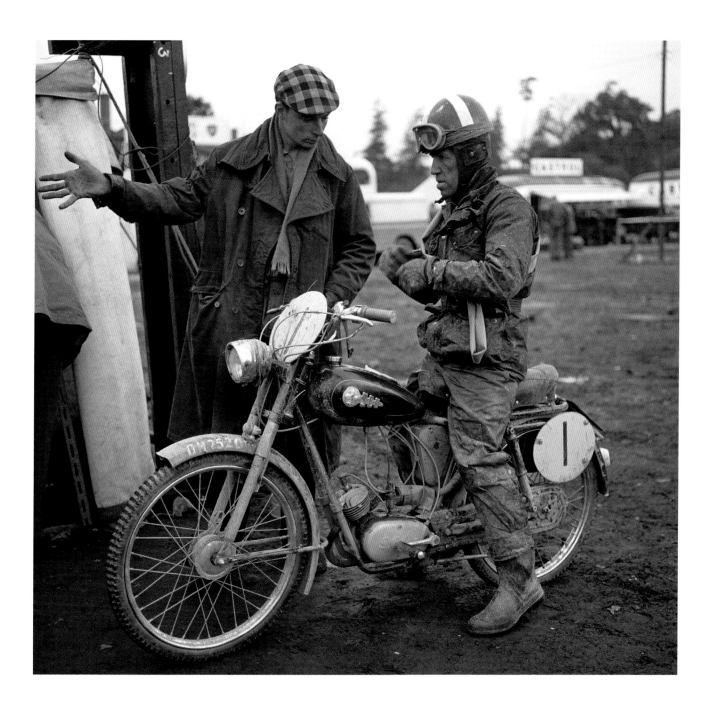

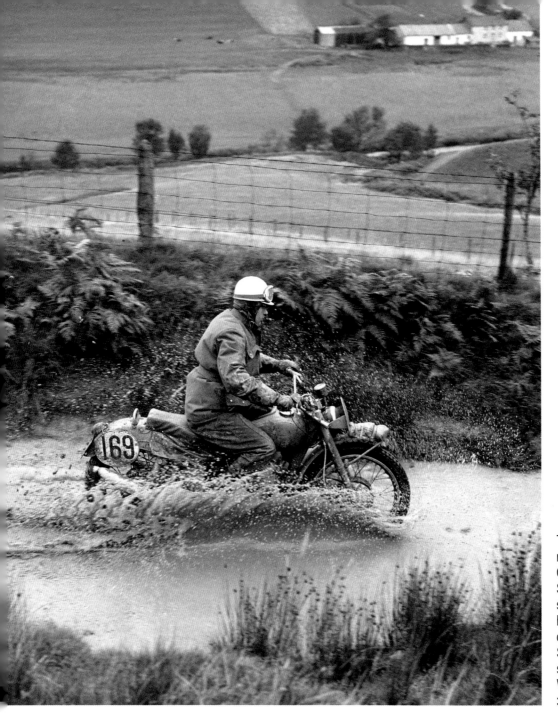

The ISDT even attracted riders from behind the 'Iron Curtain'. Here Soviet rider S Staryck of Moscow rides steadily through a water hazard during the first day of the 36th International Six Days Trial, which started from Llandrindod Wells, Wales.

3rd October, 1961

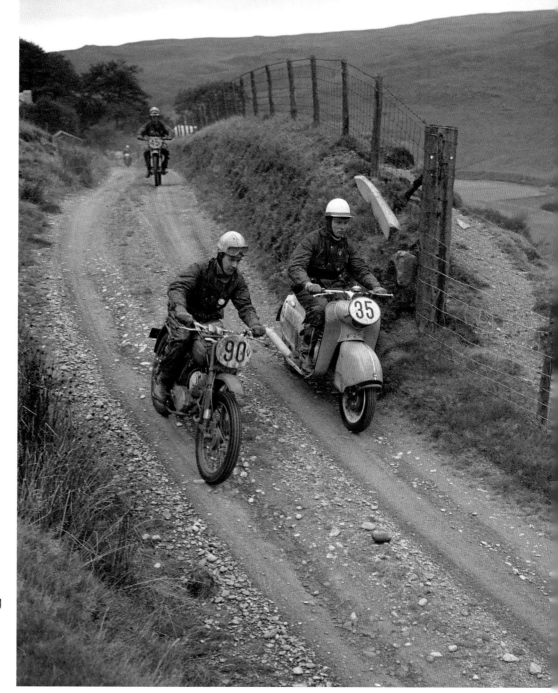

C Svenman of Solna, Sweden (L) and Polish rider J Rewerlli from Varszawa negotiate a rutted farm track at Llandovery on the opening day of the 36th International Six Days Trial. Rewerlli's scooter hardly seems suitable for the task.
3rd October, 1961

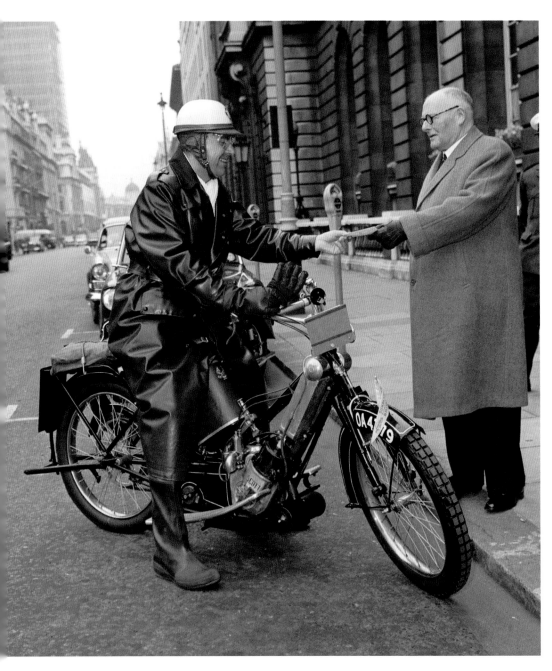

Stanley Turner, the Royal Automobile Club's motorcycle manager, is handed a letter by Captain W Gregson, director of the associate section of the RAC, prior to leaving the club's headquarters in Pall Mall, London to ride to Sheffield on a 1913 Scott Standard 600cc motorcycle. The machine was unusual in that the engine was water-cooled, a radiator being mounted to the front down-tube.

12th April, 1962

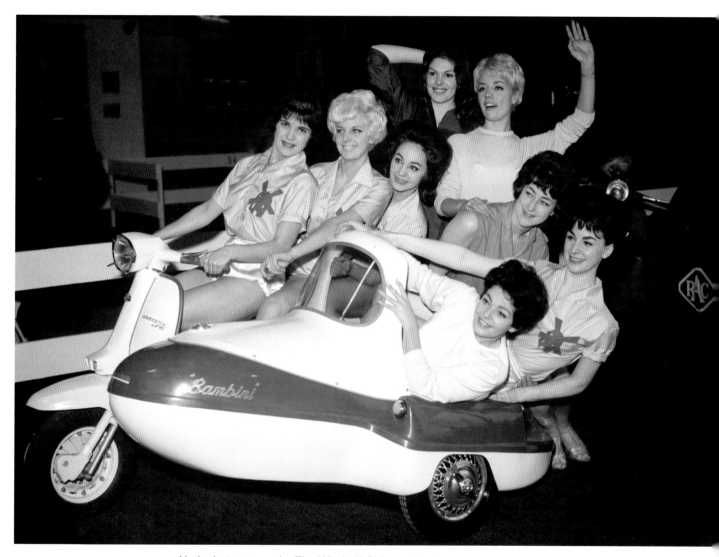

Nude, but never rude. The Windmill Girls, exotic dancers from London's renowned Windmill Club, adopt more conservative costumes and strike less provocative poses on a Lambretta TV175 scooter and Watsonian Bambini sidecar at the Motorcycle Show, Earls Court, London.
9th November, 1962

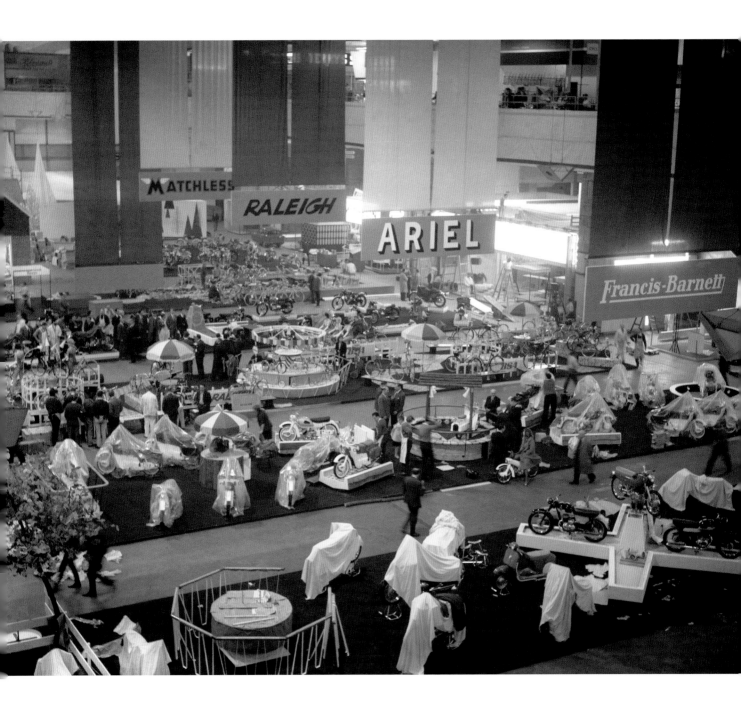

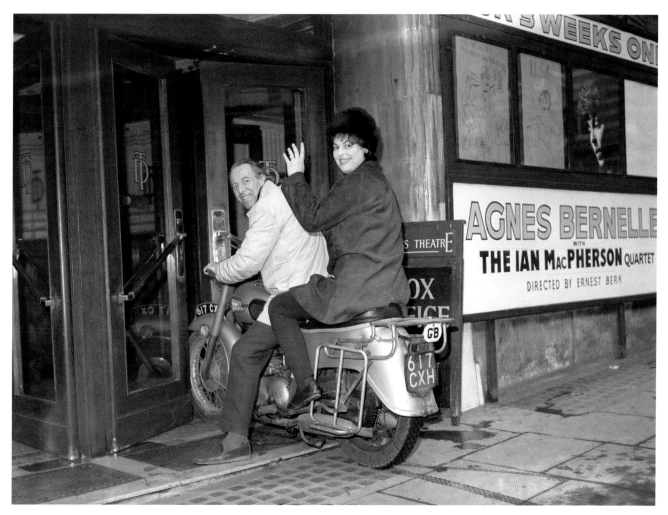

Facing page: With a host of new machines under wraps, London's Motorcycle Show prepares for opening day. The names on the banners are but a few of Britain's once great motorcycle industry, which by the early 1960s was beginning to feel the pinch from the burgeoning car industry and from a sleeping giant in the Far East – Japan, whose motorcycle manufacturers would soon take over the world.

9th November, 1962

A grand entrance. Actress and singer Agnes Bernelle arrives for rehearsal at the Duchess Theatre, London, where she was due to open a solo performance entitled *Savagery and Delights*. The motorcycle, a Triumph 'bath-tub' twin, so named because of its ample rear fairing, is ridden by Ernest Berk, who directed the performance.

10th April, 1963

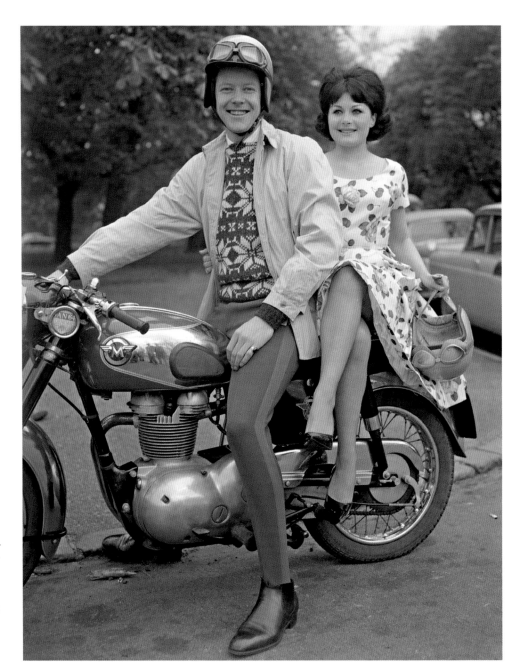

Broad smiles all round as pop star Craig Douglas shares his 250cc overhead-valve Matchless with singer Cherry Roland in London's Hyde Park. With hair like that, no wonder she carries her helmet in her hand, but as for riding side-saddle…
30th April, 1963

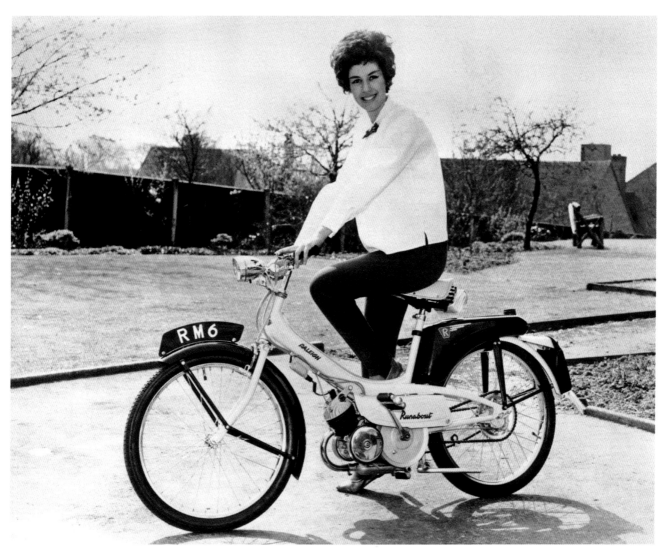

Raleigh's 50cc RM6 Runabout was typical of the mopeds of the day, being a popular ride-to-work machine. The type's bicycle origins can clearly be seen. To start the engine, it was necessary to pedal fiercely, as with all mopeds.
6th May, 1963

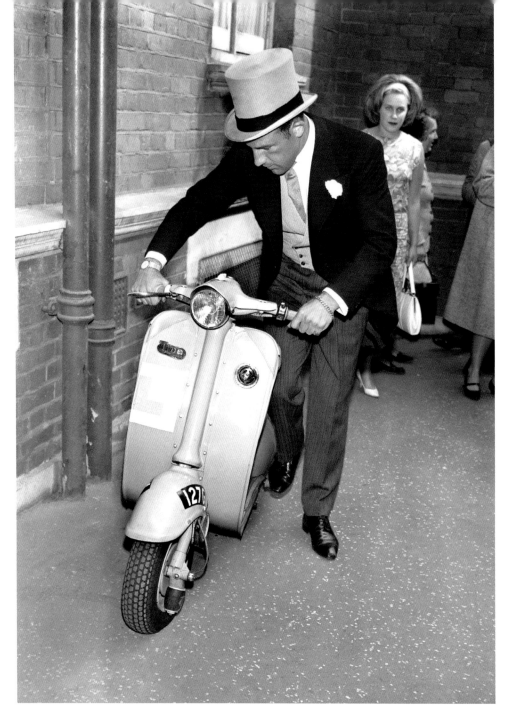

Motor racing legend Stirling Moss relied on a Triumph Tina scooter for running around town. Here he is leaving Caxton Hall, Westminster after attending his sister's wedding. Despite his vast experience on four wheels, he is clearly a novice on two, as indicated by the L-plate.
9th July, 1963

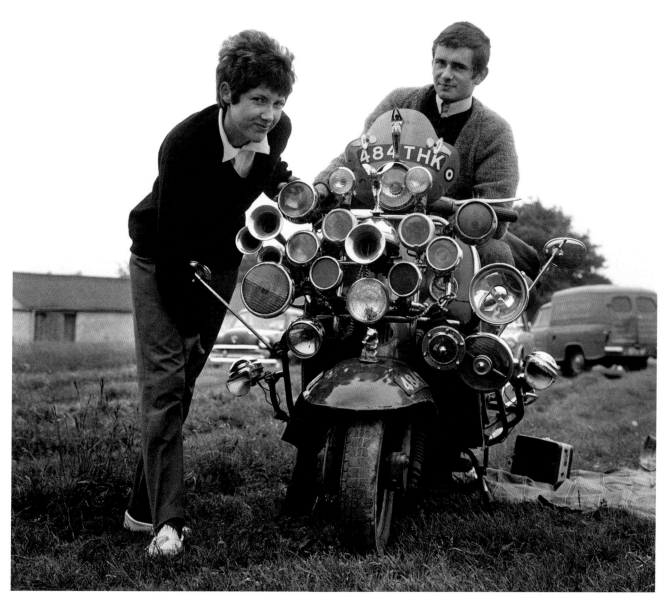

During the late 1950s and early 1960s, a lifestyle culture emerged among the young that put great emphasis on fashion, pop music such as soul, ska and R&B, and Italian scooters. Devotees were known as Mods, and one of their enthusiasms was to customize their scooters by adding a vast array of spotlights and horns. A prime example is this Vespa owned by Roy Young and Linda Jarvis, who were enjoying a day out at Epsom Downs, Surrey for Derby Day.
31st May, 1964

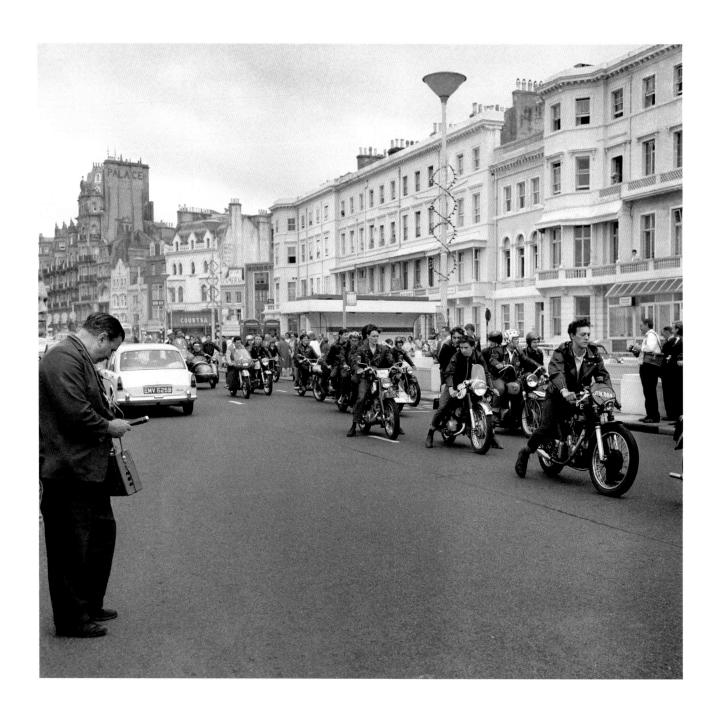

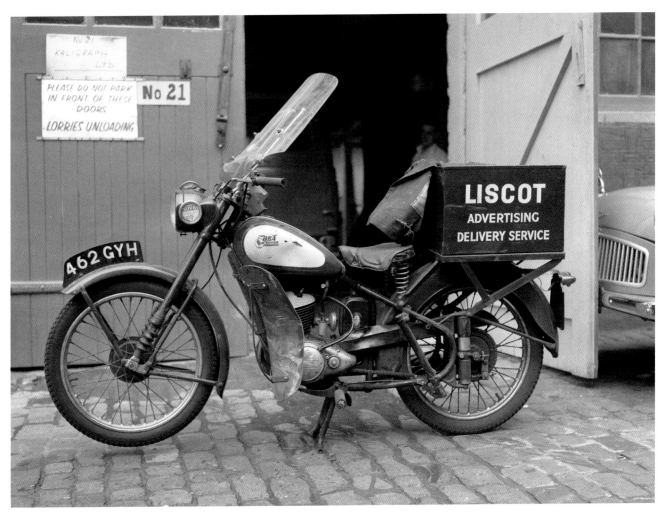

Facing page: A group of Rockers, traditional enemies of the Mods, ride their motorcycles along the sea front at Hastings in Sussex. Style was not important to Rockers, who invariably wore grubby jeans and leather jackets. The two groups often clashed in running battles at major seaside towns, as was the case in this instance just after the photograph was taken.

2nd August, 1964

BSA's 125cc (later 175cc) two-stroke Bantam was a real workhorse, a lightweight inexpensive machine that saw widespread personal and commercial use for over two decades. The Post Office, for example, employed a large fleet for delivering telegrams, while Liscots obviously got the most from their battered example.

12th August, 1964

Former world motorcycle champion and current Formula One champion John Surtees (R) enjoys a few lighthearted words with VF Smith of Barnes Common, London before he sets off from Tattenham Corner, Epsom, Surrey in the 29th Pioneer Run to Brighton. Mr Smith was riding a 1904 396cc Quadrant.

14th March, 1965

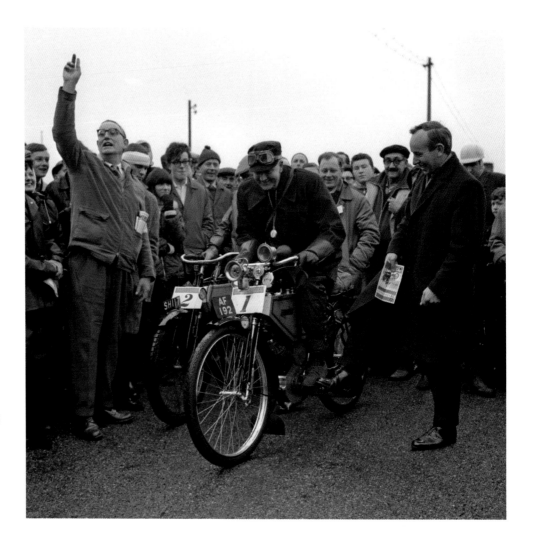

The 250–350cc race of the 1965 Easter Monday meeting at Crystal Palace, south London saw three riders crash at the side of the track. Remarkably, a fourth, Gordon Pantall (22), on an AJS, was able to thread his way through the pile-up and continue.

19th April, 1965

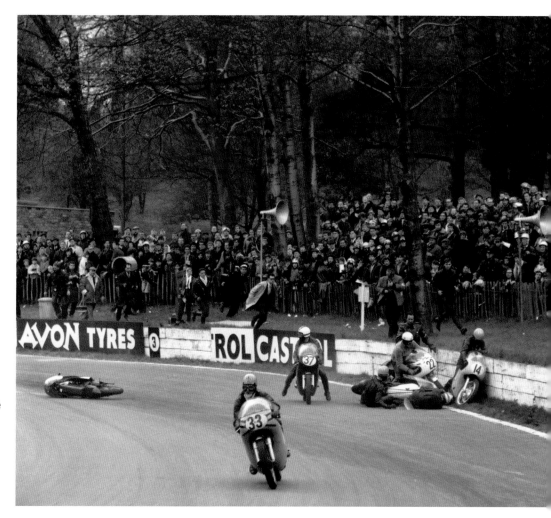

Although better known for its scooters, Lambretta also built a small number of mopeds, such as this example demonstrated by Karen Young at the International Motorcycle Show, London.
11th November, 1966

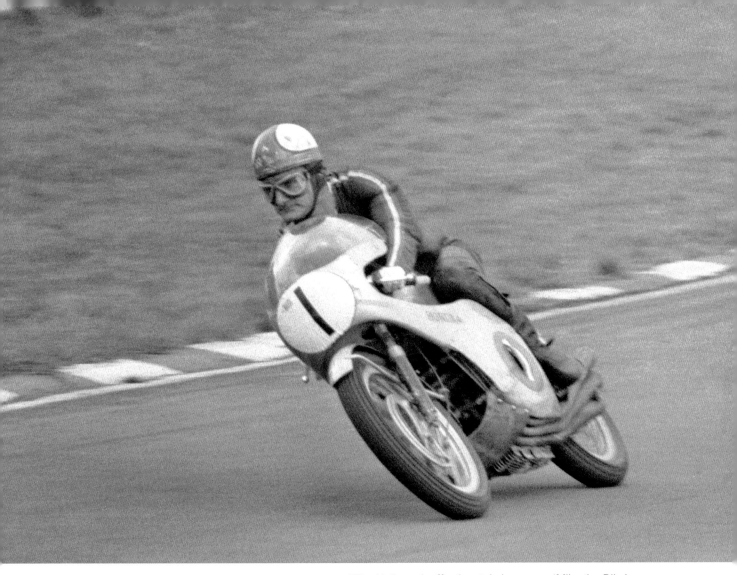

Mike Hailwood, affectionately known as 'Mike the Bike', on a 250cc Honda during the Allcomers race at the 35th International Hutchinson 100, at Brands Hatch, Kent. A year later he would retire from motorcycle racing and move to four wheels in Formula Two, Formula One and World Sports Cars.
13th August, 1967

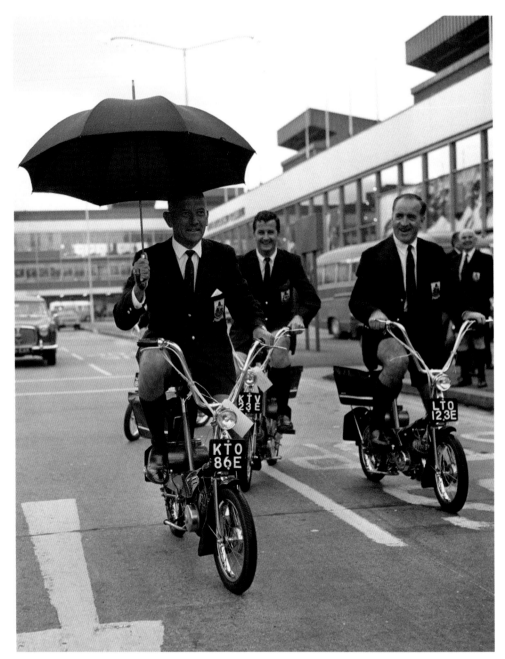

A short shower. A group of Bermudian hoteliers on a promotional tour of the UK are led by an umbrella wielding Peter Rosorea past the terminal at London's Heathrow Airport. They ride Raleigh Wisp mopeds, which were part of a consignment destined for Bermuda, where motor assisted cycles were the most popular mode of transport.

7th November, 1967

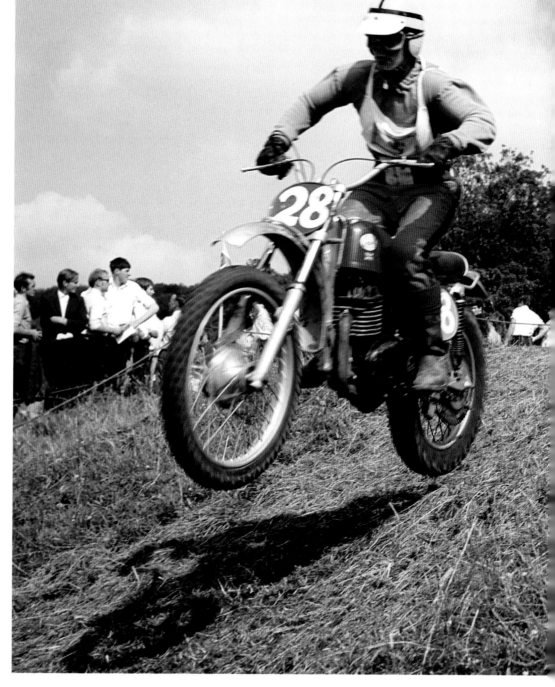

Scotland's Vic Allan prepares to land his Greeves 246cc two-stroke 24TJSB during the International Motocross Grand Prix at Dodington Park, Gloucestershire. Greeves was the major British manufacturer of off-road motorcycles. It also built road racing machines and the pale blue Invacar three-wheeled invalid cars that were once a common sight on British roads.

11th August, 1968

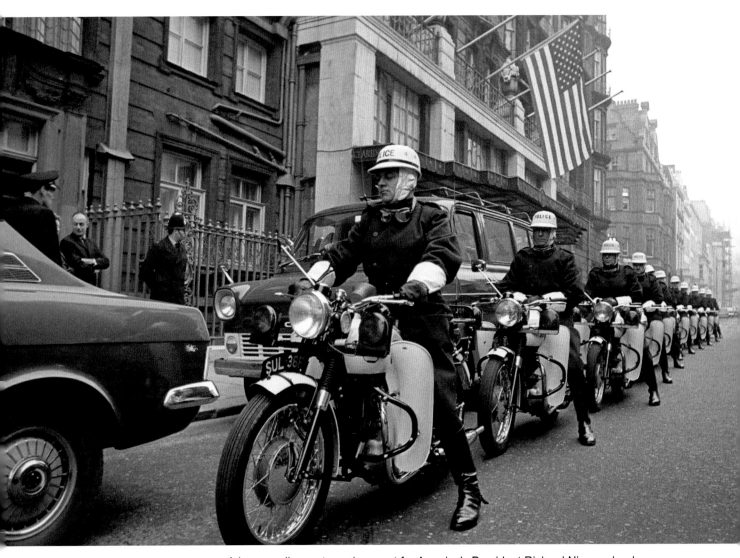

A heavy police motorcycle escort for America's President Richard Nixon, who drove from Claridges Hotel to No 10 Downing Street, London for talks with the Prime Minister, Harold Wilson. The police outriders are on 650cc Triumph Trophy TR6P machines, which bore the model name Saint. This stood for 'Stops Anything In No Time'.
25th February, 1969

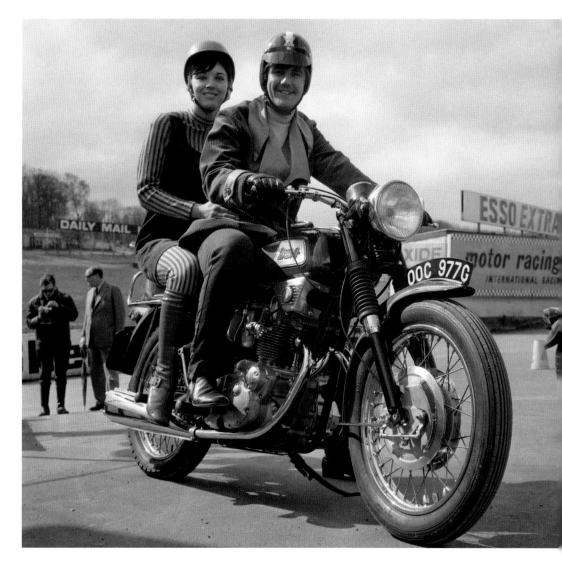

Paul Whitehouse and girlfriend Jill Hardwicke get to grips with the BSA 750cc Rocket 3 during a presentation to the press at the Brands Hatch circuit in Kent. Unusually for a British bike, the Rocket 3 had a three-cylinder engine. It was also marketed as the Triumph Trident.

3rd April, 1969

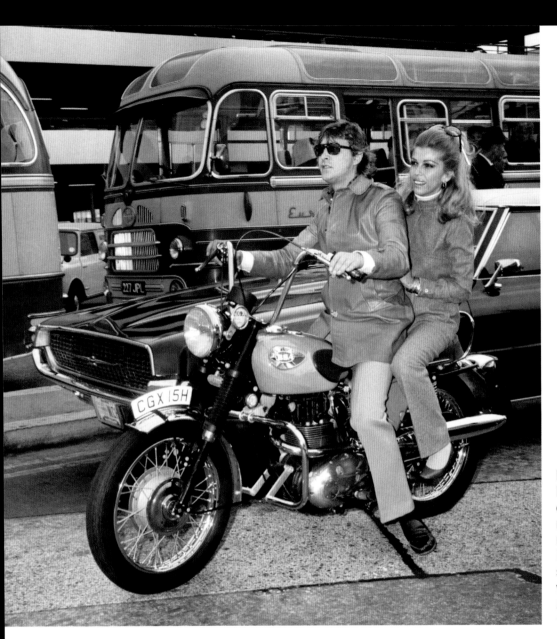

Boots no longer walking. Nancy Sinatra grabs a lift on a BSA A65 Lightning motorcycle ridden by British record producer Mickey Most. He had met the American singer at Heathrow Airport when she arrived to record *Highway Song* for him.
12th October, 1969

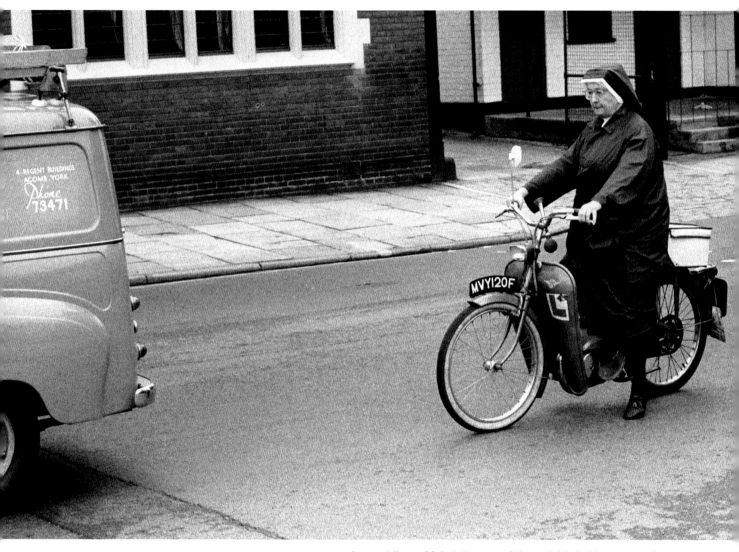

A nun riding a Mobylette moped through York. Her community had bought the machine so that one of their number could visit sick people over a wide area more quickly.

22nd August, 1970

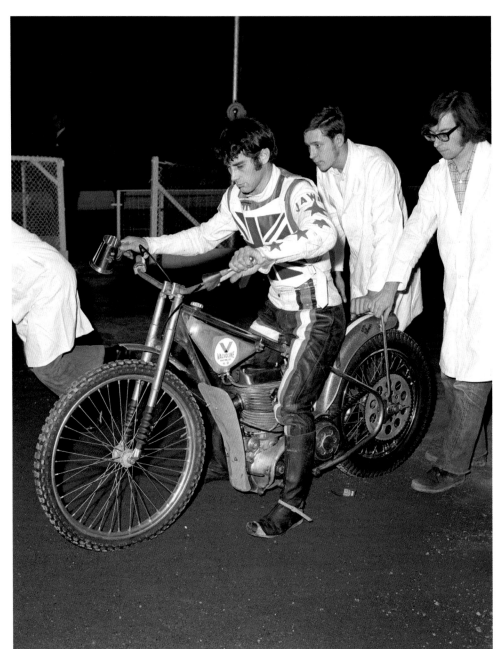

Speedway legend Ivan Mauger on one of his famous Jawa bikes, being pushed into the pits after winning his race during an international contest between Britain and Sweden. Born in New Zealand, Mauger rode for a number of British teams and won a record six world championships. Awarded the OBE and MBE, he also won a gold-plated speedway bike.
19th September, 1970

During a nationwide postal strike, mail continued to be delivered to the residents of Caistor, Norfolk, by five postwomen. Here one of them, Mrs Fay Taylor, prepares to start her round on a GPO moped.

25th January, 1971

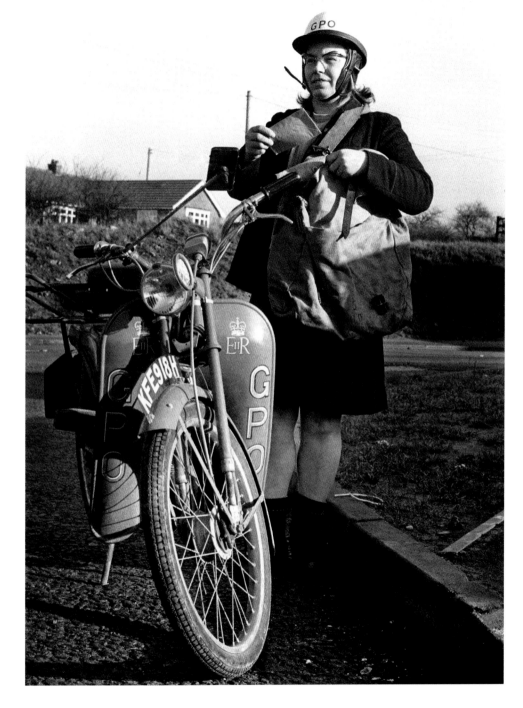

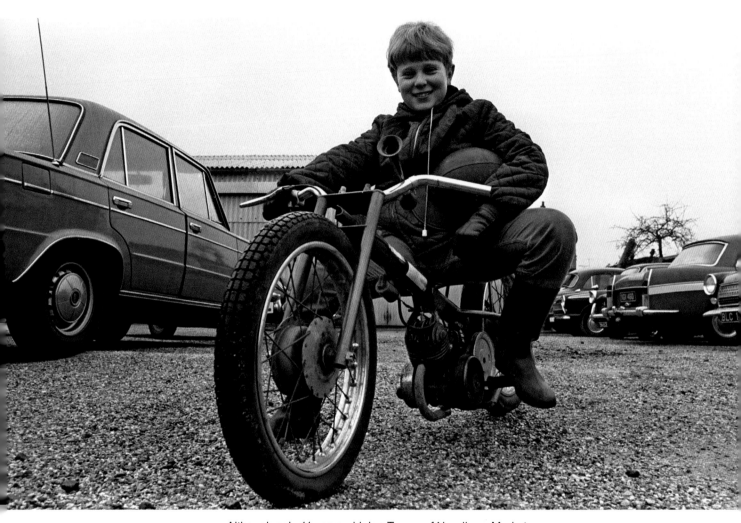

Although only 11 years old, Ian Turner of Needham Market,
near Ipswich, Suffolk had his own motorcycle, a gift from his
parents. It had a welded tubular frame, was powered by a 50cc
two-stroke engine and was capable of 25–30mph. The young
lad loved speed and had an ambition to become a racing driver.
8th March, 1971

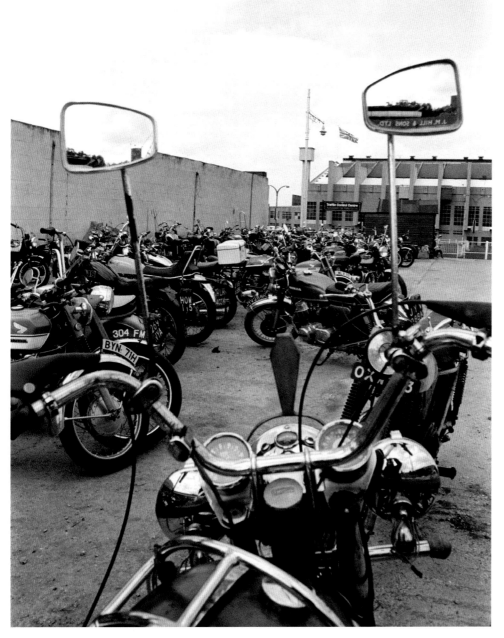

By the early 1970s, motorcycles were no longer common personal transport, as the ready availability of relatively inexpensive cars had relegated them to enthusiasts' machines. Even so, there were still plenty of bikers, as attested by the motorcycles of fans attending a rock revival festival in 1972.

5th August, 1972

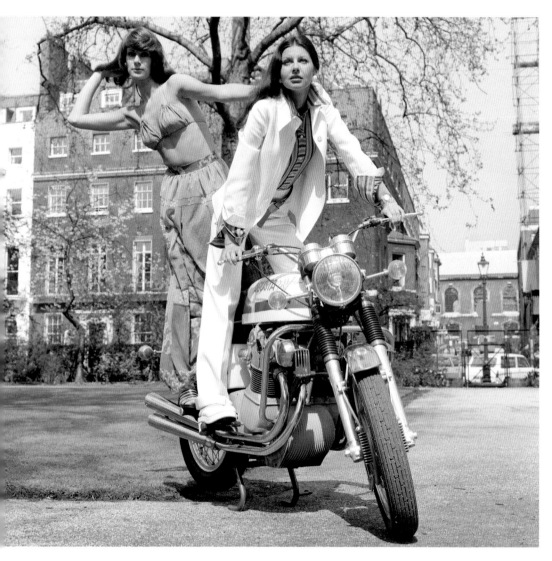

An exotic Italian MV Agusta 750cc Sport motorcycle provides a useful prop for these two models during a photoshoot to promote Italian fashion.
30th April, 1973

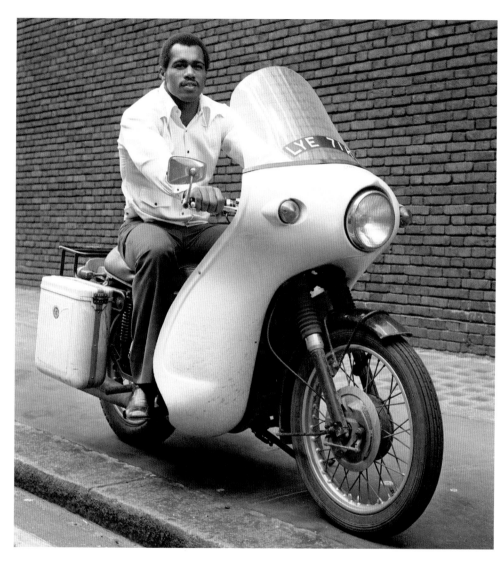

Norton on a Norton. Boxer Ken Norton, who defeated Muhammad Ali for the NABF Heavyweight Title, sits astride a 750cc Norton Fastback Commando. The motorcycle is fitted with a Dolphin fairing, which provided a degree of weather protection for the rider.

11th May, 1973

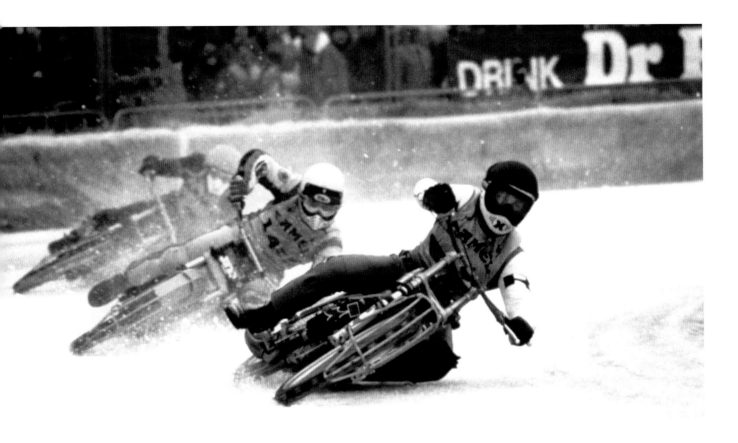

At full lean, three riders broadside in spectacular fashion around a turn during a special speedway ice race held at King's Lynn. Rare in the UK, ice racing is common in northern latitudes, where frozen lakes provide suitable tracks.

14th July, 1974

Facing page: American stunt man Evel Knievel during his display at Wembley Stadium, London, where he attempted to leap his motorcycle over 13 London buses. He crashed, breaking his pelvis. In great pain, he announced his retirement to the audience and then walked out of the stadium, despite pleas for him to use a stretcher.

26th May, 1975

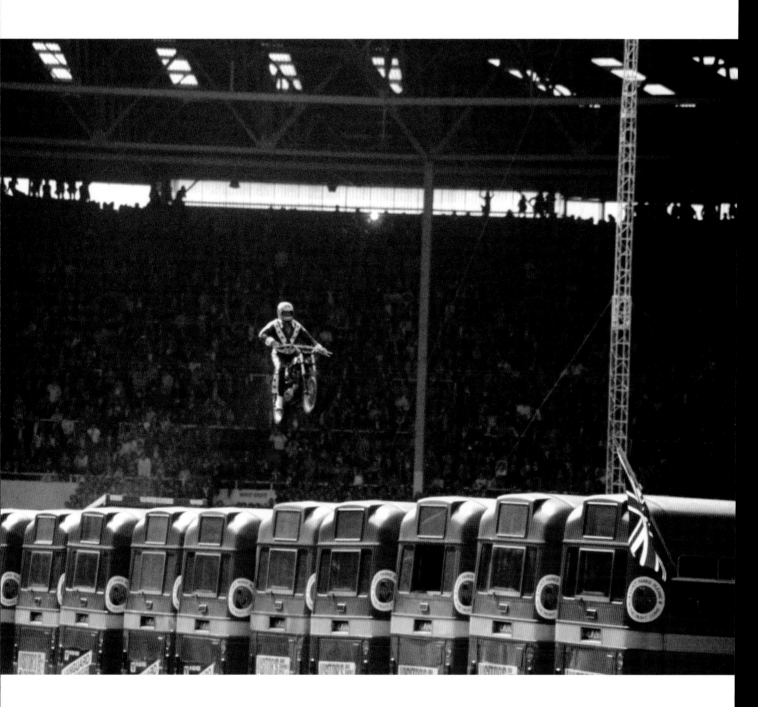

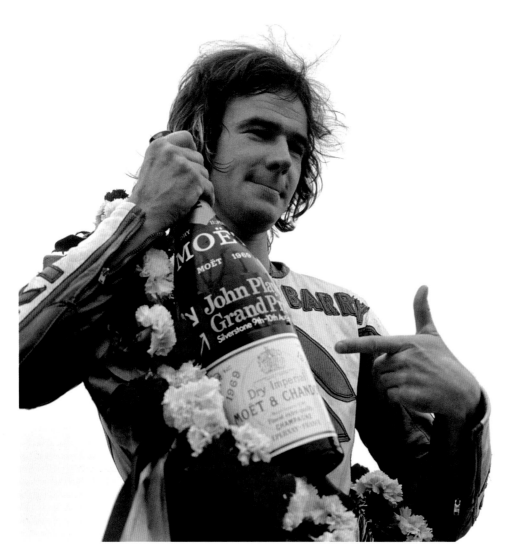

Motorcycle racing legend Barry Sheene celebrates victory on his Suzuki in the 1975 British 500cc Grand Prix. That year Sheene suffered a horrendous crash at the Daytona 200 in the USA, breaking his left thigh, right arm, collarbone and two ribs. The accident threatened to end his career, but within seven weeks he was racing again.
10th August, 1975

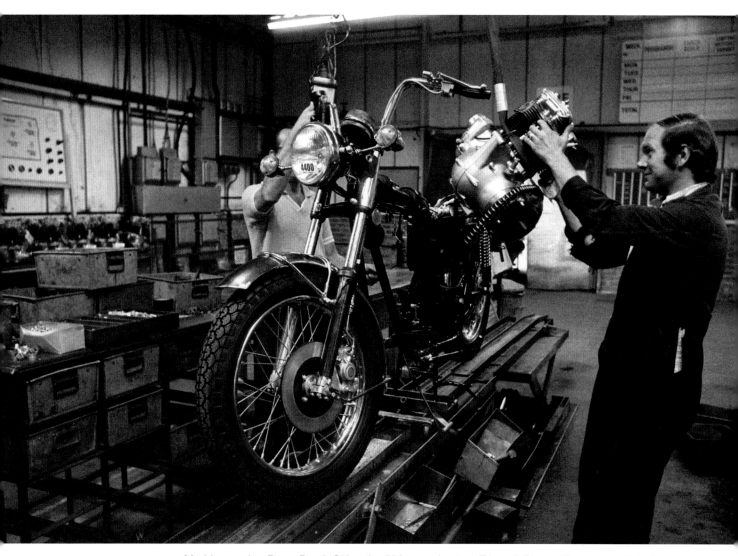

Meriden worker Barry Booth fitting the 750cc engine to a Triumph Bonneville motorcycle in the former Norton-Villiers-Triumph factory being operated by a workers' co-operative backed by £5m from the British government. Following announcement of the closure of the factory by NVT, the workers had staged a two-year sit-in eventually leading to the formation of the co-operative.
11th August, 1975

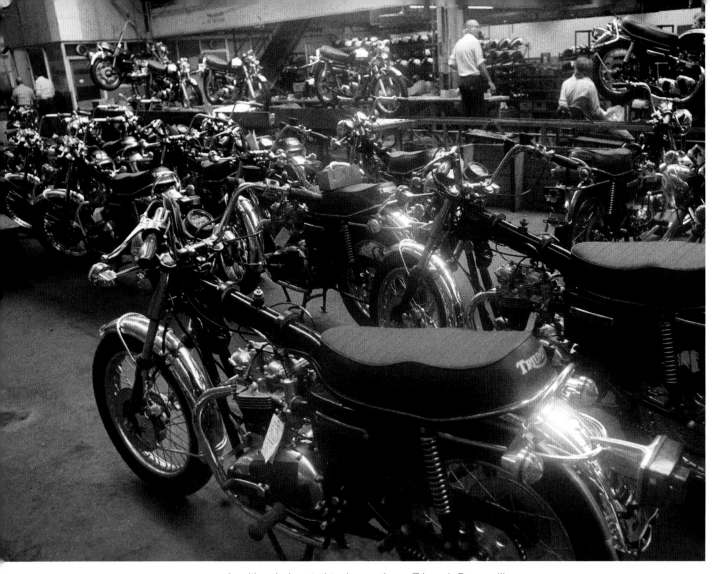

Awaiting their petrol tanks are these Triumph Bonneville
motorcycles at the Meriden plant. The workers' co-operative
sold the finished machines directly to Norton-Villiers-
Triumph. The Meriden operation enjoyed some success and
introduced a series of new models. However, a strong pound
hit exports, while recession at home caused further problems
and the co-operative became bankrupt in 1983.
11th August, 1975

Sally Anne Gautahier tries out a Norton Commando 850cc twin at the Earls Court Motorcycle Show, London. The Commando was equipped with electric starting and disc brakes front and rear. It was the last piston-engined machine to be built by the company, which subsequently switched to rotary engines.

29th August, 1975

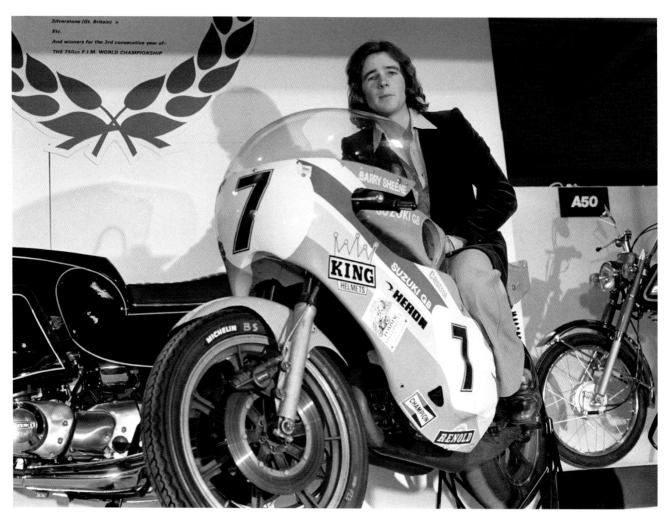

Barry Sheene with his Suzuki racer at the Motorcycle Show, London. Sheene's business acumen led to him becoming one of the first riders to make a large sum of money from product endorsements.
29th August, 1975

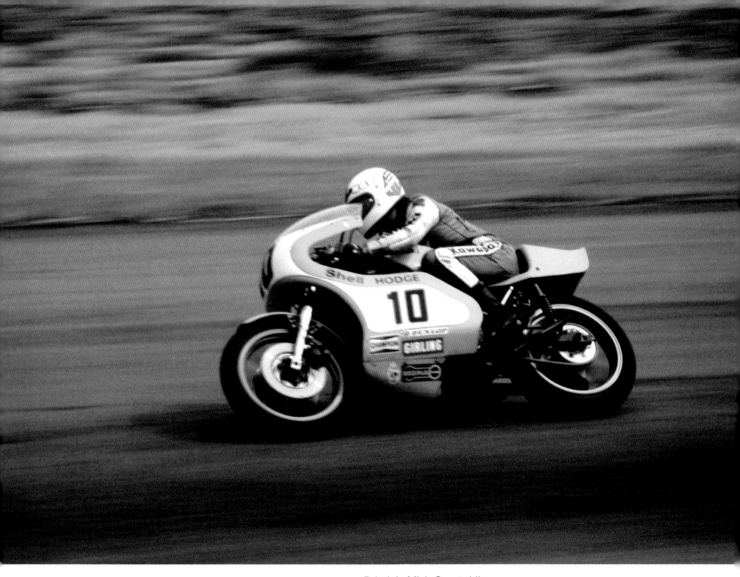

Britain's Mick Grant riding a
Kawasaki KR750. Grant's racing
achievements include seven
wins in the Isle of Man TT.
19th July, 1976

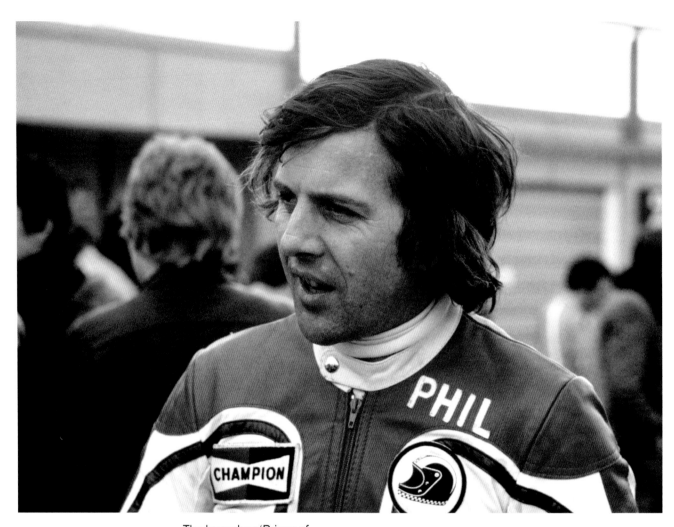

The legendary 'Prince of Speed', Phil Read, who became the first rider to win world championships in the 125cc, 250cc and 500cc classes. He retired from grand prix racing in 1976.
8th April, 1977

British daredevil rider Eddie Kidd poses in front of the 14 double-decker buses that he intended attempting to jump to break American Evel Knievel's world distance record at Radlett Airfield in Hertfordshire. Kidd was successful and went on to gain many more long-distance jump records. In addition, he acted as a stunt rider in several films.
8th April, 1978

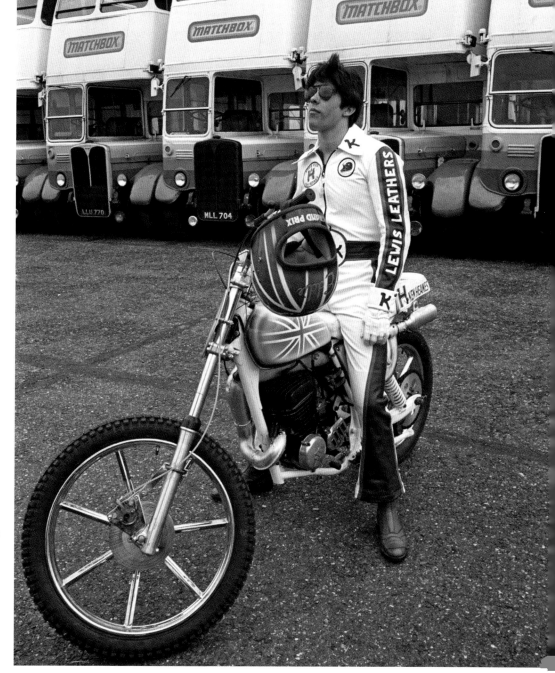

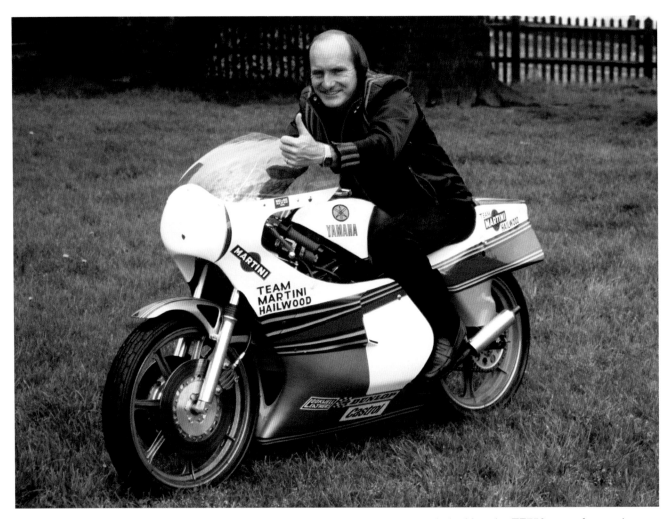

Mike Hailwood gives a thumbs-up as he poses with the Yamaha TZ750, one of several machines on which he intended to make a comeback in motorcycle racing. At the 1978 Isle of Man TT, his Team Martini Hailwood entered 250cc, 500cc and 750cc Yamahas. In addition, he had been sponsored to ride an 864cc Ducati in the prestigious Formula One event. Few gave him much of a chance after 11 years away from the sport, but he proved them wrong by winning on the Italian machine.

4th May, 1978

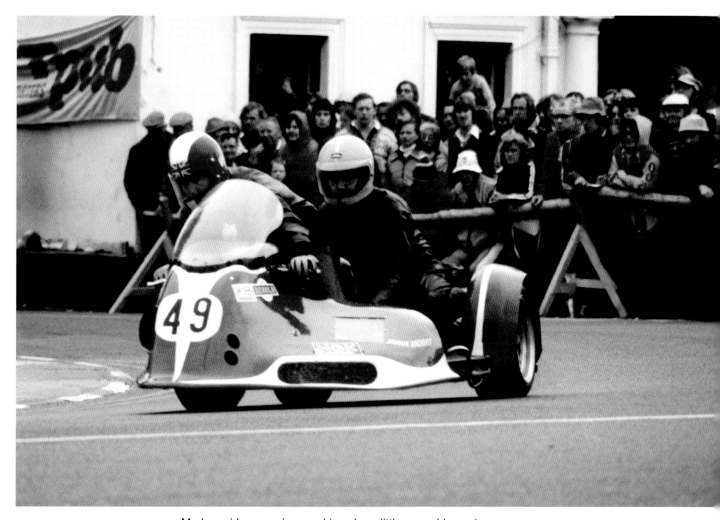

Modern sidecar racing machines bear little resemblance to
the combinations of old. They don't even look like motorcycles.
Here British pair Ian MacDonald and David Bickley roar past
the crowd during the Sidecar TT on their Kawasaki 903.
31st May, 1978

Love me, love my bike. Marion Allman of Kingswinford, West Midlands poses with her husband Noel's treasure, an AJS 350cc G6 motorcycle dating from 1920. AJS continued to build bikes of this basic design with V-twin side-valve engines into the 1930s.
18th July, 1978

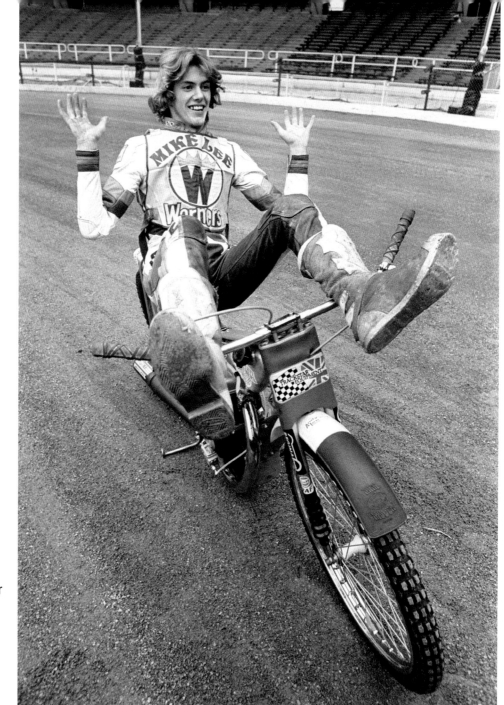

Michael Lee, 19-year-old British speedway champion from King's Lynn, in confident mood at Wembley Stadium, where he and other competitors were practising for the final of the World Speedway Championship. Lee came seventh in the championship that year, but he would win it in 1980.

31st August, 1978

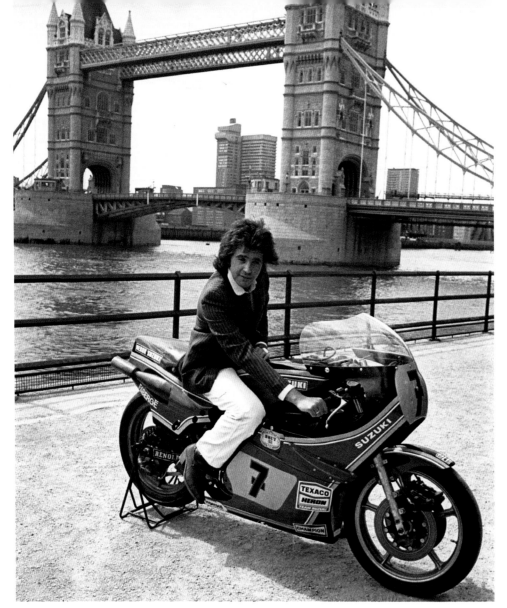

Actor and singer David Essex on a Suzuki GT750 racing motorcycle during the filming of the movie *Silver Dream Racer*. The bike is finished in the colours of Barry Sheene's machine.

20th July, 1979

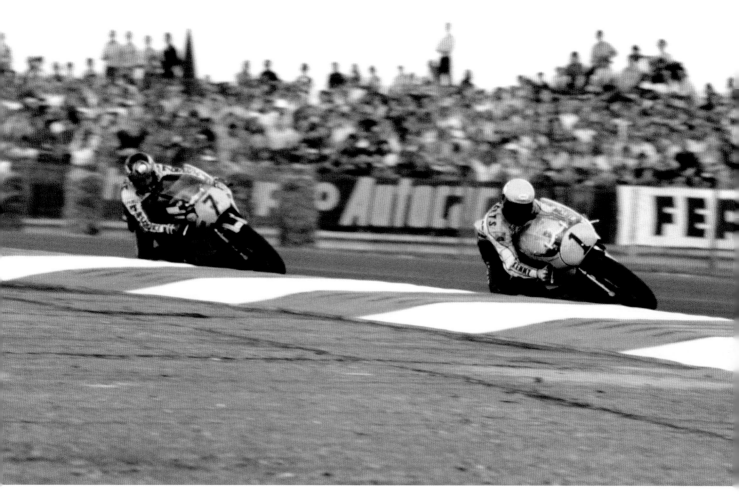

American Kenny Roberts riding a Yamaha YZR500 leads Britain's Barry Sheene on his Suzuki GT500 during the 500cc event at the British Motorcycle Grand Prix. Roberts stayed at the front to win the race.
12th August, 1979

What am I doing here? A reluctant looking Mike Hailwood, former world motorcycling champion, poses with model Vicki Scott alongside a giant Vespa P150-X motor scooter at the Motorcycle Show. After his comeback in the previous year, Hailwood finally retired from racing in 1979.

25th August, 1979

The Hesketh V1000 was the first new British motorcycle to be announced for 11 years. It was powered by a 1000cc V-twin engine produced by Weslake and was the brainchild of Alexander, 3rd Lord Hesketh, who conceived the idea to make full use of the facilities he had developed to support his Formula One racing team. The latter, with James Hunt as driver, was the last private team to win a grand prix.

3rd April, 1980

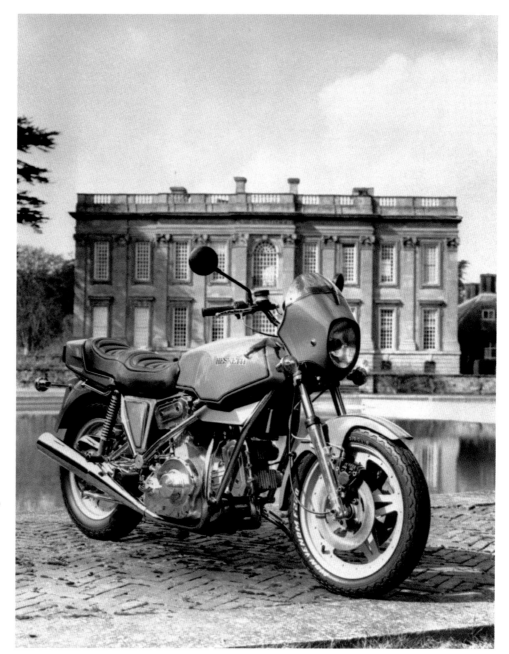

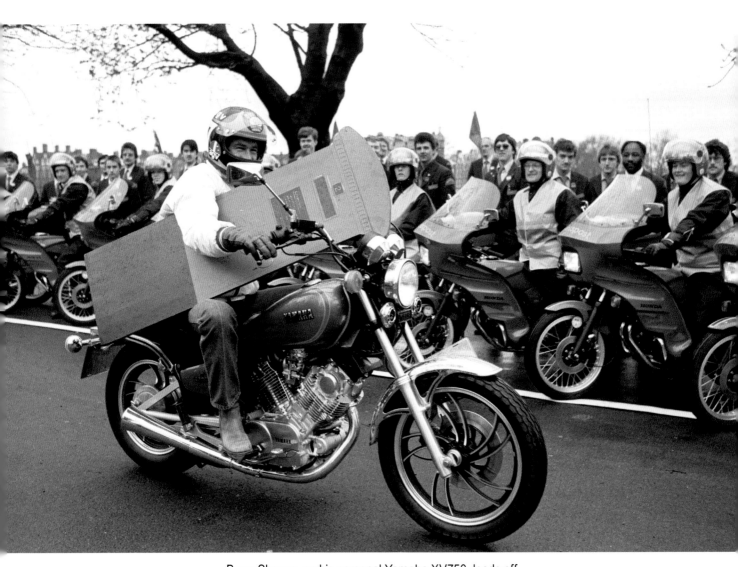

Barry Sheene, on his personal Yamaha XV750, leads off
the first 20 Royal Mail radio courier service riders on Honda
CX500s for a safety teach-in in Battersea Park.
23rd March, 1981

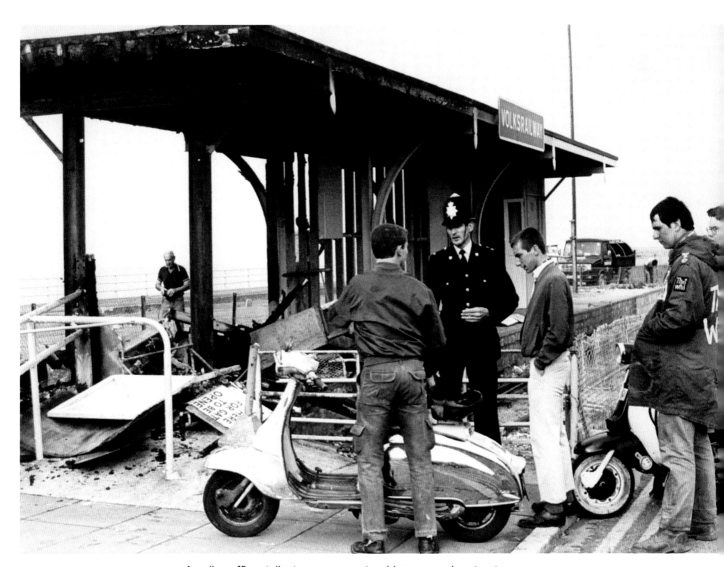

A police officer talks to young scooter riders near a burnt-out station of Brighton seafront's electric railway. The station had been petrol bombed during the invasion of the Sussex resort by hundreds of Mods.

31st July, 1981

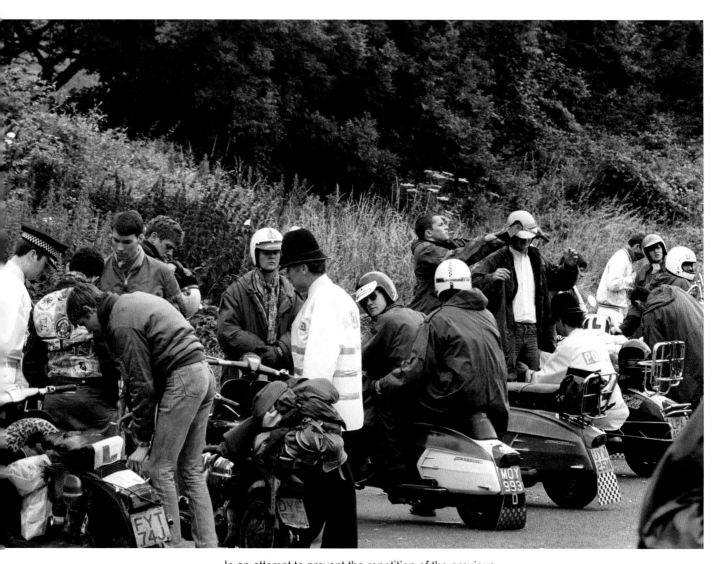

In an attempt to prevent the repetition of the previous weekend's violence, police search scooters and their riders on the A23 leading into Brighton, Sussex, following reports that Mods were to hold a Lambretta rally there.

8th August, 1981

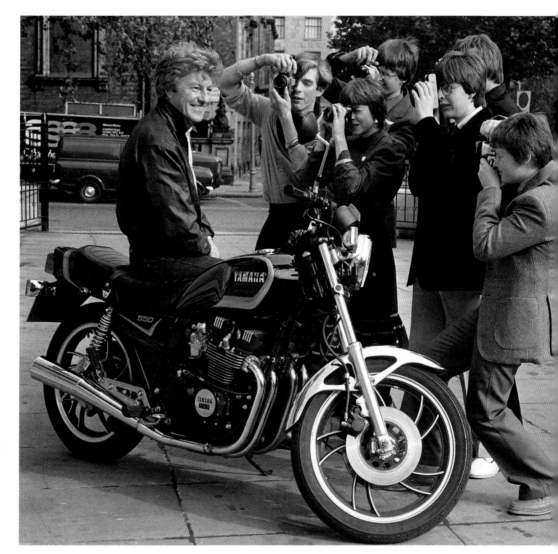

Renowned photographer Lord Lichfield sits on his Yamaha XZ550 motorcycle to act as model for six Young Photographers of the Year, who were trying out the cameras he had just presented to them as prizes. L–R: Fergus Bremner, 17, Suzanne Sach, 18, Alan Lavender, 15, Paul James, 15, Kean Salmon, 15, and Robert McDonald, 13.
28th October, 1981

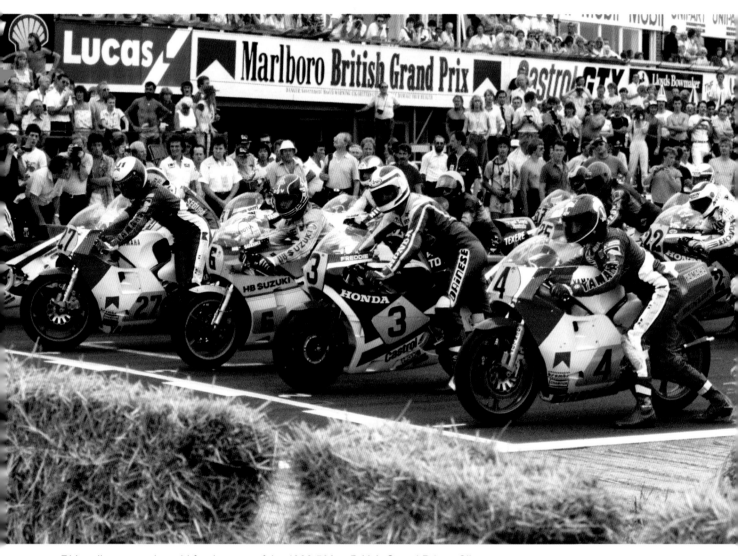

Riders line up on the grid for the start of the 1983 500cc British Grand Prix at Silverstone in Northamptonshire. L–R: Eddie Lawson (27, Yamaha Marlboro), Randy Mamola (6, HB Suzuki), Freddie Spencer (3, Honda), Kenny Roberts (4, Yamaha Marlboro). American Kenny Roberts would take the victory.

31st July, 1983

A group of Hell's Angels who had moved into a £100,000 farmhouse on the Woburn Abbey estate in Bedfordshire with the blessing of Lord Tavistock. The bikers, members of the Nomads Group, lived rent-free in the cottage, provoking claims that the marquis had given in to threats.
14th May, 1984

Mike Barnes, of Derby, rides around Parliament Square, London in his invention, the Nippi three-wheeled scooter, which he had developed for the disabled. The bike had been designed so that a wheelchair user could roll the chair onto its platform and drive it away while remaining in the chair.

17th July, 1984

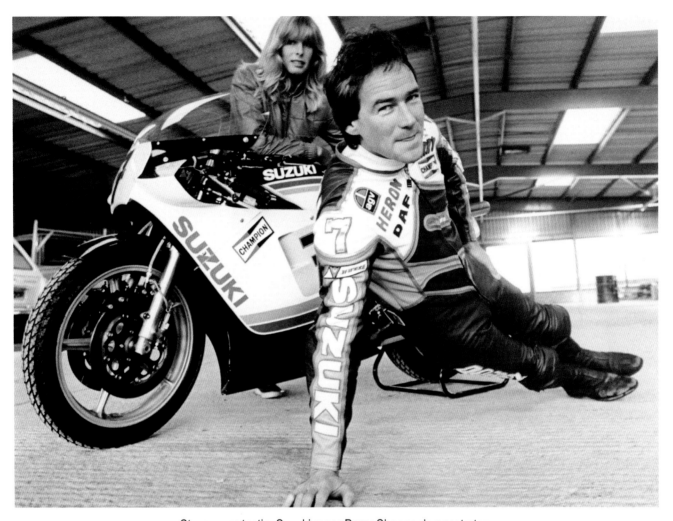

Strong-arm tactic. Suzuki racer Barry Sheene demonstrates his strength while his wife, Stephanie, looks on. Sheene's many injuries had caused him to develop arthritis, and in an attempt to reduce the pain he moved to the warmer climate of Australia in the late 1980s, although he made many return visits to the UK and became involved in racing historic bikes.
1st July, 1985

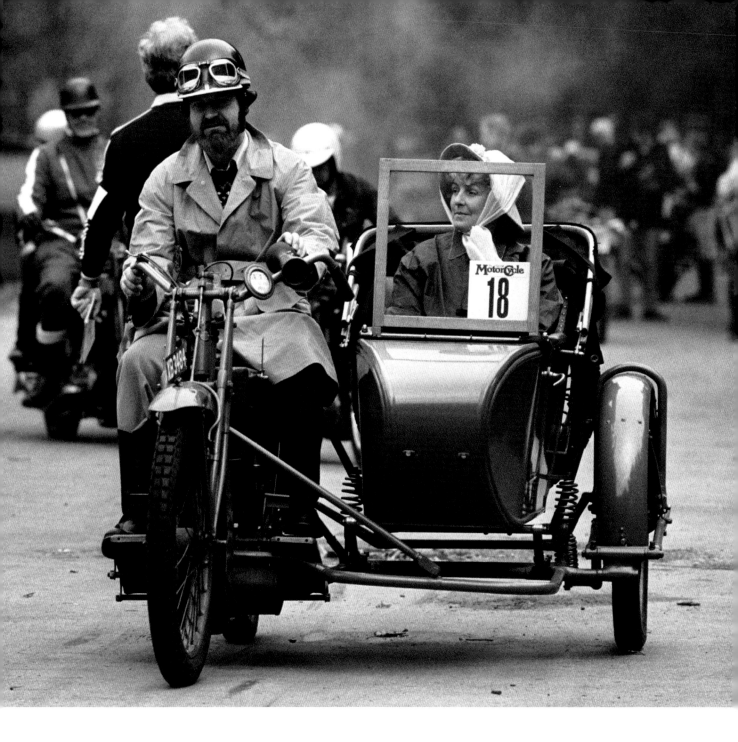

Facing page: Ernest Cummins, of Shoreham-by-Sea, Sussex, sets off on his 1928 BSA Deluxe motorcycle and Watsonian sidecar combination from London's Battersea Park at the start of the London Run, a 25-mile tour around London by over 200 historic and classic motorcycles.
11th August, 1985

Basket case. Many early sidecars were built with wicker bodies, which were light in weight, making them suitable for the low-powered machines of the time. This well restored motorcycle and wicker sidecar combination is leaving Battersea Park at the start of the London Run.
11th August, 1985

In a cloud of exhaust smoke, another competitor sets off from Battersea Park on the London Run. This machine is fitted with a two-seater sidecar and is carrying a full complement of passengers.

11th August, 1985

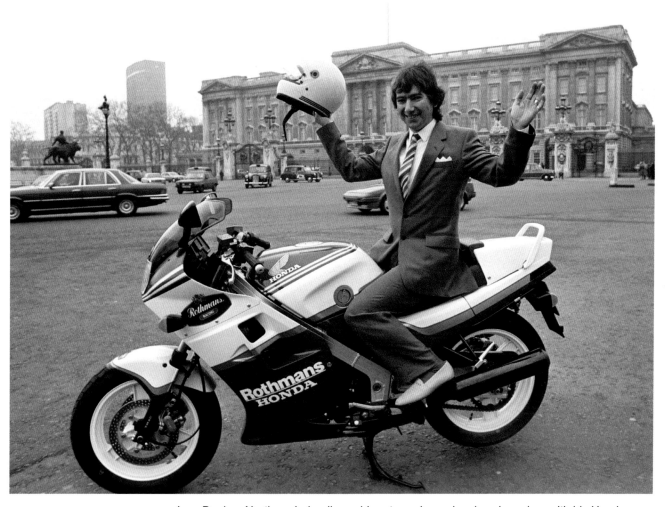

Joey Dunlop, Northern Ireland's world motorcycle road racing champion, with his Honda VFR 750F outside Buckingham Palace in London, prior to being presented with an MBE by the Prince of Wales. During his career, Dunlop won 26 Isle of Man TT races and the Ulster Grand Prix 24 times. He received his MBE for services to sport, and was given an OBE for humanitarian work in Romanian orphanages. He died in 2000 in Tallin, Estonia while leading a 125cc race.

7th March, 1986

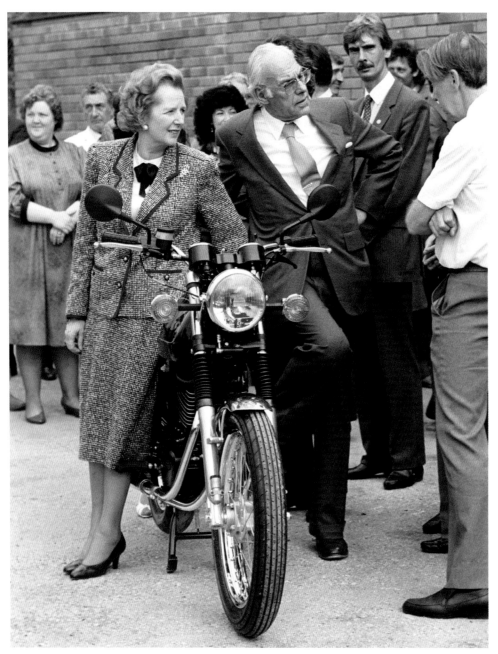

Prime Minister Margaret Thatcher and husband Denis are shown a new British-made Matchless G80 motorcycle at the LF Harris plant at Newton Abbot, Devon. Les Harris was a manufacturer and supplier of spare parts for classic British motorcycles, but began making Triumph Bonnevilles under licence following the collapse of the Meriden co-operative. Subsequently, he did not renew the licence, developing the G80 instead. This remained in production for only two years, after which the company concentrated on its spares business.
27th May, 1987

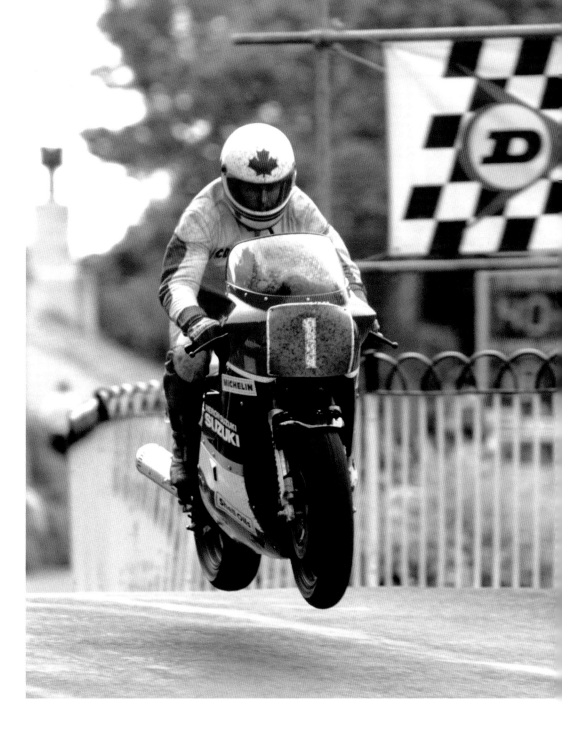

Flying lap. Canadian rider Kevin Wilson on a 750cc Suzuki takes to the air as he hits a bump in the road at high speed during the Isle of Man TT.
14th June, 1987

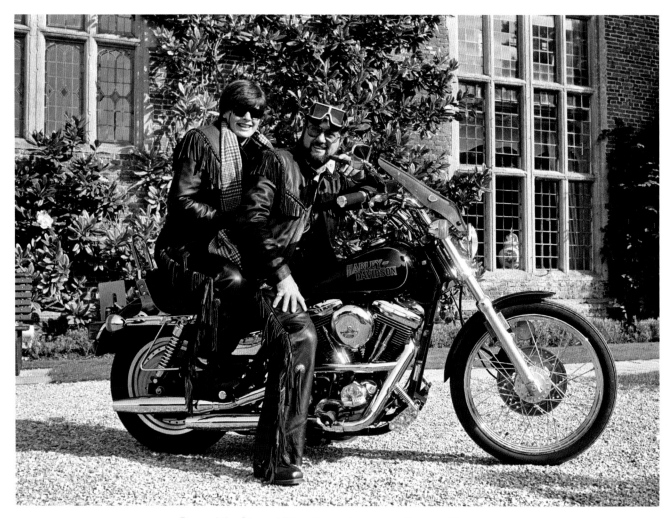

Beyond the fringe. Millionaire businessman Peter de Savary and his wife, Lana, don fringed motorcycle leathers to lead a ride-out of enthusiasts from their historic country home, Littlecote House, near Hungerford, on their Harley-Davidson FXR Super Glide.

1st October, 1988

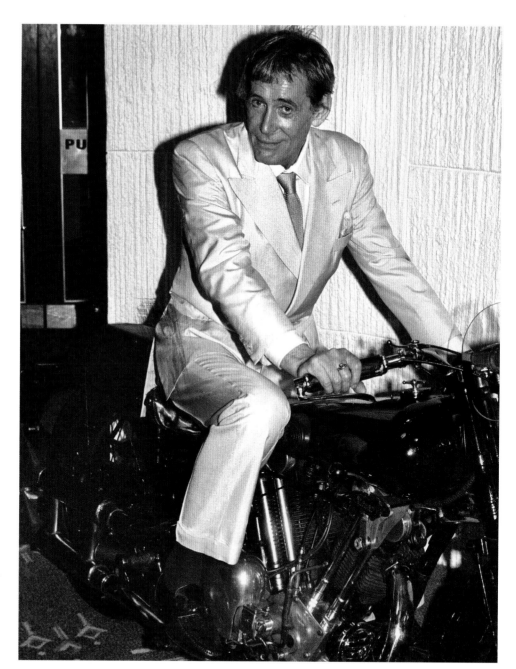

Actor Peter O'Toole sits astride the Brough Superior SS100 motorcycle on which TE Lawrence met his death in 1935. The actor's arrival at the Odeon Marble Arch marked a new version of the film *Lawrence of Arabia*, in which he played Lawrence and which was directed by David Lean.

21st May, 1989

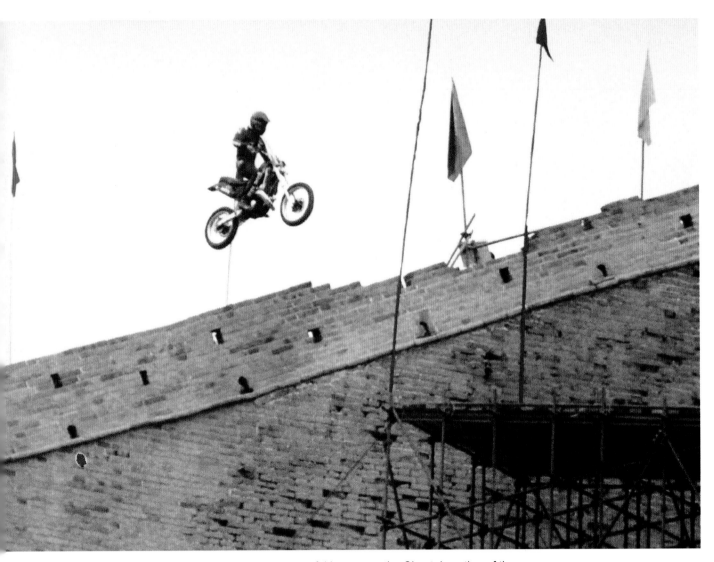

Motorcycle stuntman Eddie Kidd makes a successful jump over the Simatai section of the Great Wall of China. At the time, this was the most dangerous jump he had ever attempted. Kidd began his career at the age of 14, and despite gaining many motorcycle jump records, he did not obtain a motorcycle licence for some 20 years.

11th May, 1993

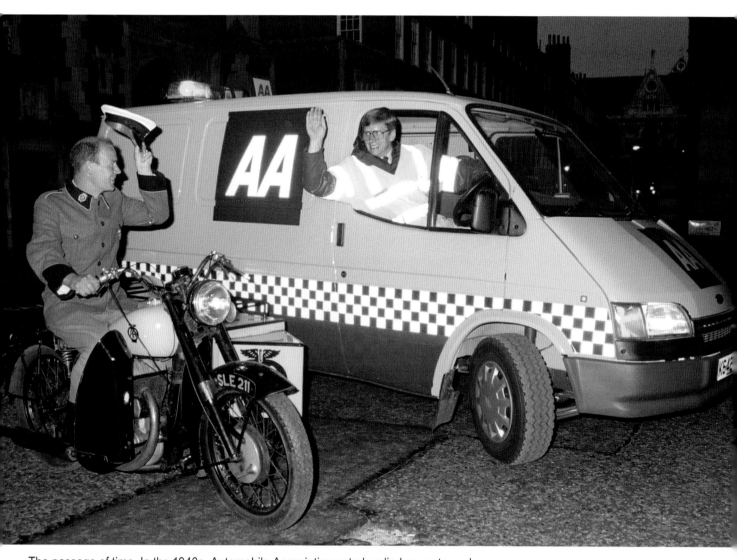

The passage of time. In the 1940s, Automobile Association patrols relied on motorcycle combinations like this 1946 BSA A7. Sufficient equipment could be packed in the sidecar to carry out a wide range of roadside repairs, but the greater range of tools and equipment necessary to deal with emergencies on modern vehicles requires the use of much larger vans.
28th June, 1993

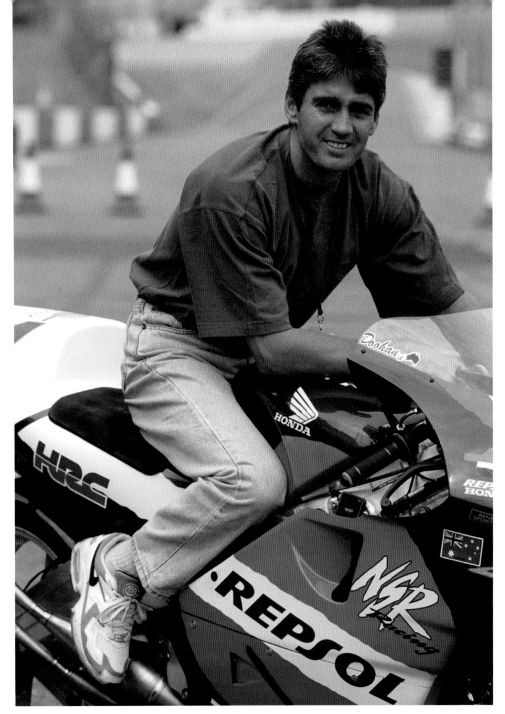

Renowned Australian racer Mick Doohan, the 500cc world champion of 1994 and 1995, astride his Repsol Honda NSR500 at the Donington Park circuit, Derby during preparations for the British Motorcycle Grand Prix. He would win three more consecutive 500cc world titles.

20th July, 1995

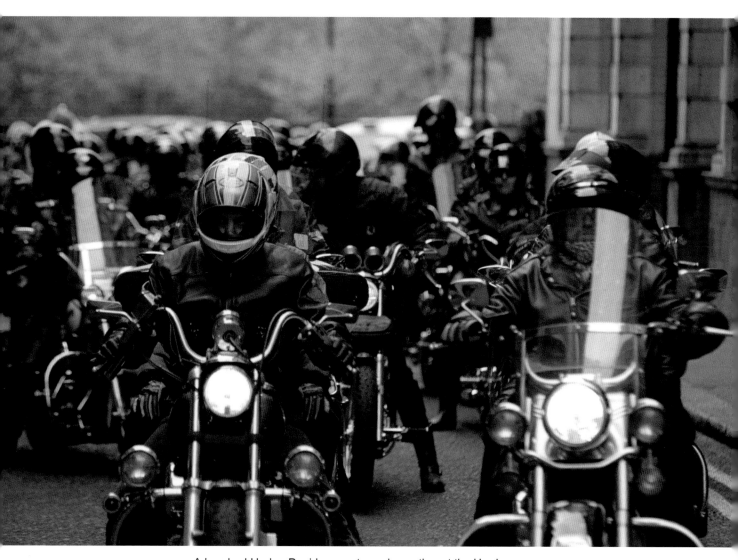

A hundred Harley-Davidson motorcycles gather at the Hard Rock Café on Piccadilly, London to honour the restaurant's 25th anniversary. From the restaurant, they would ride to Dover to catch ferries to Calais and then cruise to Paris for a party at the Hard Rock Café on the Boulevard Montmartre.
11th May, 1996

A 'paparrazzi' photographer's motorcycle outside the gates of the chateau in the south of France where Diana, Princess of Wales and Sarah, Duchess of York and their children were staying. Two photographers were arrested in the grounds of the property. Photographers have long used the agility and speed of the motorcycle to hunt their celebrity prey.
19th July, 1996

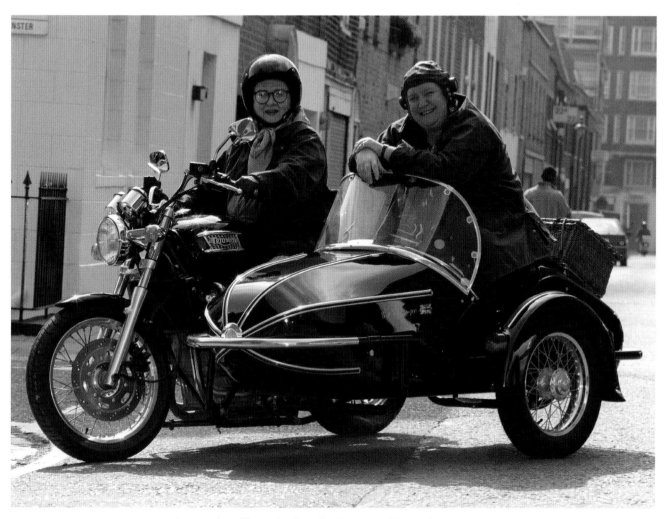

Larger-than-life cooks Jennifer Paterson (L) and Clarissa
Dickson Wright aboard the classic Triumph Thunderbird
motorcycle and Watsonian sidecar combination used in their
BBC television show, *Two Fat Ladies*.
28th August, 1996

Only dreaming! Seven-year-olds Darren Sharpstone and Mark Jones of Nottingham try a Kawasaki ER-5 for size during the opening day of the International Motorcycle Show at Birmingham's NEC. The bike had a liquid-cooled, double-overhead-camshaft twin-cylinder engine.

7th November, 1996

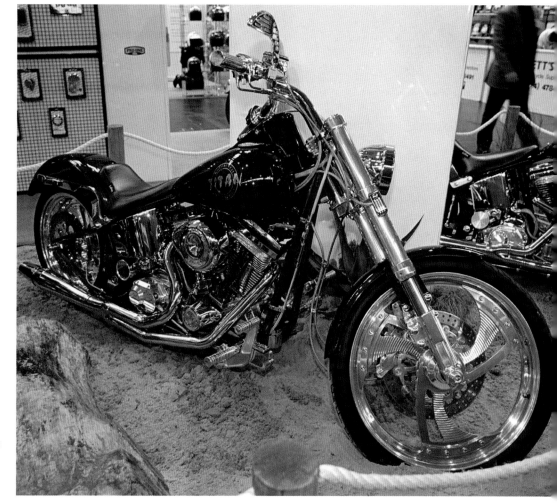

The Titan Gecko, at £25,469 in standard form, was the most expensive bike on display at the 1996 International Motorcycle Show at the NEC Birmingham. This example of the custom street machine sported a special paint job that cost a further £1,200.

7th November, 1996

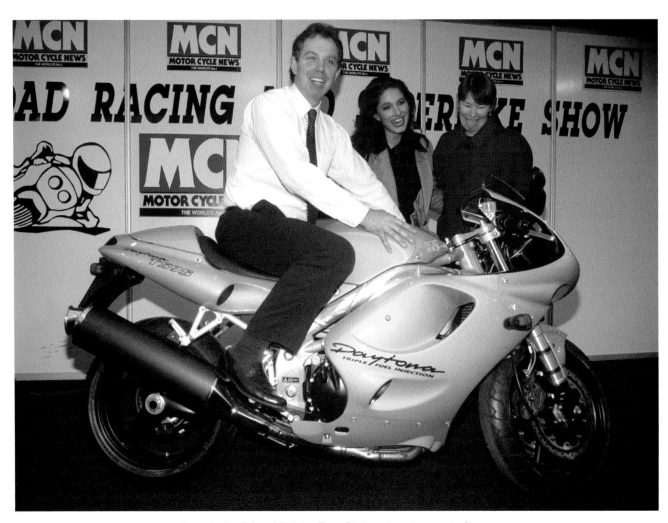

Soon-to-be Prime Minister Tony Blair makes the most of a
photo op astride a Triumph Daytona motorcycle during a visit
to the Motor Cycle News Road Racing and Superbike Show at
London's Alexandra Palace. Diane Youdale (C), better known
as Jet from the television show *Gladiators*, and Hampstead and
Highgate MP Glenda Jackson clearly see the funny side.
31st January, 1997

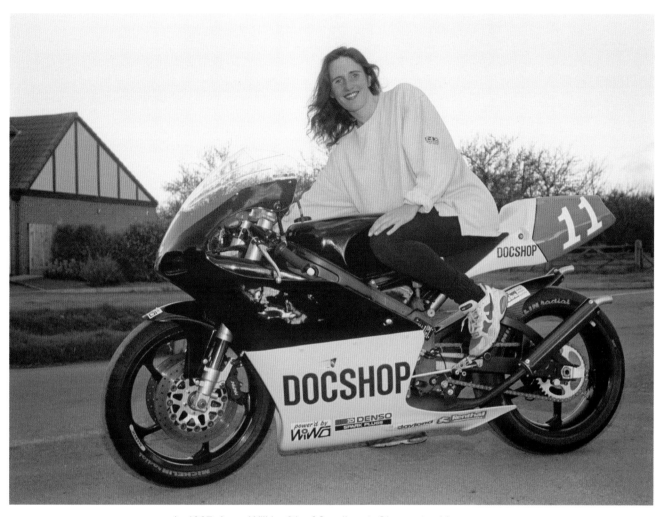

In 1997, Anna Wilkin, 21, of Sandhurst, Gloucestershire was
Britain's only woman motorcycle road racer. Her machine
is a Yamaha TZR250 2MA. Anna would be the first woman
to take part in the prestigious British 250cc Championship
at Donington Park, Derby.
5th April, 1997

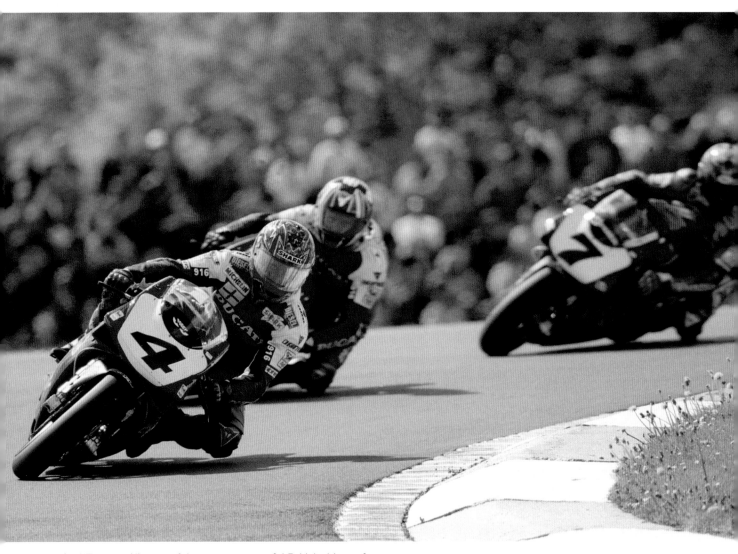

Carl Fogarty (4), one of the most successful British riders of
all time, leads the field on his Ducati 916 during the British
round of the World Superbike Championship at Donington
Park, Derby. 'Foggy' would win the race, but lose the
championship to the American John Kocinski.

4th May, 1997

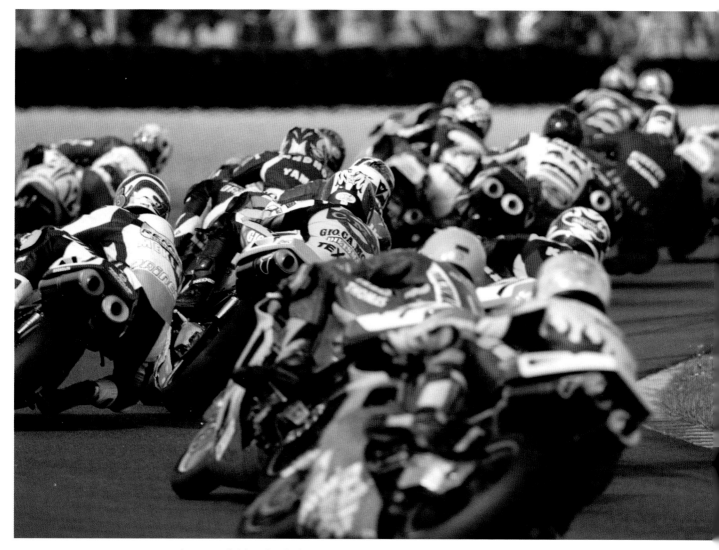

A mass of riders jostle for position at the start of the
British round of the 1997 World Superbike Championship,
Donington Park, Derby. Unlike the purpose-built Grand
Prix or MotoGP racing machines, Superbikes are based on
manufacturers' road bikes.
4th May, 1997

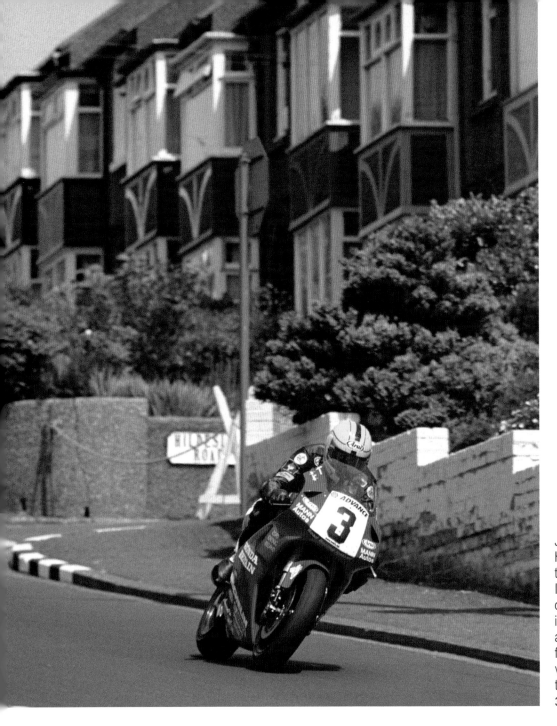

Joey Dunlop riding his Honda RVF750 RC45 during the Formula One race of the Isle of Man TT. The TT is run on the public roads of the island, which are closed to allow the racing. Competitors flash through towns and villages with onlookers close to the action.

31st May, 1997

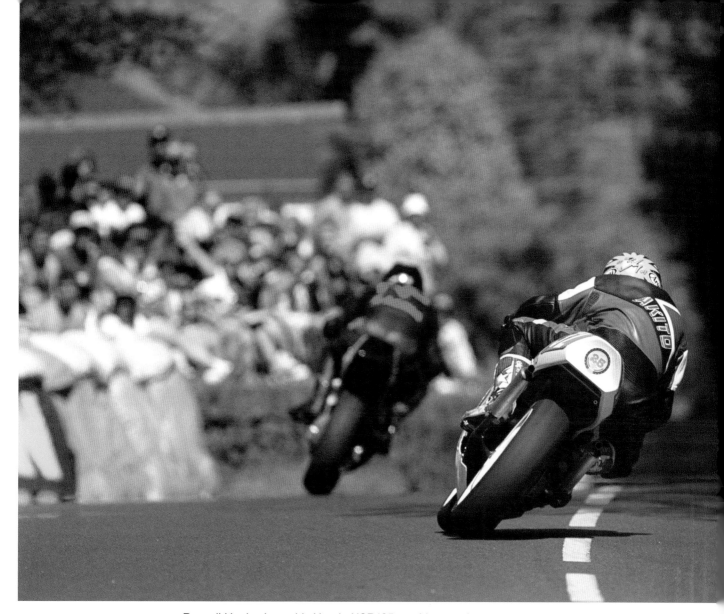

Russell Henley leans his Honda NSR125 machine to take a
bend during the Ultra-Lightweight TT. Spectators can almost
reach out and touch the riders as they fly by, and there are
no crash barriers to catch a runaway machine.
2nd June, 1997

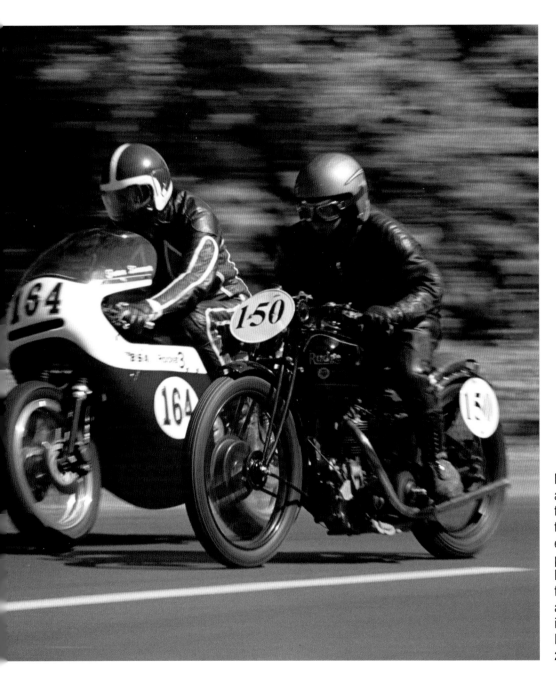

Machines are sent off one at a time to compete against the clock during the TT, the more powerful bikes eventually catching and passing the slower ones. Every year there are events for classic machines. Here a Rudge 500cc TT Replica is passed by a much later BSA Rocket 3.

2nd June, 1997

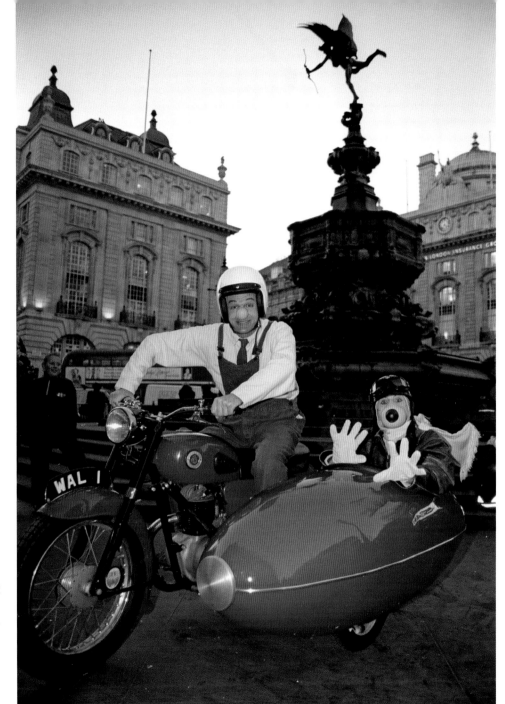

Say cheese! The success of the *Wallace and Gromit* animated films led to the creation of a stage show, titled *A Grand Night Out*, at London's West End Peacock Theatre. Here the actors who played the leading roles pose on their motorcycle combination in front of the Eros statue, Piccadilly Circus, to launch the show.
29th October, 1997

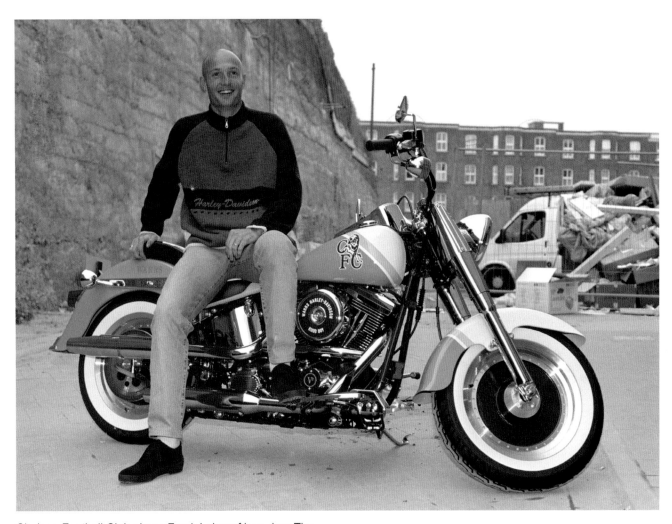

Chelsea Football Club player Frank Leboeuf launches The
Ruud Boy motorcycle in London. The bike, a customized
limited-edition Harley-Davidson, was named in honour of player/
manager Ruud Gullit and was offered for sale at £19,995.
30th October, 1997

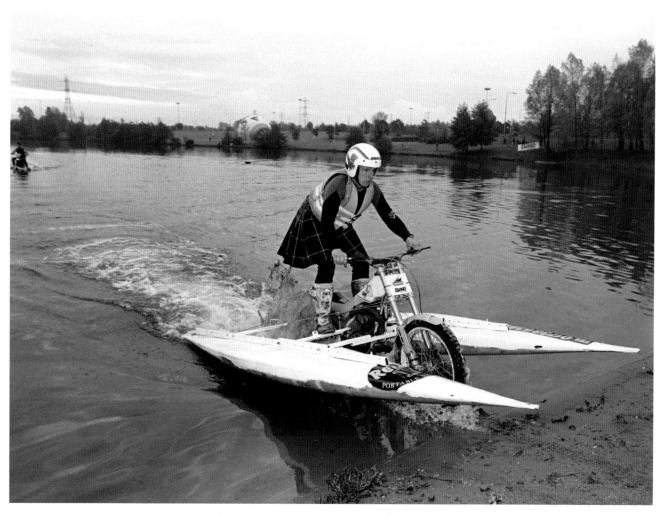

A kilted Gordon Halley of Perth emerges from the lake
at the NEC Birmingham during an amphibious motorcycle
challenge. He was competing against 30 others for the
£3,000 prize at the International Motorcycle Show.
6th November, 1997

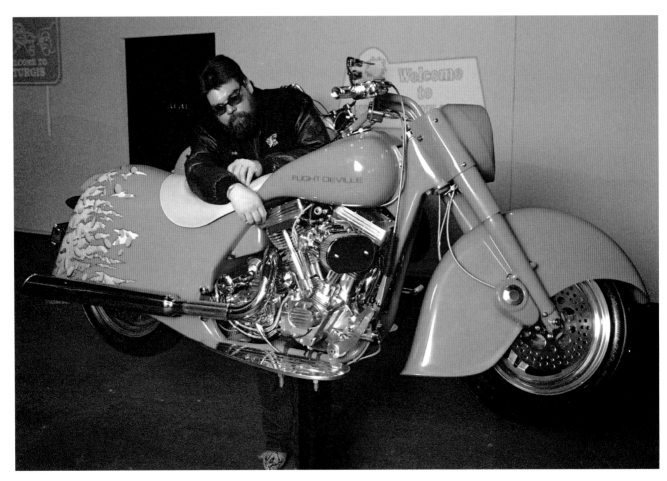

Pink Tank. Motorcycle builder Tank Ewsichek, from
Cleveland, Ohio, contemplates the styling of his customized
Harley-Davidson, named Flight DeVille, which was part of
the *Art of the Harley* exhibition that was opened at London's
Barbican Art Gallery.
20th January, 1998

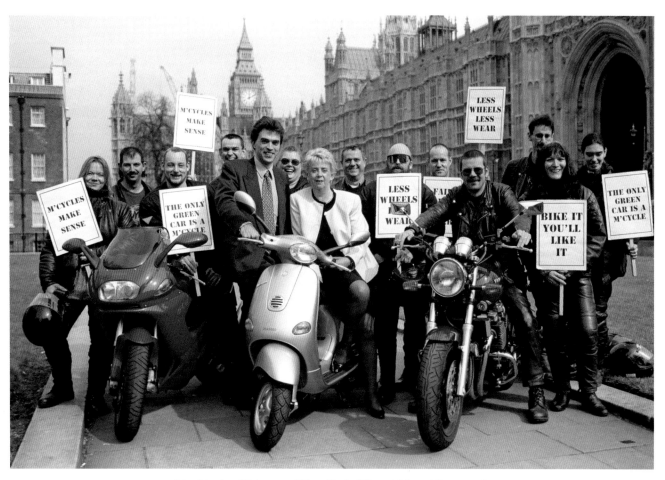

Mrs Monica Dickman of RoadSafe (C) and Liberal Democrat
MP Tom Brake (to her right) join motorcycle enthusiasts outside
Parliament at Westminster to lobby MPs in preparation for the
Government's Integrated Transport Policy to be published
in May.
31st March, 1998

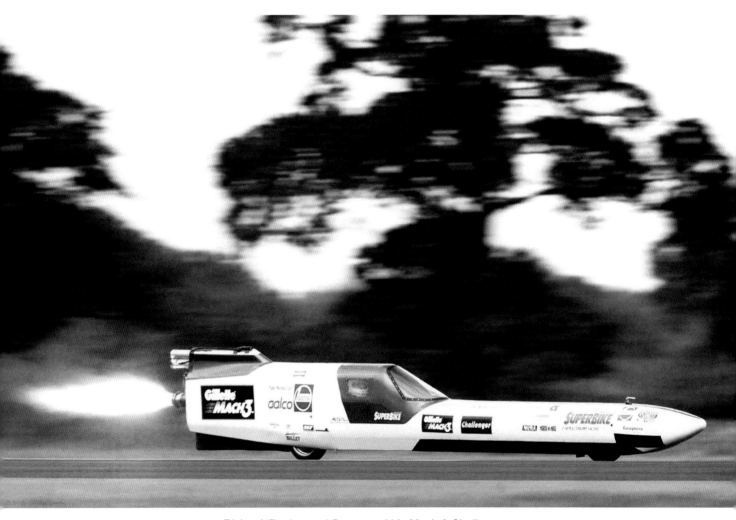

Richard 'Rocketman' Brown and his Mach 3 Challenger
rocket bike make an attempt on the British motorcycle land
speed record at Elvington airfield, near York. The thrust
powered machine achieved an average speed over two runs
of 216.55mph, raising the record by over 7mph.
15th October, 1998

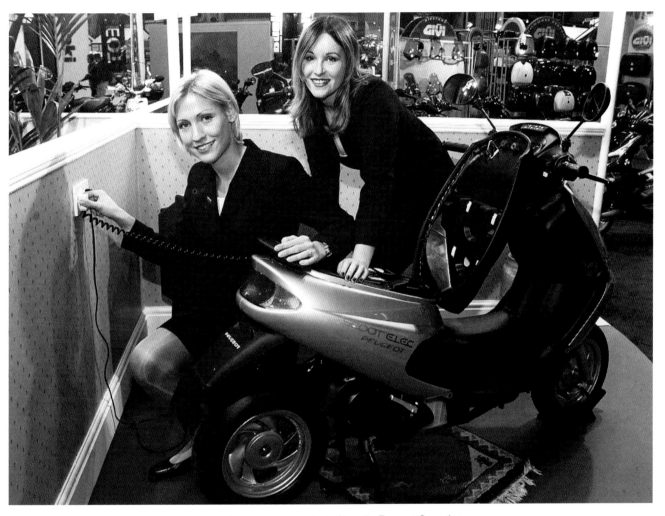

Free plug. The environmentally friendly Peugot Scootlec
is demonstrated at the International Motorcycle Show,
NEC Birmingham. Powered by a 100ah battery, the machine
offered similar performance to a 50cc scooter and had
a range of 30 miles.
12th November, 1998

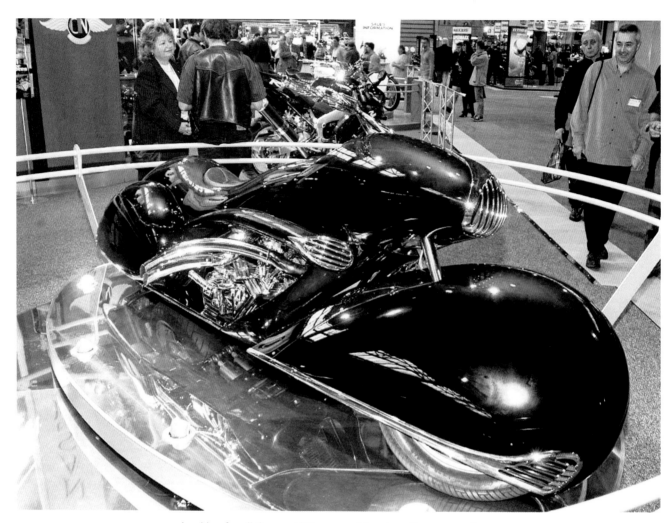

Looking for all the world like something from the pages of a 1930s comic book, this amazing creation was the work of renowned Californian motorcycle builder Arlen Ness. Having used a 1340cc Harley-Davidson V-twin engine for power, Ness claimed that the styling of the striking machine had been inspired by Bugatti's lavish automobiles of the 1930s.

12th November, 1998

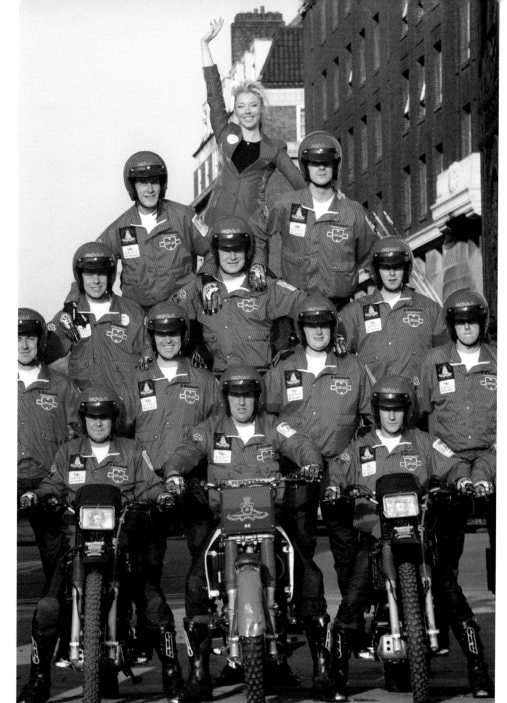

Riding high. Model Tamara Beckwith joins the Royal Artillery's Motorcycle Display Team at the annual charity draw in aid of the Soldiers, Sailors, Airmen and Families Association (SSAFA). The team was renowned for its motorcycle antics.

14th December, 1998

Cereal offender. Today motorcycles, particularly Harley-Davidsons, are often used for all manner of publicity feats, sometimes without any obvious connection with the product. Here, for example, Farley Bear, from the Farley's baby food range, sits on a Harley with Tomas Deason and Samira Abdeslam to relaunch the company's range of rusks and cereals.
27th April, 1999

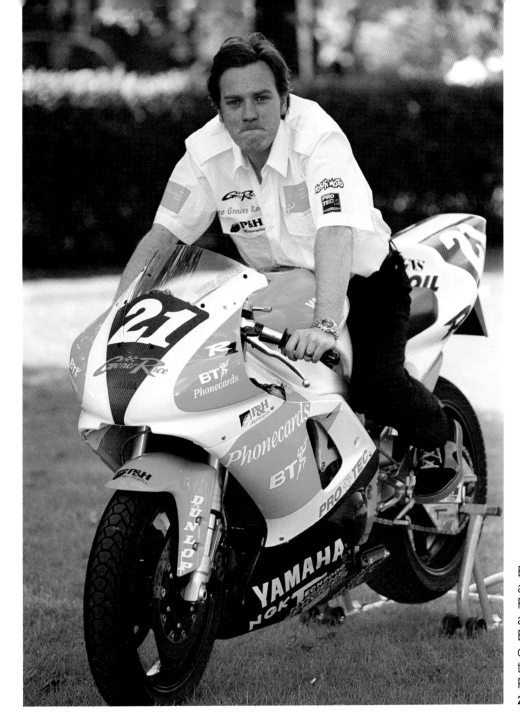

British actor Ewan McGregor astride a Yamaha YZF-R1 in London, where he and fellow actor Charley Boorman launched their own Superbike racing team sponsored by BT Phonecards.
28th April, 1999

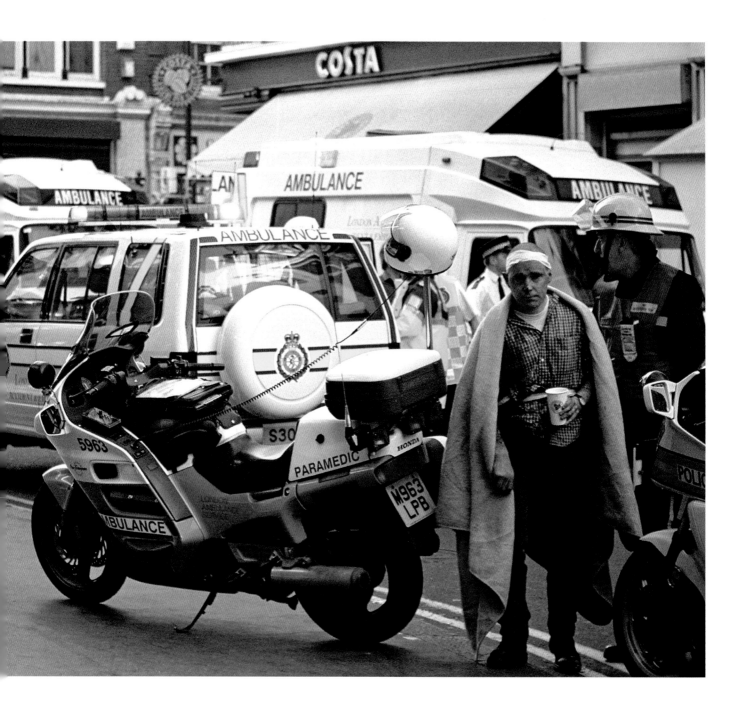

Facing page: In cities like London, where heavy traffic can delay an ambulance on its way to an incident, motorcycle mounted paramedics provide a vital first response. Here a paramedic bike is seen along with other emergency vehicles following a bomb blast at the Admiral Duncan pub in Old Compton Street, central London. Up to 30 people were feared injured after the explosion in the popular gay bar. The bomb had been set by neo-Nazi David Copeland in an attempt to stir up homophobic tensions.
30th April, 1999

Former motorcycle champion Barry Sheene astride a 1931 Matchless Silver Hawk during the Louis Vuitton Classic at the Hurlingham Club, London. The legendary rider was one of the judges deciding the Best of Class winners.
5th June, 1999

'It' girl about town Tamara Beckwith with a Minimoto scooter. She is wearing a fashion creation entered for the Morada Inside Out Fashion Awards during Bhs Graduate Fashion Week. The Minimotor could be folded up and carried in the boot of a car.
6th June, 1999

Martin Jones, 25, of Swindon, Wiltshire arrives at court with his Go-Ped, a motorized skateboard. He was due before Swindon Magistrates Court, charged with careless driving and drink driving. Such scooters are not legal for use on the road.
28th June, 1999

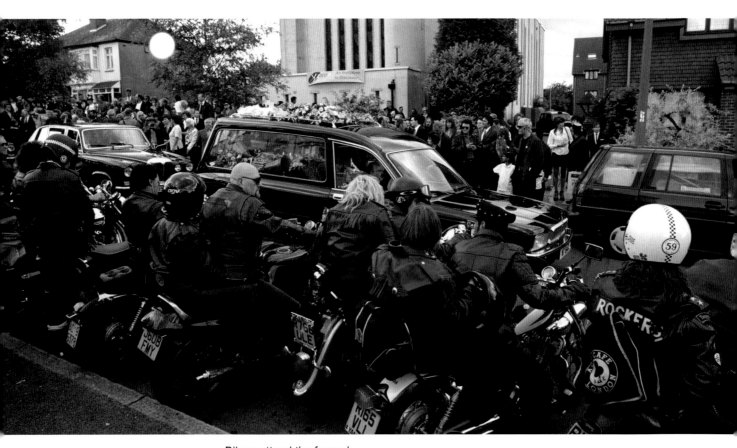

Bikers attend the funeral
of David Sutch, known as
Screaming Lord Sutch,
the eccentric leader of the
Monster Raving Loony Party.
The 58-year-old musician,
who had committed suicide,
was buried at Pinner New
Cemetery after a service at
St Paul's Church in South
Harrow, London.
28th June, 1999

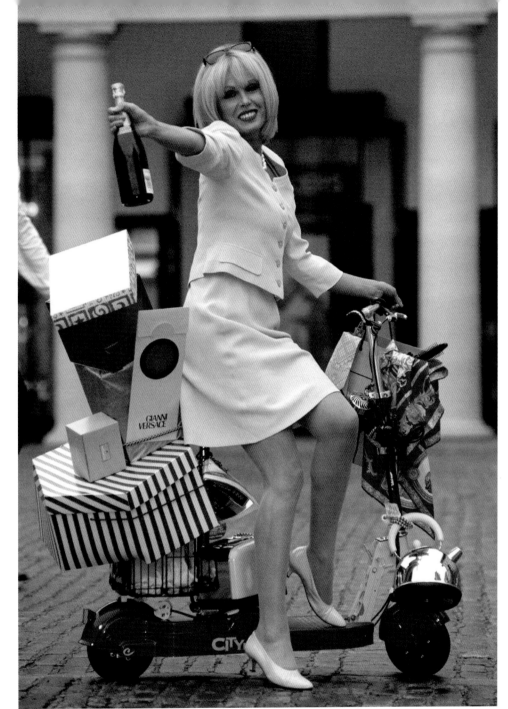

Actress Joanna Lumley arrives in Covent Garden on an electric Go-Ped ESR750 City Scooter, laden with shopping bags, to launch Europe's newest and largest on-line shopping site, Bigsave.
15th September, 1999

Health Secretary Frank
Dobson chats with
motorcycle paramedic
Chris Moss at the London
Ambulance Service
headquarters in London.
Dobson was there to thank
Moss personally for the
work he had done to help
survivors of the Paddington
rail crash, where he was
second on the scene.
9th October, 1999

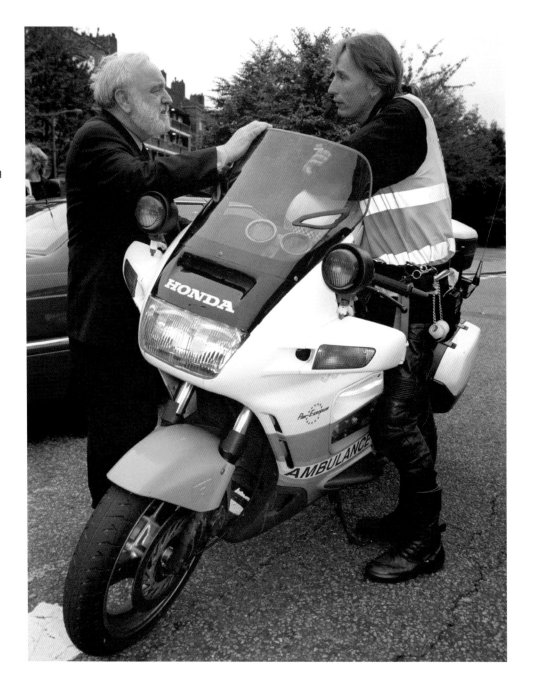

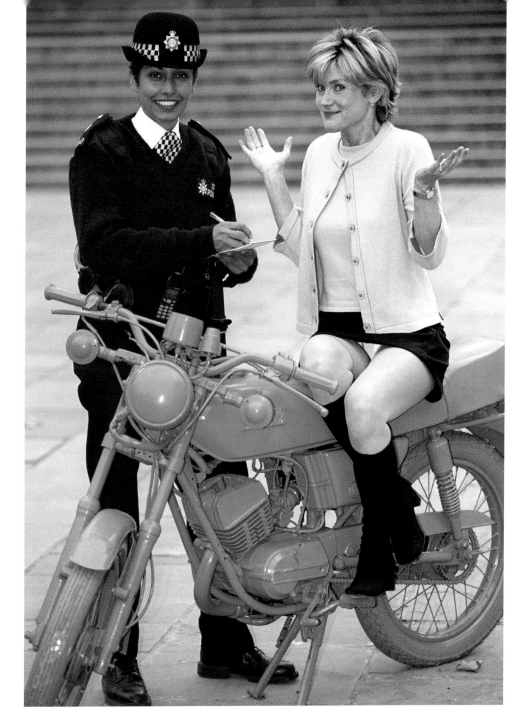

A fair cop? Television presenter Anthea Turner, on a pink motorcycle, receives a ticket from WPC Pepe Kaur at the official opening of *Everyday Icons*, an art exhibition at the Mall Galleries, London. The machine was one of the exhibits.

20th October, 1999

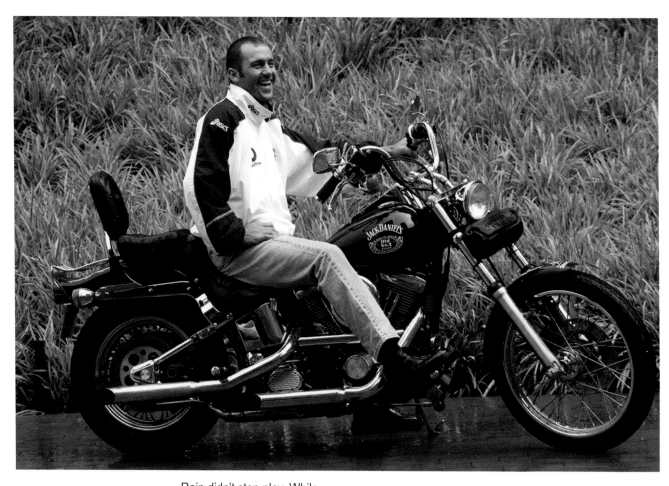

Rain didn't stop play. While on tour in Johannesburg, South Africa, England cricketer and motorcycle enthusiast Craig White takes the opportunity to try out a 1998 1340cc V-twin Softail Custom Harley-Davidson.

10th February, 2000

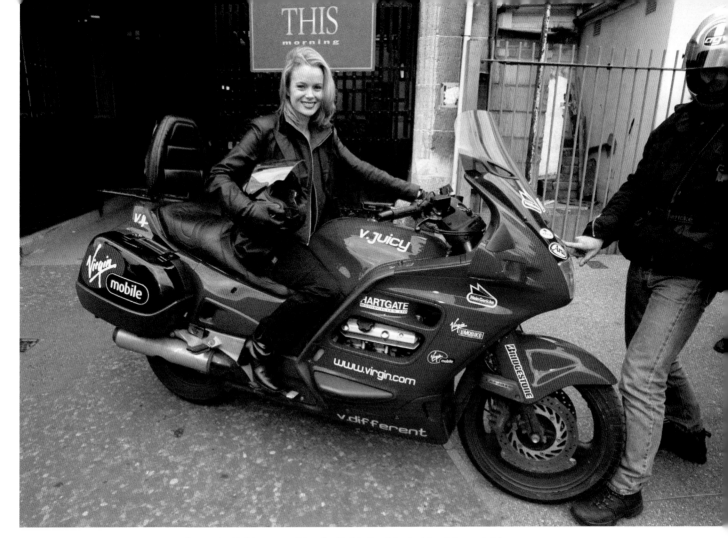

Amanda Holden on a Honda Goldwing Virgin Limobike outside the TV studios in central London where she and her husband, Les Dennis, were standing in for regular presenters Richard Madeley and Judy Finnigan on the *This Morning* programme. The Limobike offers a motorcycle taxi service in London, providing a rapid means for individuals to get around.

23rd February, 2000

Britain's oldest motorcyclist, and former motorcycle manufacturer, 100-year-old Len Vale Onslow, who fulfilled a lifelong ambition to ride his motorcycle, a Super Onslow Special built by himself, along the Mall in London on his 100th birthday. He would enjoy his last ride at the age of 102 and pass away two years later in 2004.

2nd May, 2000

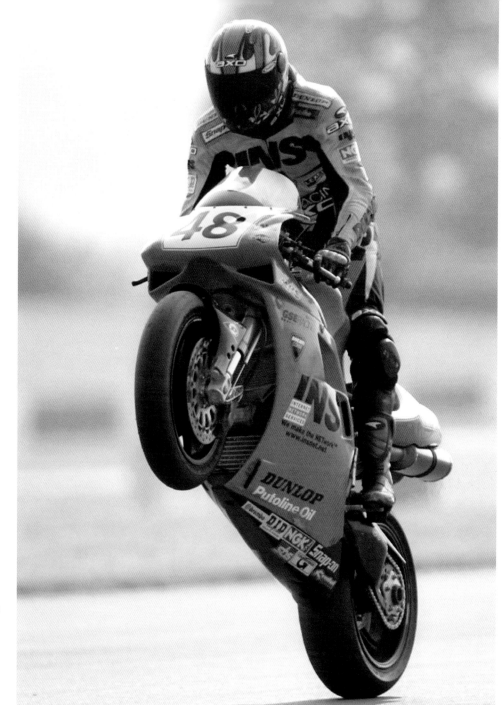

Great Britain's Neil Hodgson performs a wheelie on his GSE Racing INS Ducati 996 after qualifying fourth on the starting grid for the FIM World Superbike Championship at Donington Park, Derby. Each round of the championship comprises two races, and Hodgson was winner of the second race that day. At the end of the year, he was 12th in the points standings.

13th May, 2000

Brough motorcyclists (L–R) Dave Clark, Justin Wand and Frank Solano outside Clouds Hill, Wareham, Dorset, the former home of TE Lawrence, before setting off on a 150-mile ride to author George Bernard Shaw's home, *Shaw's Corner*, in Ayot St Lawrence, near Welwyn, Hertfordshire. The machines were similar to those preferred by both Shaws.

21st May, 2000

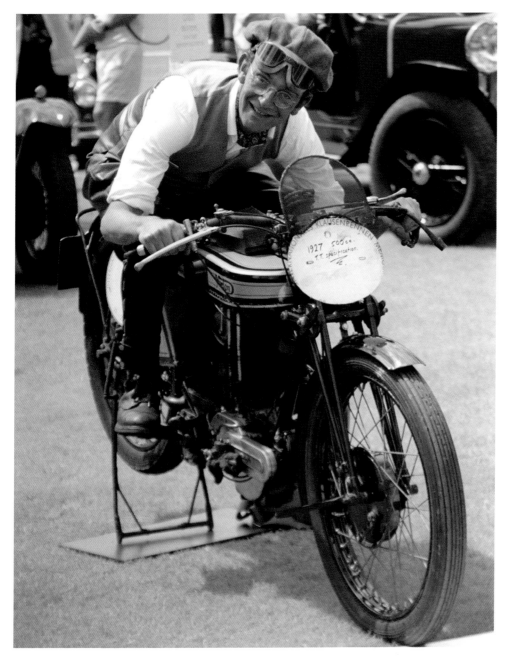

Going nowhere fast.
Dr George Cohen, in period
dress, gets to grips with
his restored 1927 Norton TT
replica motorcycle at
the Louis Vuitton Classic,
a classic car and motorcycle
event held at the Hurlingham
Club in London.
3rd June, 2000

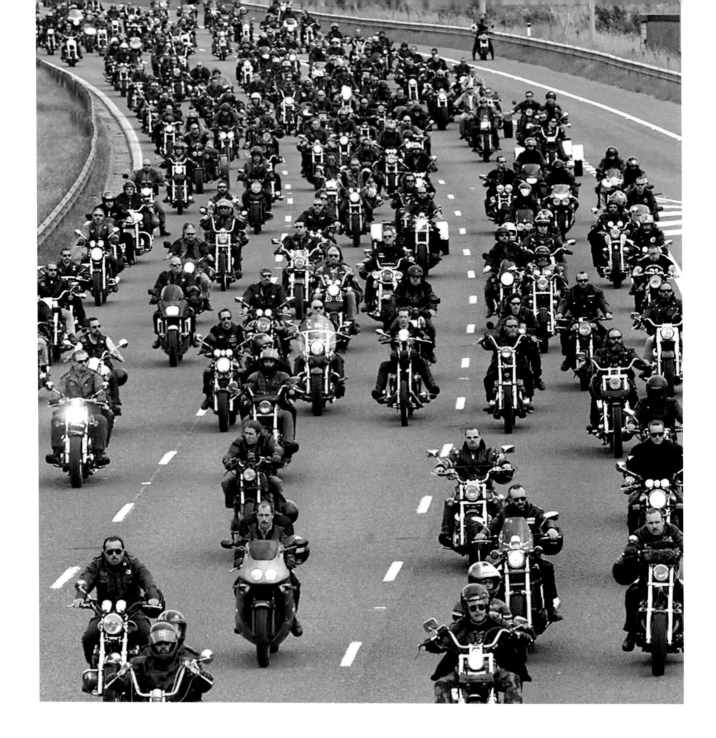

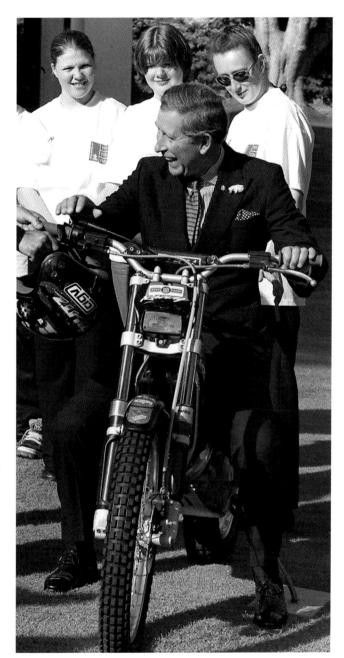

Facing page: Around a thousand Hell's Angels travel in convoy behind the funeral procession for Dr Ian 'Maz' Harris, who had founded the British branch of the motorcycle organization. The cortege stretched over a distance of three miles and was escorted by police outriders to St Paulinus Church, Crayford, Kent.
15th June, 2000

The Prince of Wales straddles a trials bike during a visit to Prince's Trust beneficiaries at Government House, Onchana, as part of a two-day trip to the Isle of Man.
4th July, 2000

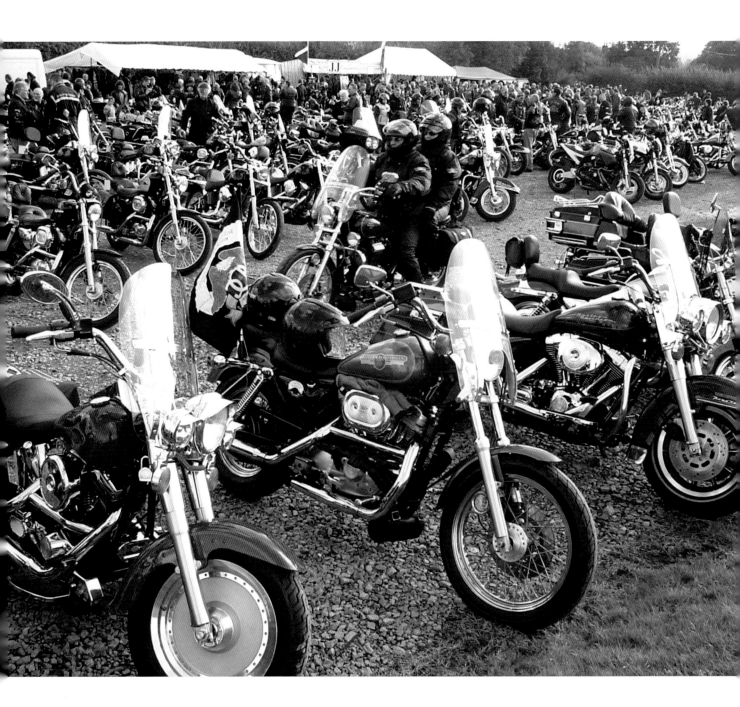

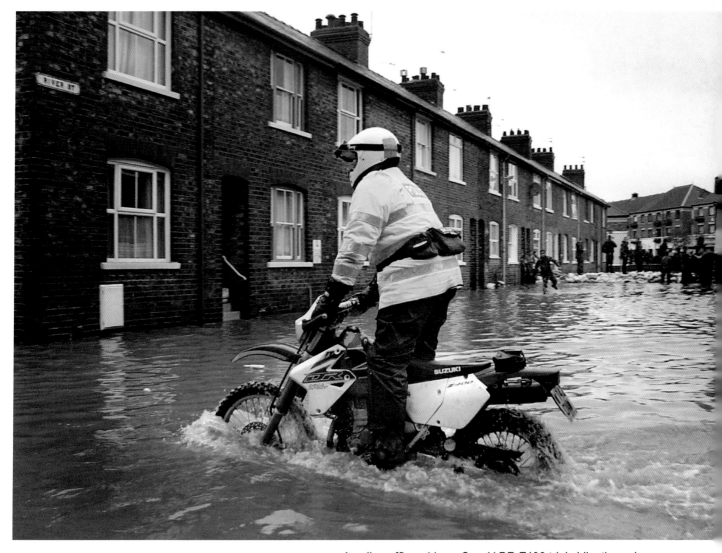

A police officer rides a Suzuki DR-Z400 trials bike through flood water as soldiers bolster defences in River Street, in the Clementhorpe area of York, North Yorkshire, after the River Ouse burst its banks. The city was bracing itself, as the river was expected to continue rising.
7th November, 2000

Facing page: A sea of Harleys. More than 600 Harley-Davidson riders greeted sponsored walkers Steve Dayman and Steve Fear at Bristol's Clifton Rugby Club as they completed the last day of a 460-mile marathon from Morpeth to Bristol.
22nd October, 2000

Legs akimbo. The Oman Army motorcycle display team during a huge military tattoo at the Wattaya Stadium, in the capital Muscat, in celebration of the Sultan's 30th year as ruler. The display was watched by Britain's Duke of York.
20th November, 2000

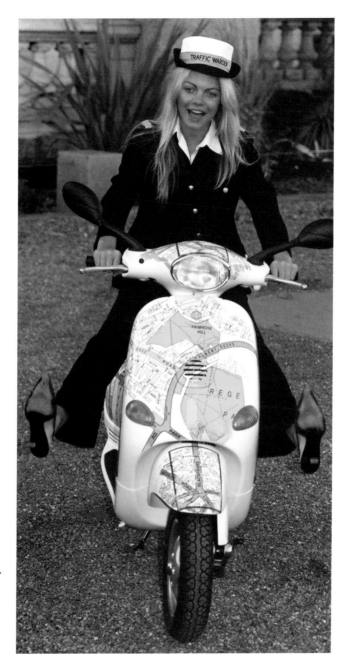

Balancing act. Dressed as a comic traffic warden, model Jemma Kidd helps launch a campaign to promote scooters as the answer to London's transport problems. Her machine is a Vespa ET4 150cc scooter, which has been given an unusual road-map livery.
14th December, 2000

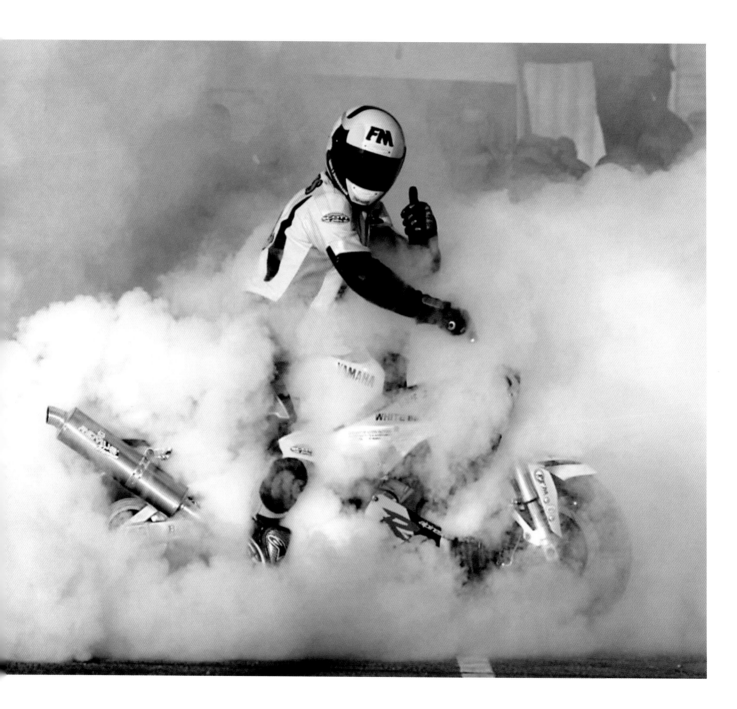

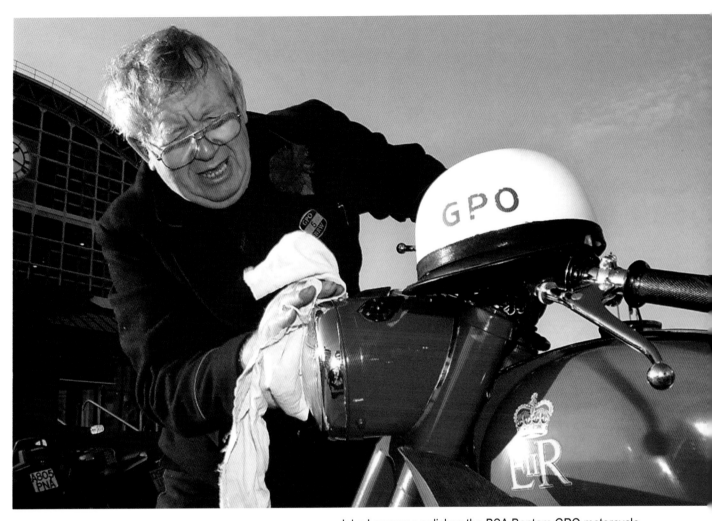

John Lawrence polishes the BSA Bantam GPO motorcycle on which he used to deliver telegrams during the 1960s. The Post Office employed large numbers of the lightweight bike for this purpose. Lawrence and his machine were part of a display at Manchester's National Motorcycle Show.
5th January, 2001

Facing page: Burning rubber. Stunt rider Dave Coates smokes the tyres of his Yamaha during a display at the National Motorcycle Show at Manchester's G-Mex centre. The rider would go on to achieve the record of riding at 151.7mph while facing backwards.
5th January, 2001

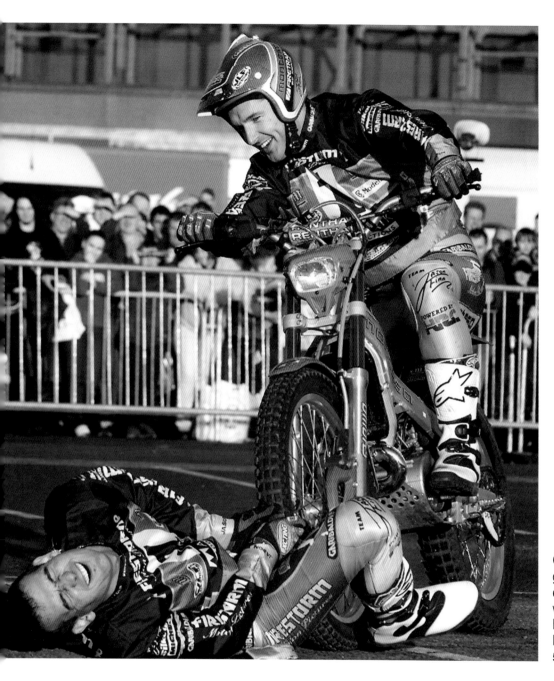

Ouch! A stunt performer gets a close shave while entertaining the crowds who flocked to the National Motorcycle Show at the Manchester G-Mex Centre.
5th January, 2001

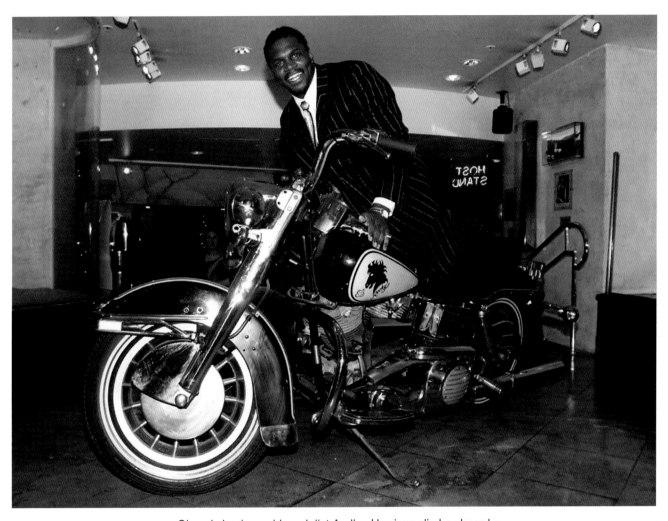

Olympic boxing gold medalist Audley Harrison climbs aboard a customized Harley-Davidson Super Glide at Planet Hollywood, London, after announcing that his long-awaited professional debut would be at Wembley Arena in May of that year.
27th February, 2001

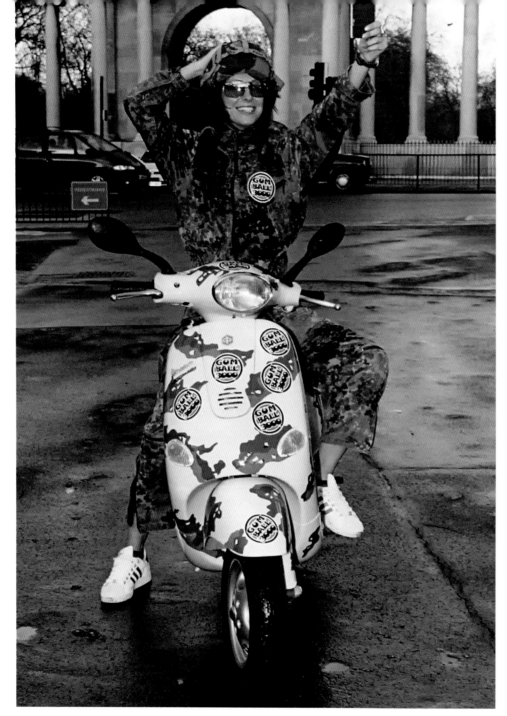

'It' girl Miss Dee on a customized Vespa ET4 150cc scooter at the start of the Gumball 3000 Rally at Hyde Park Corner, London. The annual event is a 3,000-mile road rally that takes place on public roads through several countries and is billed as an adventure, not a race. It attracts many celebrities.

26th April, 2001

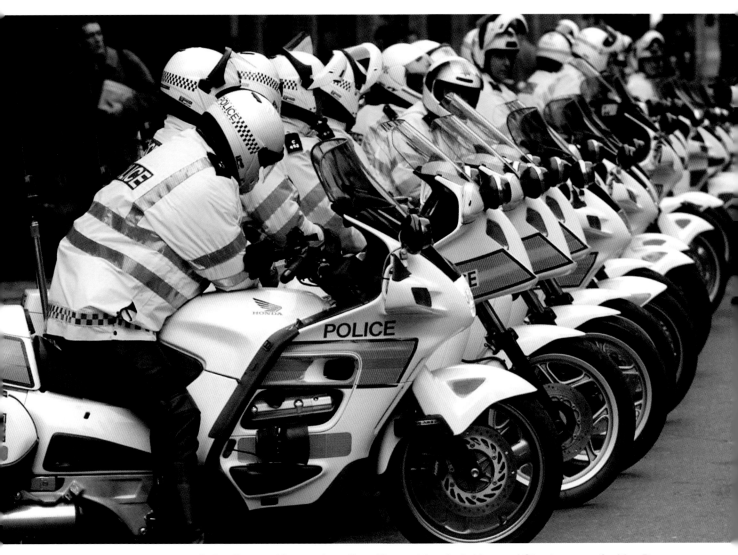

Police line-up. Motorcycle police officers at London's Liverpool Street prepare for May Day anti-capitalist protests. Metropolitan Police chief Sir John Stevens had ruled out the use of plastic bullets, despite police intelligence estimates that around 1,000 activists were intent on causing trouble. Some protesters went on a violent rampage, however, smashing a large number of shop fronts and damaging bank premises.

1st May, 2001

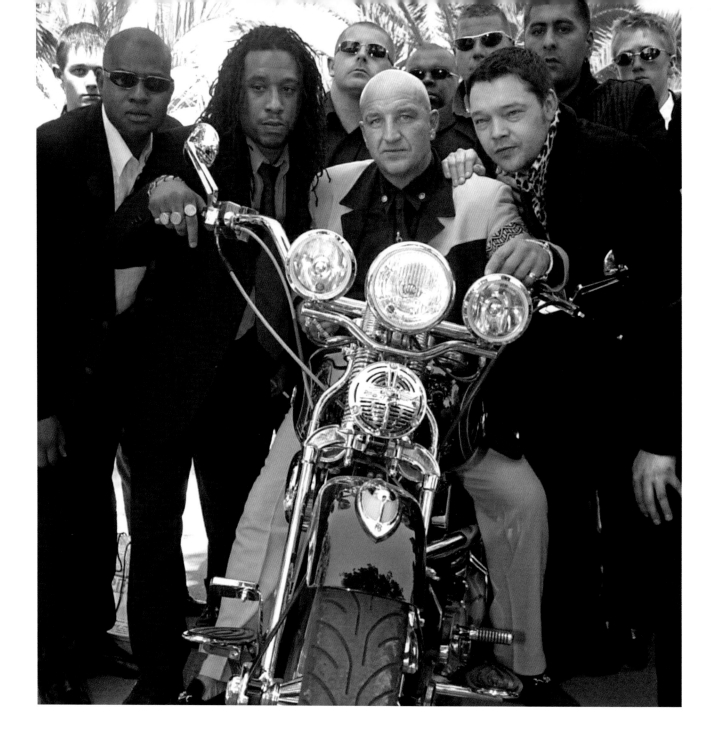

Facing page: Centre of attention. Self-styled former London gangster turned actor Dave Courtney sits on a Harley-Davidson motorcycle in Cannes, France while surrounded by fellow 'gangsters' from the movie *Hell to Pay*, in which he starred and which was being screened at the film festival.
12th May, 2001

Taking a leaf. With his bargain buys balanced precariously on his Aprilia Habana 125cc scooter, this plant enthusiast leaves the Chelsea Flower Show at Chelsea Royal Hospital, London, where plants are sold off cheaply on the last day.
25th May, 2001

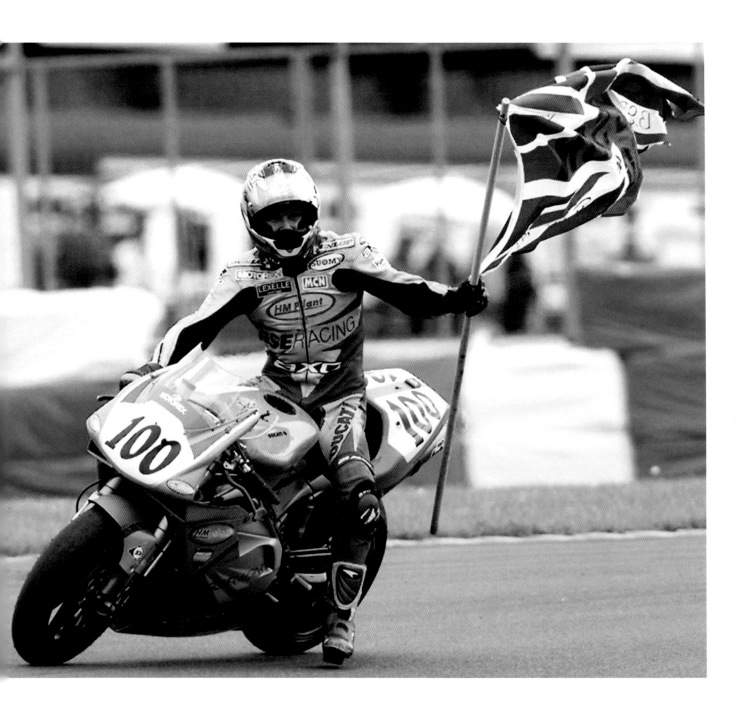

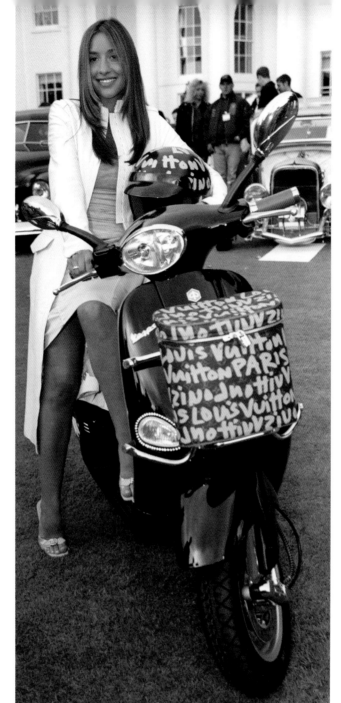

Facing page: Waving the flag. Neil Hodgson, on his Ducati 999F03, celebrates winning the first race of the fifth round of the Superbike World Championship at Donington Park, Derby. At the end of the season, he was fifth in the points standings.
27th May, 2001

Former All Saints member, Melanie Blatt, sits on her Louis Vuitton Vespa scooter at the Hurlingham Club, in London, during the Louis Vuitton Classic car and motorcycle show. The machine had been specially designed for the singer by the luxury goods company.
2nd June, 2001

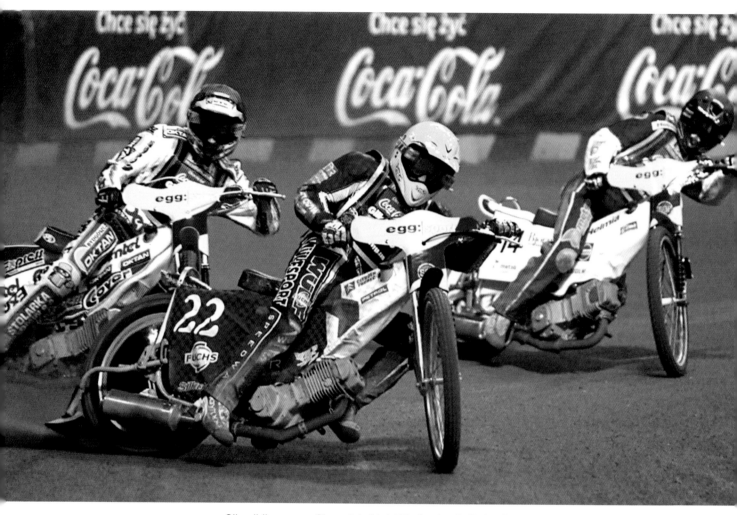

Slip sliding away. Slovenia's Matej Ferjan leads Poland's
Piotr Protasiewicz (L) and Norway's Rune Holta, during
the Speedway Grand Prix of Great Britain at the Millennium
Stadium in Cardiff, Wales. The winner was Tony Rickardsson
of Sweden.

9th June, 2001

Leeds United midfielder David Batty (R) sampled one of
the fastest sports in the world at Donington Park, Derby, where
he rode pillion on a double-seat Marlboro Yamaha MotoGP
bike with racing legend Randy Mamola at the controls.
Batty's ride took place before the British Motorcycle Grand Prix.
8th July, 2001

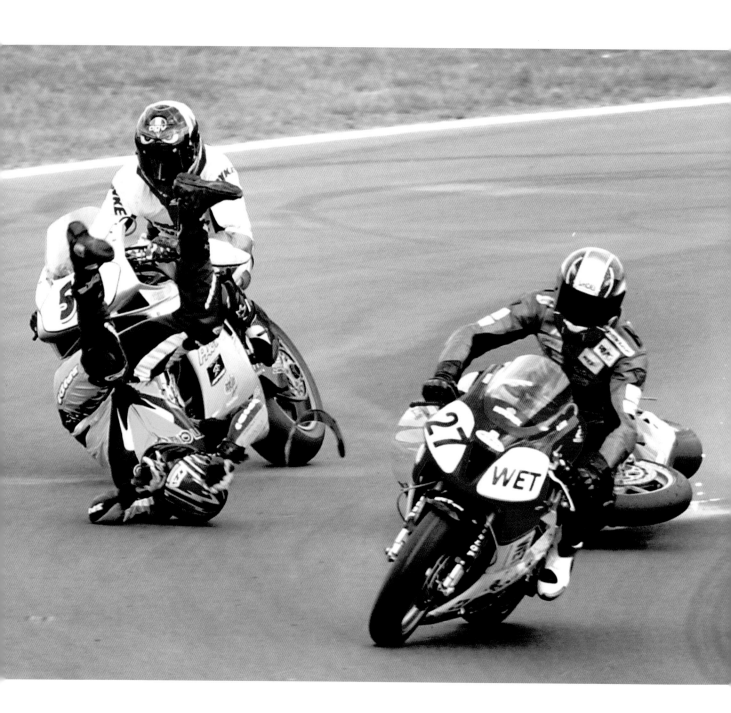

100 Years of Motorcycles • Twentieth Century in Pictures

Facing page: Narrow escape. Spain's Juan Bautista Borja falls from his bike and is narrowly missed by Australian Martin Craggill (L) during the first lap of the second race of the British round of the Superbike World Championship at Brands Hatch, Kent.
29th July, 2001

Young British rider Jamie Robinson, on his Virgin Mobile Yamaha R7, performs a burnout for the crowd at the end of the British Superbike race at Donington Park, Derby. Robinson was ninth in the points standings that year.
14th October, 2001

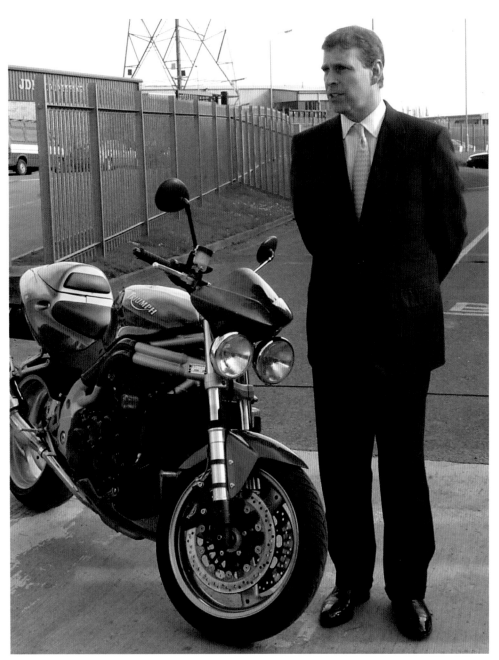

The Duke of York stands next to a Speed Four motorcycle during a visit to the Triumph factory in Hinckley, Leicestershire. The company, known as Triumph Motorcycles Ltd, took over the rights to the brand when the original company collapsed in the 1980s. Today, it has regained its position of being one of the world's leading motorcycle manufacturers.
21st March, 2002

George P Bush, nephew of the US president, with television personality Cat Deeley, who sits on a customized Harley-Davidson FXD Dyna Super Glide, at the opening of a new Tommy Hilfiger store in Manchester's King Street.
10th April, 2002

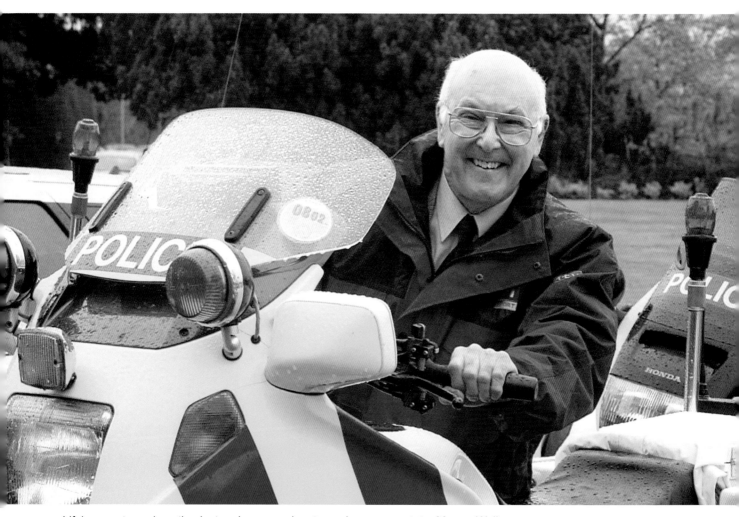

Lifelong motorcycle enthusiast and renowned motor racing commentator Murray Walker helping to launch a West Mercia Constabulary campaign aimed at bikers and entitled 'Ride and Survive'. The initiative had been formulated as a result of the death of ten and injury of more than 100 motorcyclists on West Mercia roads during the previous year. Walker's passion for motorcycling began as a child when his father, Graham, was a winner in the Isle of Man TT.

30th April, 2002

The Duke of Edinburgh rides a Jingcheng DX50 Easy-Rider mini-bike during the Royal Windsor Horse Show. He was on his way to watch his friend, Lady Romsey, compete in the carriage driving competition.
16th May, 2002

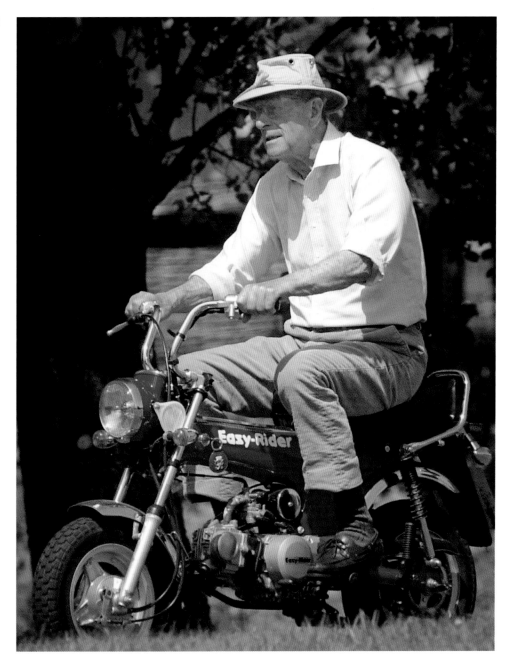

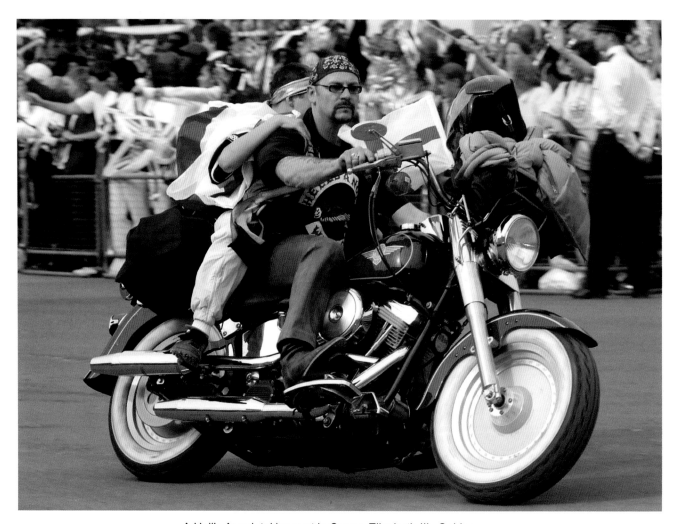

A Hell's Angel, taking part in Queen Elizabeth II's Golden Jubilee celebrations, rides a Harley-Davidson Fat Boy loaded with baggage past Buckingham Palace. The riders were taking advantage of the merriment to flout the law by not wearing helmets.
4th June, 2002

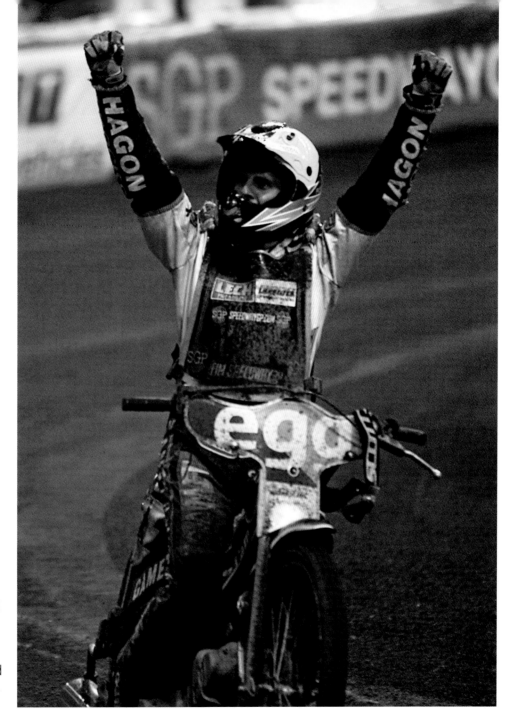

Ryan Sullivan, of Australia, celebrates his victory in the Egg-sponsored British round of the Speedway Grand Prix at the Millennium Stadium, Cardiff. He also won the Slovenian race that year, and would take two wins in 2003.
8th June, 2002

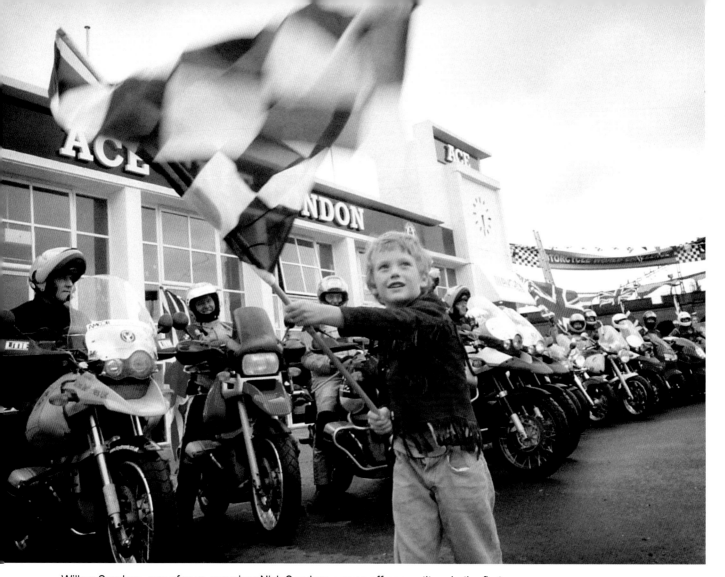

Willow Sanders, son of race organizer Nick Sanders, waves off competitors in the first-ever round-the-world motorcycle race at the Ace Café in north London. Riders taking part in the 25,000-mile event included an eye surgeon, a 65-year-old and a postman. Due to pass through 20 countries, five deserts and four continents, the 24 competitors would be on the road for 95 days. The event was expected to raise more than £100,000 for charities.
8th July, 2002

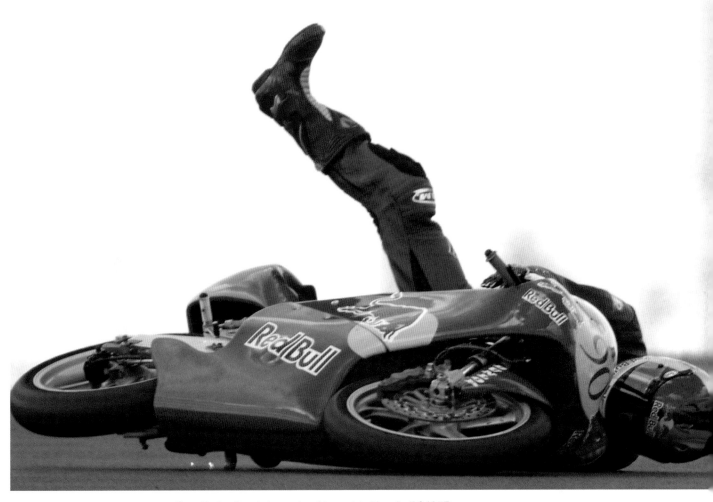

Guy Farbrother takes a tumble on his Honda RS125R race machine. Farbrother was a rising star in the Red Bull Rookies Team, but was tragically killed in a road accident in April 2003.
13th July, 2002

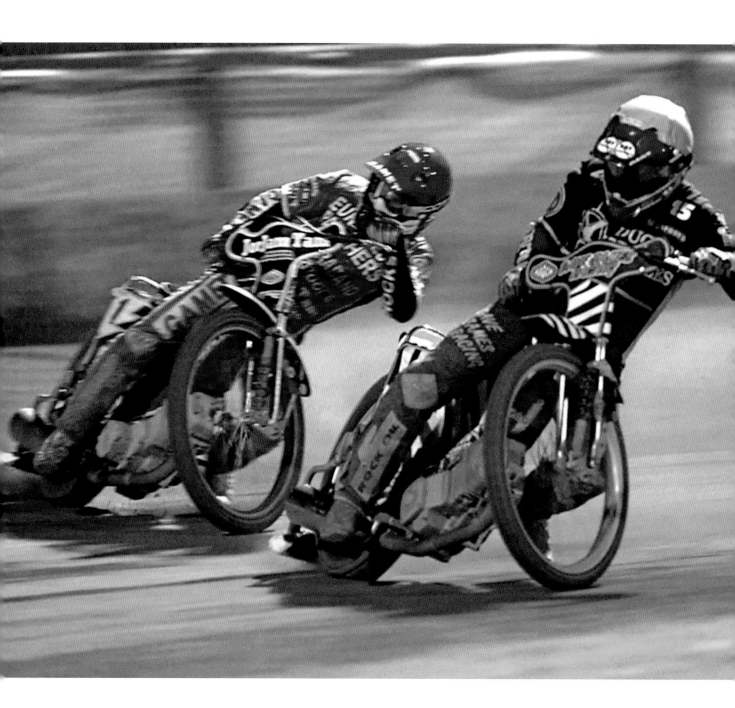

Facing page: Joe Screen (R) leads Ryan Sullivan into a corner during the Elite League Riders' Championship held at Poole Stadium, Dorset. The championship was for the season's highest points scorers in the league.
21st August, 2002

Australian born speedway rider Adam Shields, of Isle of Wight Islanders, celebrates winning the Premier League Pairs Championship at Manchester's Belle Vue track. The Premier League is the second division of British speedway.
8th September, 2002

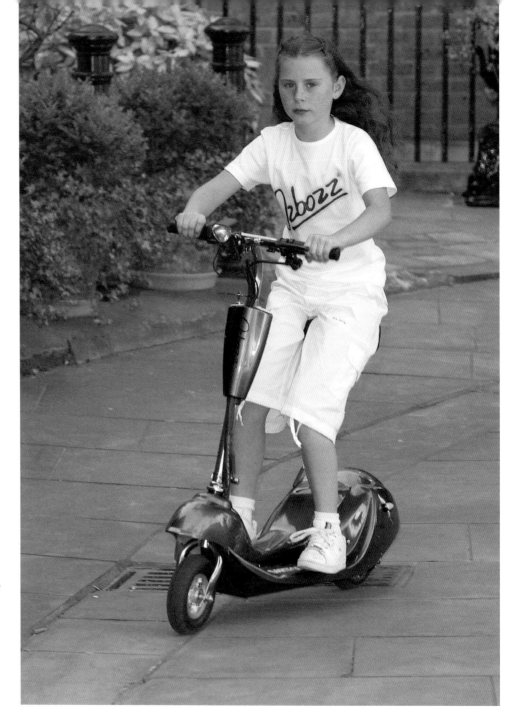

Leah-Verity White rides the electric Ozbozz Dart Force scooter during the toy industry's exhibition *Dream Toys 2002* in London. The scooter, with a seat, had a top speed of 11mph and could be ridden by adults as well as children.

25th September, 2002

Australians Ralph and Fionnuala Dixon are overjoyed at being
reunited with their BMW F650 Funduro motorcycle, which had
been stolen. They were on a round-the-world charity fundraising
journey when the bike was taken in Cardiff.
6th November, 2002

Peter Parker with his BMW C1 scooter outside Bedford Magistrates Court. The architectural technologist had been summonsed three times for allegedly contravening the Road Traffic Act by not wearing a helmet while driving his machine. Parker and his legal team argued successfully that the Act did not apply to the C1 because the rider was strapped in and surrounded by a protective cage.
3rd March, 2003

Facing page: Broadcaster Jonathan Ross on a Piaggio Zip 4T scooter during a photocall to launch the City of London ScooterSafe scheme at the Guildhall in the City of London. The initiative was a road awareness campaign aimed at scooter riders in the city.
2nd April, 2003

Facing page: Members of the Over the Top motorcycle stunt team during their performance at the British Motorcycle Federation's outdoor motorcycle show at the East of England showground, Peterborough.
17th May, 2003

Hazel Blears, MP for Salford, near Manchester, astride her Yamaha Virago motorcycle, after she and several hundred bikers had ridden into the House of Lords car park to raise £100,000 for the NSPCC charity.
10th May, 2003

Northumbria Police show off the country's only Harley-
Davidson police motorcycle in Newcastle upon Tyne. The
1450cc Road King, a common mount for US police officers,
was in full police livery, and fitted with horns and blue lights.
It had been obtained for general patrol use.

29th May, 2003

Elizabeth Woodcock, former contestant on the *Big Brother* TV show, with her Yamaha FZ1 before heading off on a three-month tour of the former communist 'Big Brother' states of Eastern Europe.
6th June, 2003

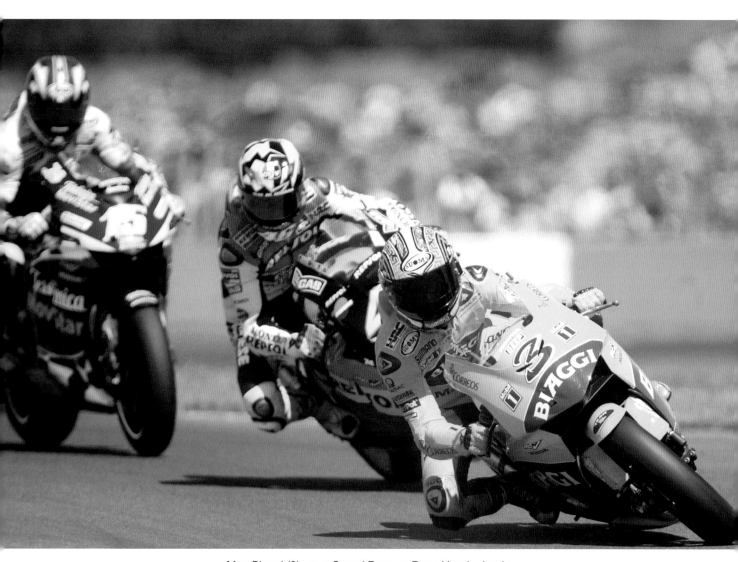

Max Biaggi (3), on a Camel Pramac Pons Honda, leads
Repsol Honda's Valentino Rossi on his way to winning the
British Grand Prix at Donington Park, Derby. Even so, Rossi,
who subsequently has earned the soubriquet 'GOAT' –
Greatest Of All Time – took the championship that year.
13th July, 2003

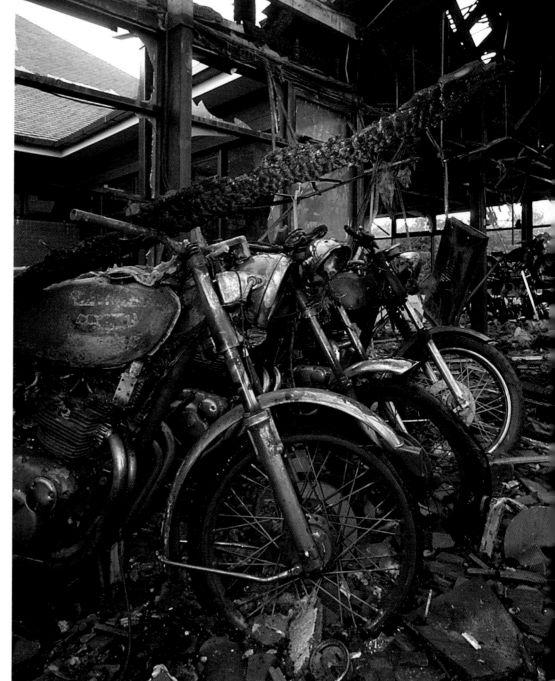

Aftermath. The devastated National Motorcycle Museum in Birmingham, where more than 120 firefighters had battled a massive blaze that destroyed hundreds of classic motorcycles. Up to 100 people had to be evacuated from the museum after the fire broke out late in the afternoon of 16th September. The building's two main halls were gutted. About 20 fire engines were called to the fire in Solihull, where firefighters were forced to pump water from the nearby National Exhibition Centre to dampen down the flames.

17th September, 2003

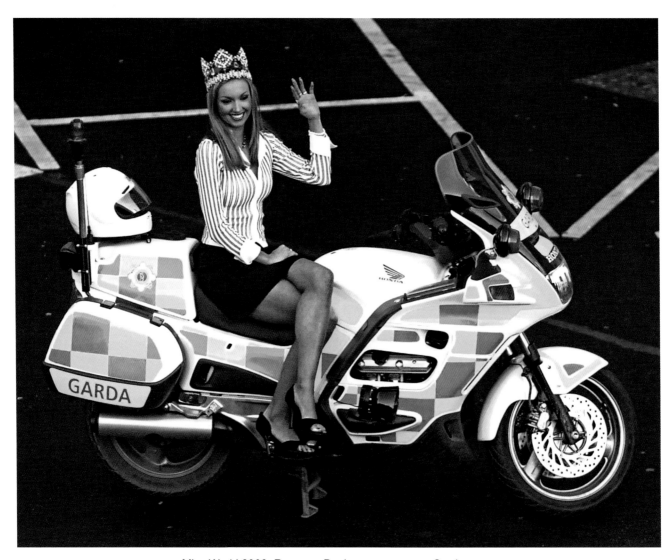

Miss World 2003, Rosanna Davison, poses on a Garda Honda motorcycle after arriving at Dublin Airport. The 19-year-old art student became the first Irish contestant to claim the title when she saw off the challenge of 105 competitors in the beauty pageant at the previous weekend.
11th December, 2003

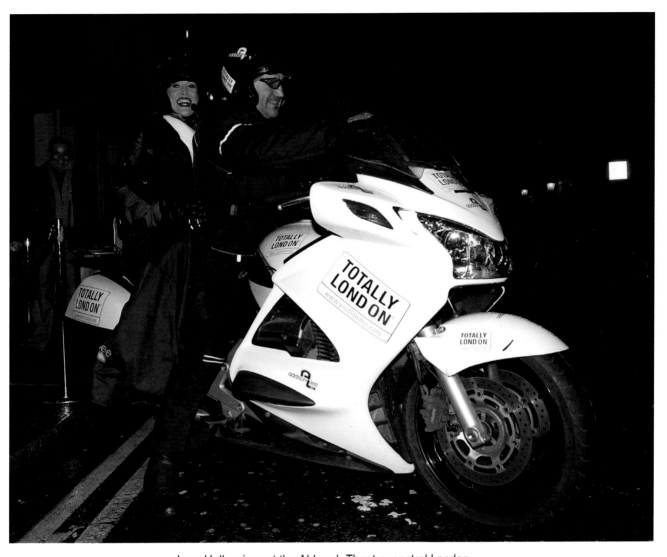

Jerry Hall arrives at the Aldwych Theatre, central London
on a Honda ST1300 Pan-European motorcycle taxi prior to
performing in *Fame: The Musical* as part of a successful
world record attempt to play in six different West End
musicals on the same night.
24th February, 2004

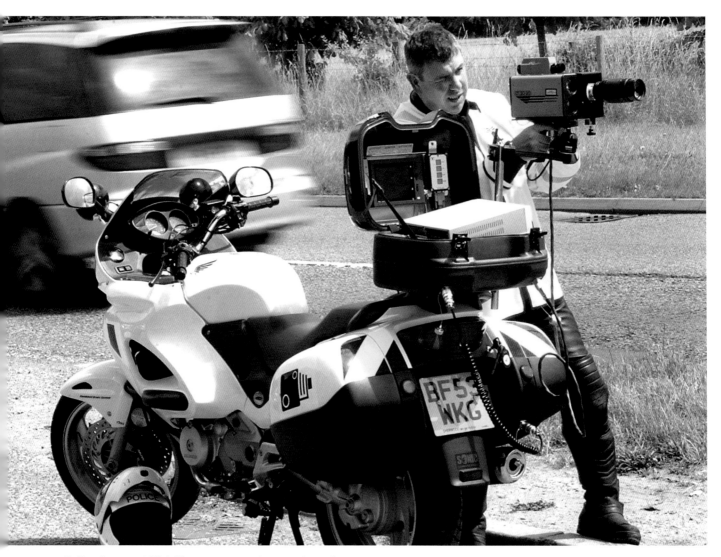

Police Sergeant Nick Blencowe operates a motorcycle-mounted road safety camera near Salisbury in Wiltshire. His bike is a 650cc Honda Deauville, which cost £30,000 and was paid for with the income from speeding fines.
29th June, 2004

Facing page: Although the Honda Deauville carries the same speed enforcement equipment as a police van, it packs away neatly into the machine's streamlined panniers. The bike is equipped with speed camera logos so that motorists can clearly recognize its purpose.
29th June, 2004

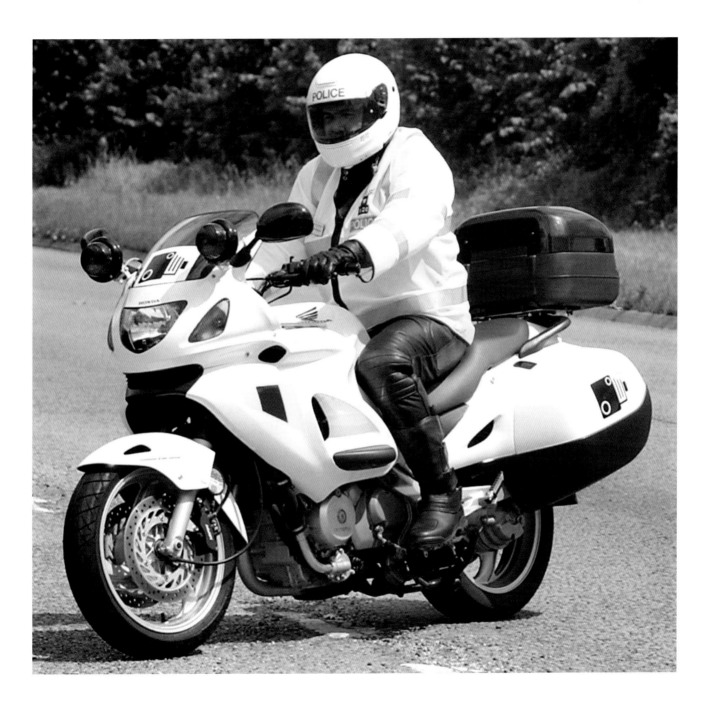

Tailor-made, custom-built. Customized motorcycles produced
by Battistinis Custom Cycles of Bournemouth, Dorset,
on display in Austin Reed's store, Regent Street, London.
The bikes were there to add sparkle to the tailor's customer
account evening.
9th September, 2004

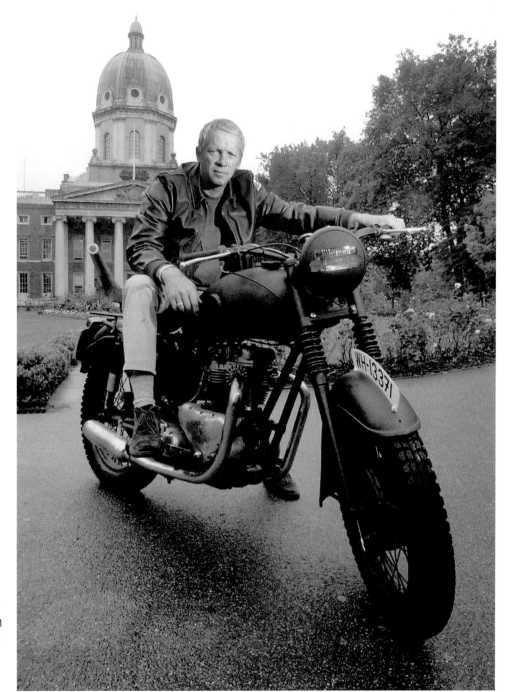

Steve McQueen look-alike Mark Myers with a replica of the 1961 Triumph 650cc motorcycle used in the film *The Great Escape*, outside the Imperial War Museum in central London. During the movie, McQueen's character stole the bike from a German dispatch rider and attempted to escape to Switzerland by jumping the border fence.

30th September, 2004

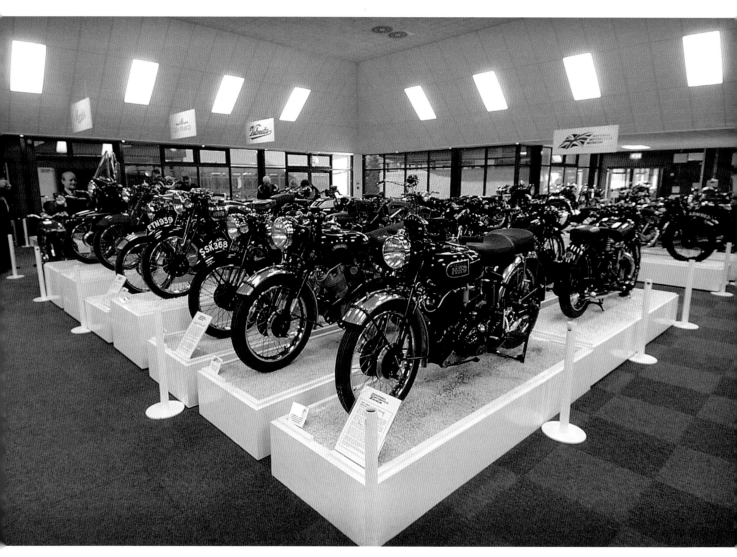

Some of the exhibits at the rebuilt National Motorcycle Museum near Birmingham, which opened its doors to the public 14 months after a fire that devastated a large part of the complex. Nearly 400 machines were lost in the fire, although many would be rebuilt and put back on display.
1st December, 2004

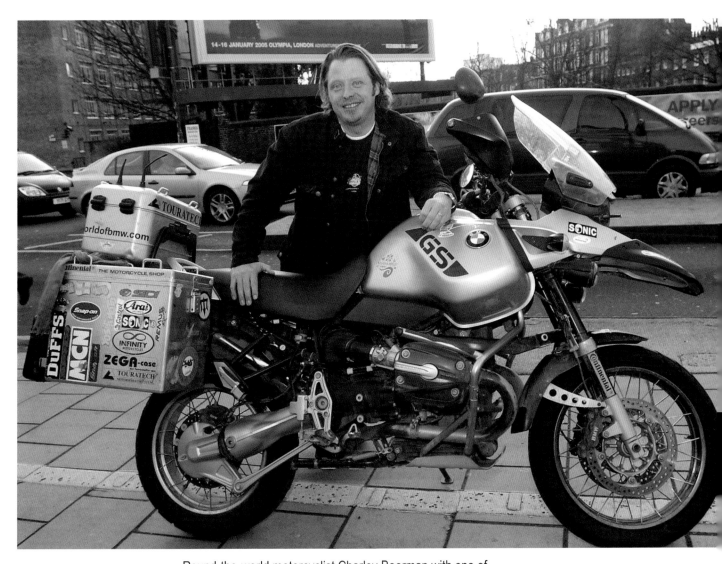

Round-the-world motorcyclist Charley Boorman with one of
the three BMW R1150GS Adventure bikes provided by BMW
for Boorman and partner Ewan McGregor's epic journey,
which was televised in the documentary *Long Way Round*.
13th January, 2005

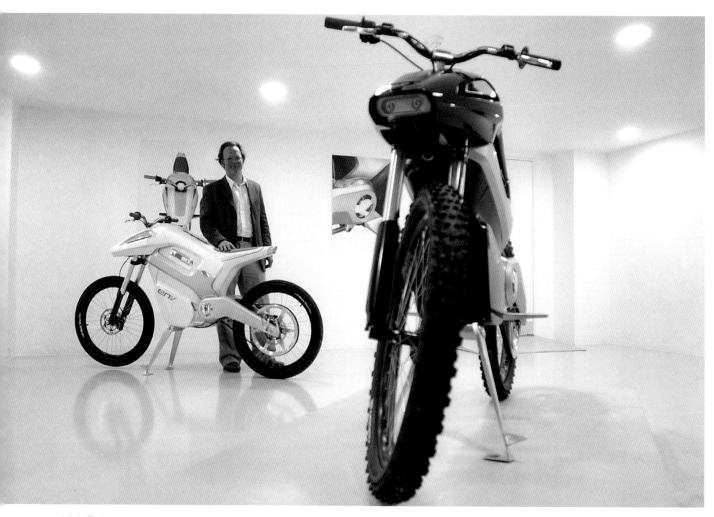

Nick Talbot, a director of Seymourpowell, with examples of the world's first purpose-built hydrogen-powered motorcycle, which his company had designed. Built by Intelligent Energy, the bike was known as the ENV (Emissions Neutral Vehicle). There was some concern initially that the machine was too quiet, since it produced no engine noise, and there was talk of it being equipped with some form of fake engine noise maker to alert pedestrians of its approach.
15th March, 2005

Facing page: Lance Corporal Stephanie McGinn jumps through a hoop of fire on her Triumph Bonneville 750cc motorcycle. McGinn was one of two women soldiers who had recently been accepted into the Royal Signals' White Helmets motorcycle display team.
24th April, 2005

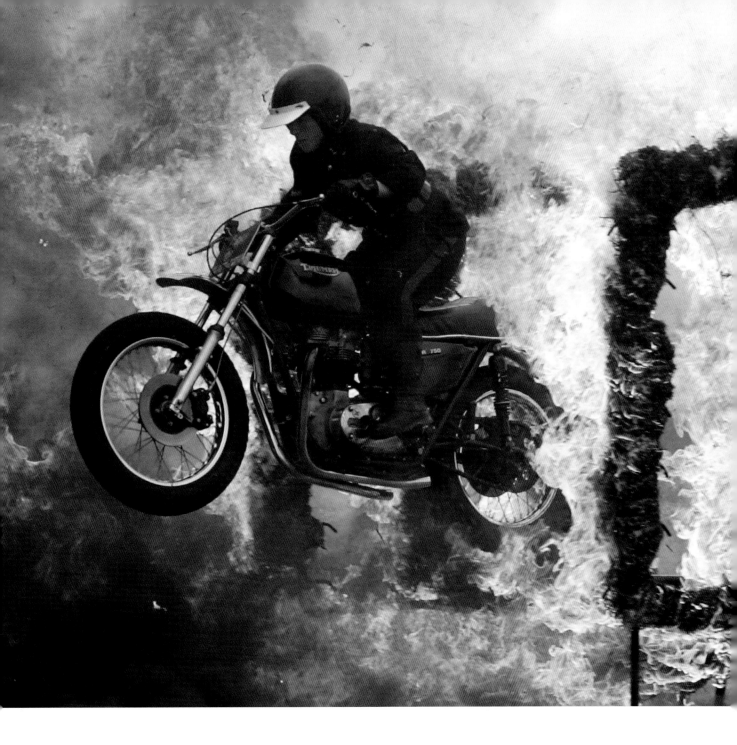

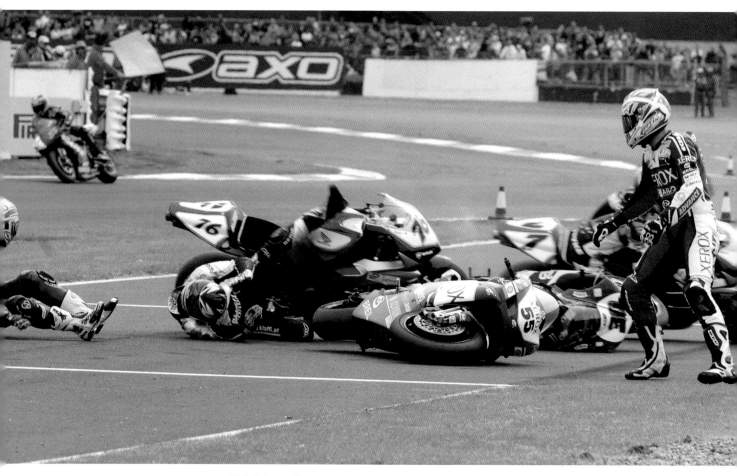

All fall down. Race one
winner Regis Laconi (R)
is involved in a crash with
José Luis Cardoso (L) and
Max Neukirchner (C) during
race two of the British round
of the Superbike World
Championship at Silverstone
in Northamptonshire.
29th May, 2005

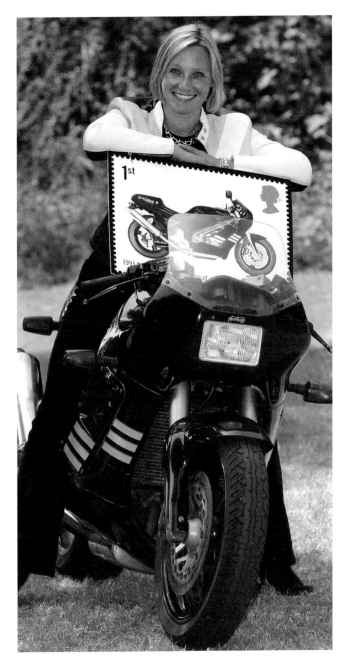

Vicki Butler-Henderson, presenter of the *Fifth Gear* television show, aboard a Norton F1 motorcycle, which was featured on a commemorative first-class stamp issued along with five others to chart the evolution of British motorcycles.
14th July, 2005

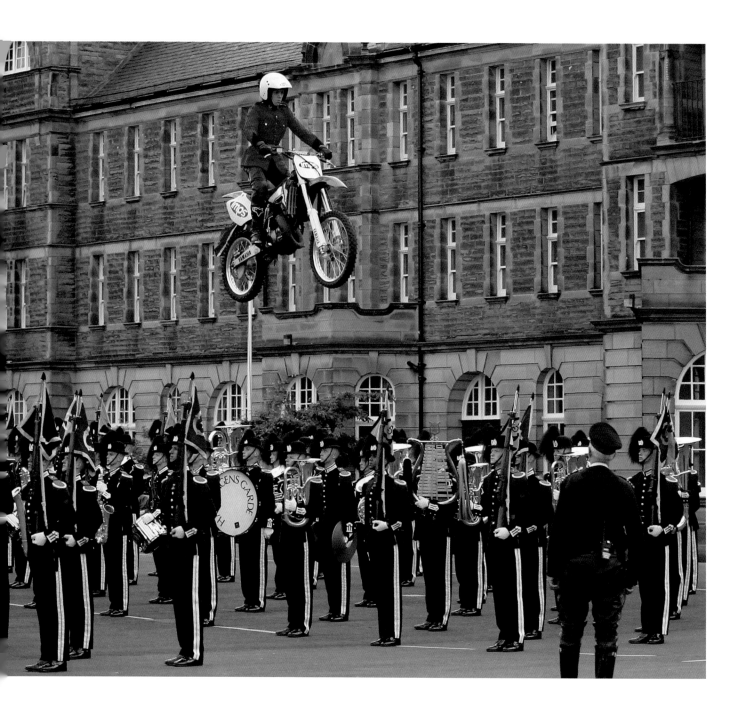

Facing page: A member of the Imps youth motorcycle display team jumps his motorcycle over the Guard of His Majesty The King of Norway's Band and Drill Team during practice for the Edinburgh Military Tattoo.
3rd August, 2005

Graham Coxon, lead guitarist of the band Blur, arrives at the Exposure Gallery, Little Portland Street, London on his Triumph Bonneville T100 motorcycle for the launch of the Rockers & Racers photography exhibition.
4th August, 2005

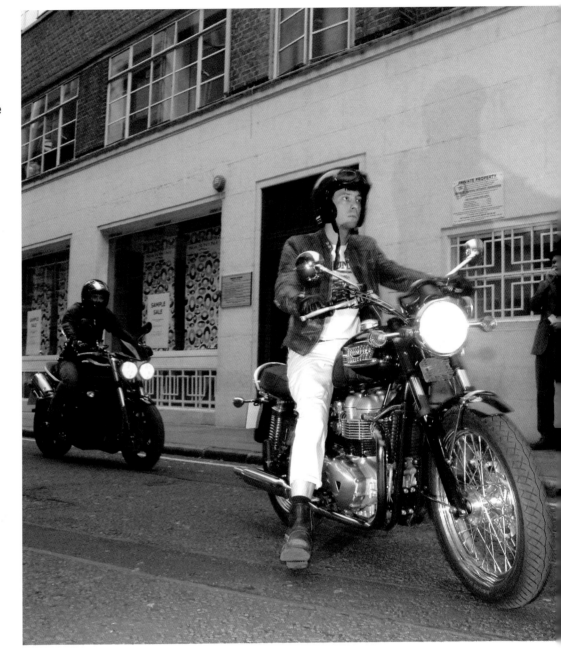

A Triumph motorcycle at the world famous Ace Café, north
London, for the launch of the Rockers & Racers photography
exhibition at the Exposure Gallery, which included a series of
stunning and iconic images from the café's photographic archive
and was produced in association with Triumph Motorcycles.
4th August, 2005

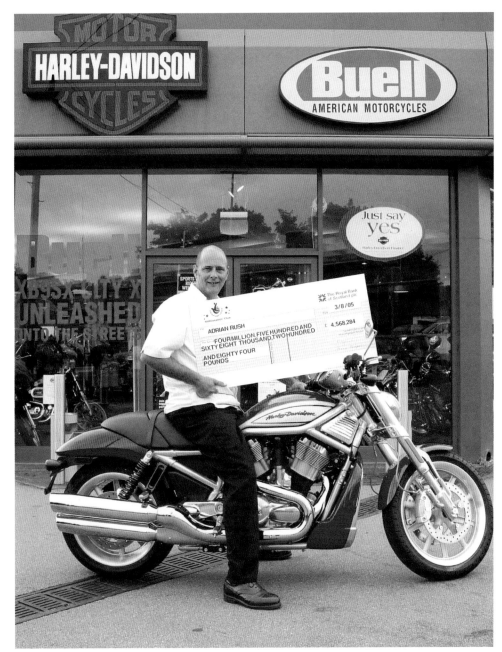

Big boy's toy. Stonemason and keen motorcyclist Adrian Rush, from Diss in Norfolk, began carving out a dream lifestyle with the purchase of a Harley-Davidson V-Rod motorcycle, having won a £4,568,284 share of a Lotto Rollover jackpot.

5th August, 2005

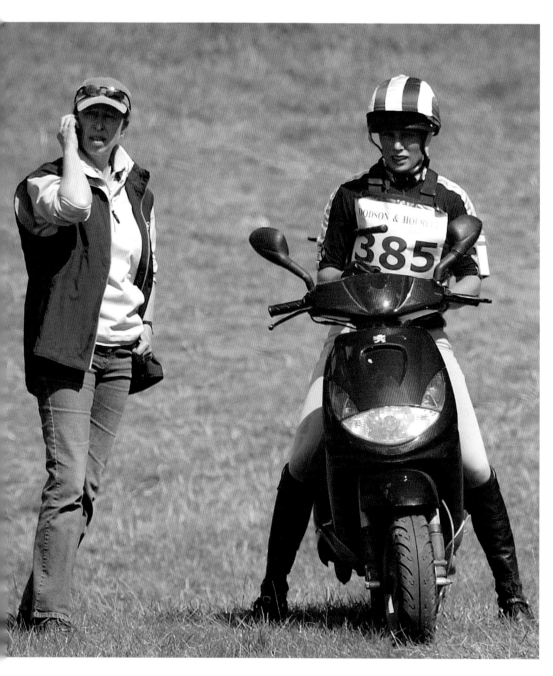

Two-wheeled horsepower.
Zara Phillips, on a Peugeot
Scoot'Elec, chats with
her mother the Princess
Royal after completing
the cross-country course
on *Red Baron* in the
Intermediate Championship
at the Festival of British
Eventing at Gatcombe Park,
Gloucestershire. The scooter
proved invaluable for getting
around the country estate.
7th August, 2005

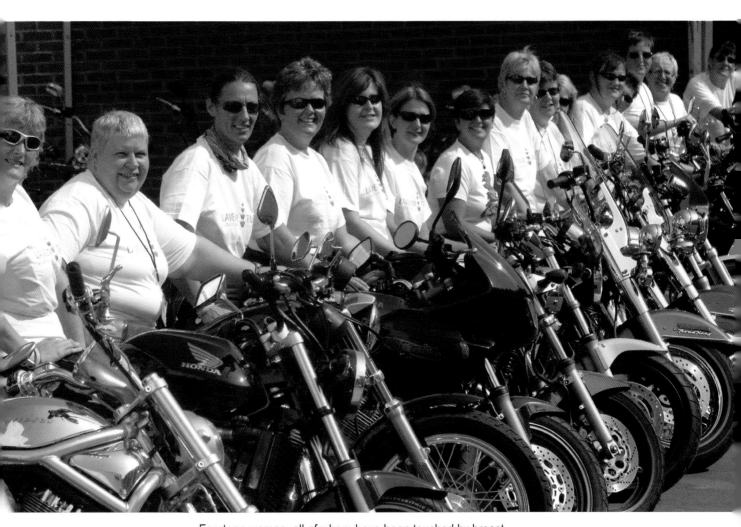

Fourteen women, all of whom have been touched by breast cancer, line up prior to embarking on a week-long motorcycle ride from London to Edinburgh to raise money for the Lavender Trust Breast Cancer Care charity.
18th August, 2005

Two of the women bikers
prepare their machines
at the Ace Café in north
London before setting off
on their charity bike ride to
Edinburgh. The adrenalin
junkies, 12 of whom survived
the disease themselves,
would cover almost 1,000
miles on their ride to the
Scottish capital. Their hope
was to raise £60,000 for the
Lavender Trust.
20th August, 2005

'Unity Ride' bikers arrive at their final stop at the London
Memorial Garden on Victoria Embankment. The ride, organized
by the Motorcycle Action Group, visited the sites of all four
7th July bombings in London before finishing at the garden.
21st August, 2005

Some of the 541 participants in The Great Honda 50 Run at
the Summerhill Culchie Festival, Meath, Ireland, which set
a new world record for the largest scramble of Honda 50
motorcycles. The Honda 50 Step-Thru is one of the most
popular motorcycles in the world.
30th October, 2005

Facing page: Snow mobile.
This rider makes full use of
his Honda XR250R off-road
motorcycle near Carron
Valley in Central Scotland
after heavy snowfall
blanketed the region.
12th March, 2006

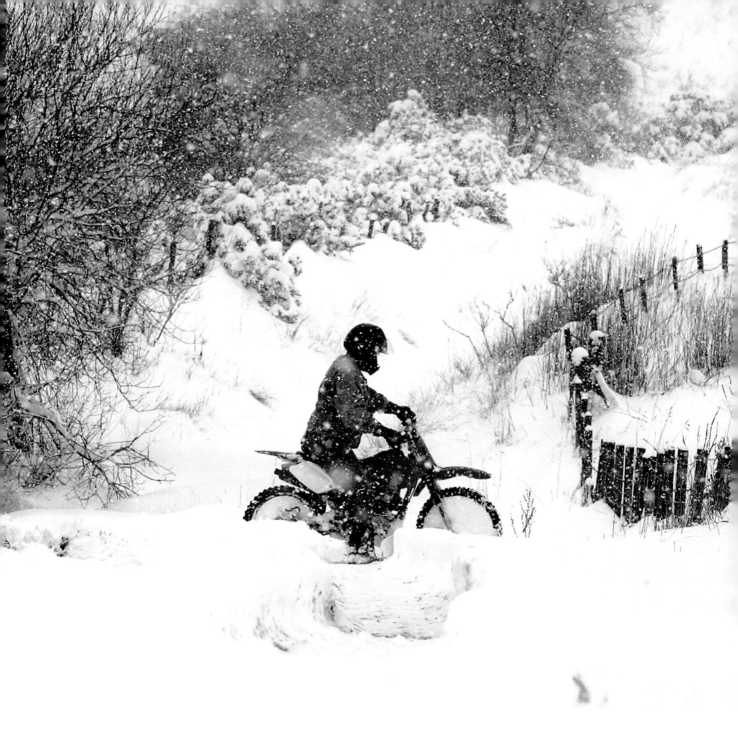

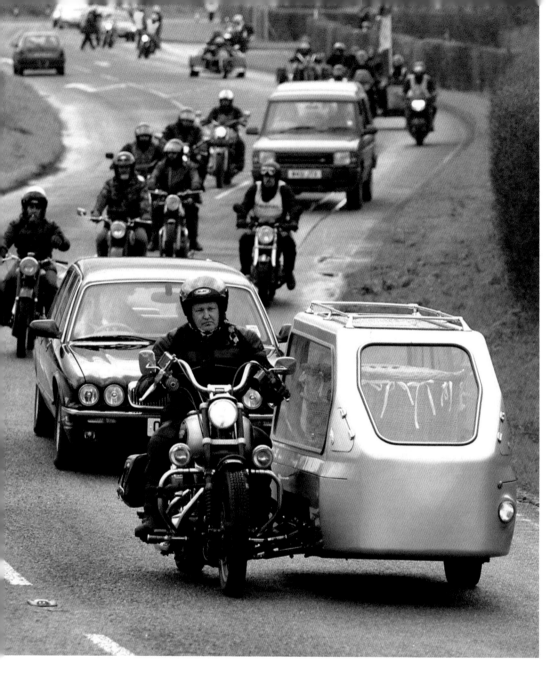

Family and friends of passionate motorcyclist Donna Proctor follow her body as it is taken in a custom-built sidecar hearse through the Cotswolds to Westerleigh Crematorium, near Bath. She would be laid to rest in Brimscombe, Stroud.
20th April, 2006

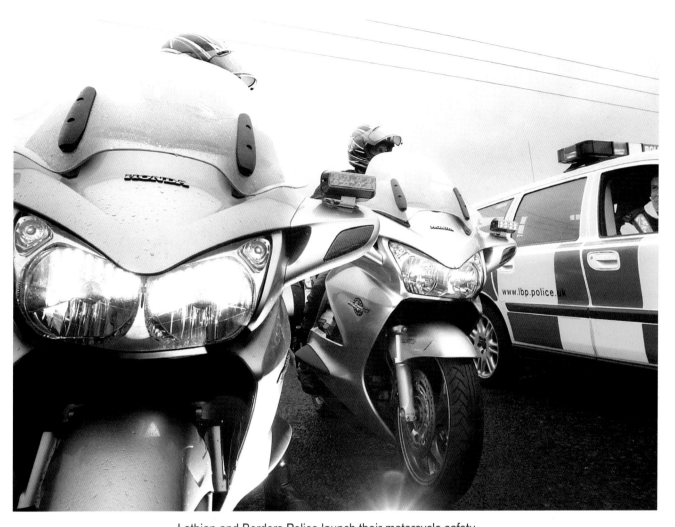

Lothian and Borders Police launch their motorcycle safety campaign in the Scottish Borders near Leadburn. The force would use unmarked Honda VFR800 machines in the hope of preventing accidents during the summer period in Scotland.
15th May, 2006

Tim Dixon rides a Kawasaki ZZR 1400cc motorcycle along the runway at London City Airport, where an event to break the London land speed record, organized by *Autocar* magazine, took place.
15th July, 2006

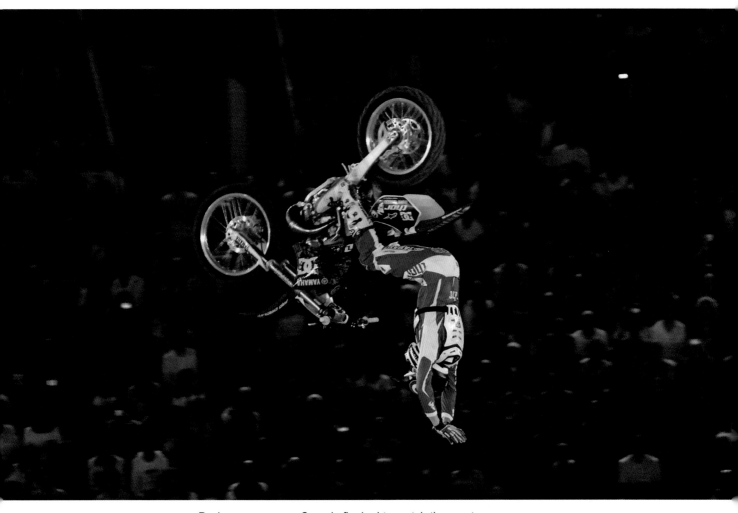

Daring young man. Crowds flocked to watch the most
amazing motorcycle acrobatics during the Red Bull
X-Fighters Motocross Freestyle International event at the
Plaza De Toros De Las Ventas in Madrid, Spain. This
prestigious competition attracts the best freestyle motocross
riders in the world.
15th September, 2006

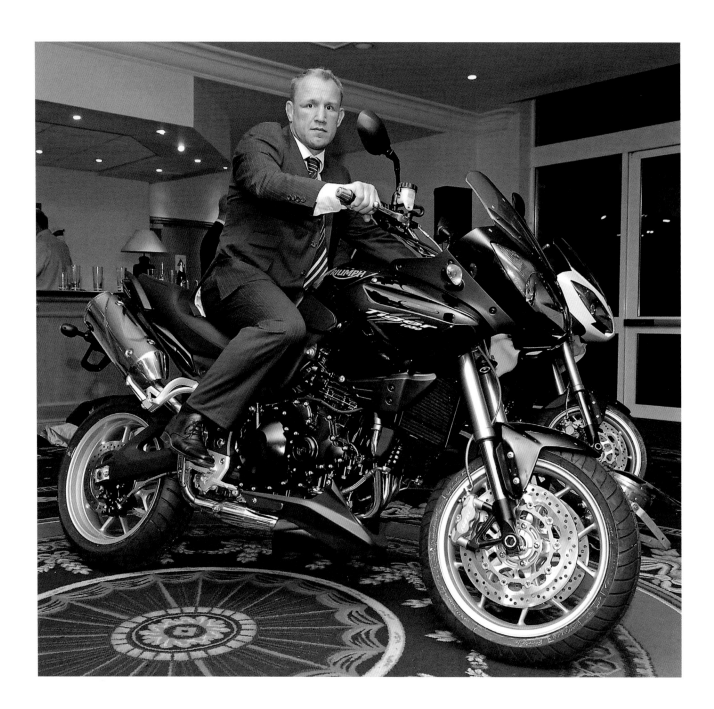

100 Years of Motorcycles • Twentieth Century in Pictures

Former England rugby international and Leicester Tigers technical director Neil Back unveils the Triumph Tiger motorcycle from the Hinckley, Warwickshire manufacturer at The Belfry, Sutton Coldfield. The new machine was powered by a liquid-cooled three-cylinder 1050cc engine.
5th October, 2006

Sultry Latvian model Baiba Andriksone, aboard a customized Harley-Davidson Fat Boy motorcycle, helps launch the annual Toys 4 Big Boys Show at the Royal Dublin Society Arena.
11th October, 2006

A police officer chats with local residents beside
a BMW R1200RT motorbike, which had been washed up
on Branscombe beach in Devon following the grounding
of the cargo vessel *Napoli*. Dozens of people swarmed
over the beach exploring containers from the stricken ship,
which went aground a mile offshore.
22nd January, 2007

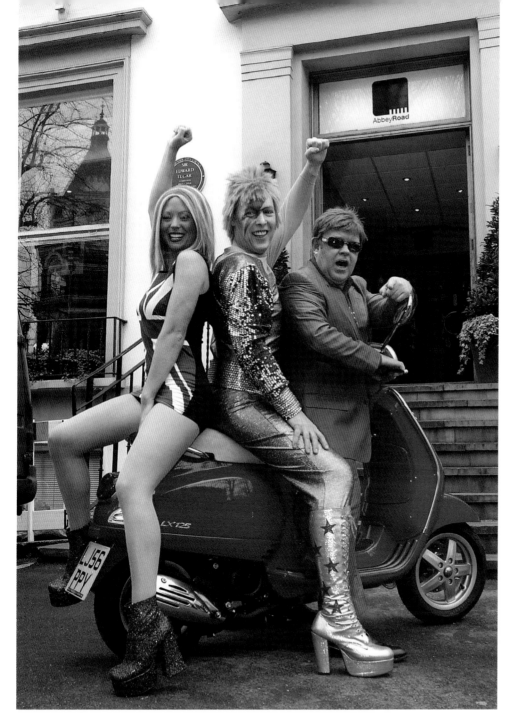

Sitting on a Vespa LX125 scooter outside Abbey Road Studios in central London, (L–R) Geri Halliwell, David Bowie (as Ziggy Stardust) and Elton John look-alikes launch the England Rocks! campaign to encourage British visitors to celebrate the best of English music.
5th February, 2007

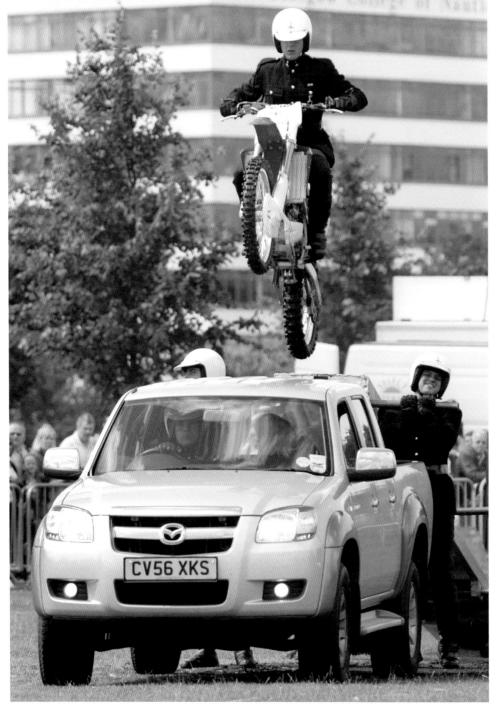

Facing page: Italian riders Michele Pirro (L) and Ayrton Badovini crash three laps from the end of the Superstock 1000 Championship Race during the World Superbike Championship at Donington Park, Derby. Meanwhile a marshal frantically waves a yellow flag to warn other riders of the accident.
1st April, 2007

High jump. Members of the Royal Signals White Helmets motorcycle display team perform in front of the crowd at the Glasgow Show. Jumping over a pickup truck was one of many thrilling manoeuvres performed by the team.
6th February, 2007

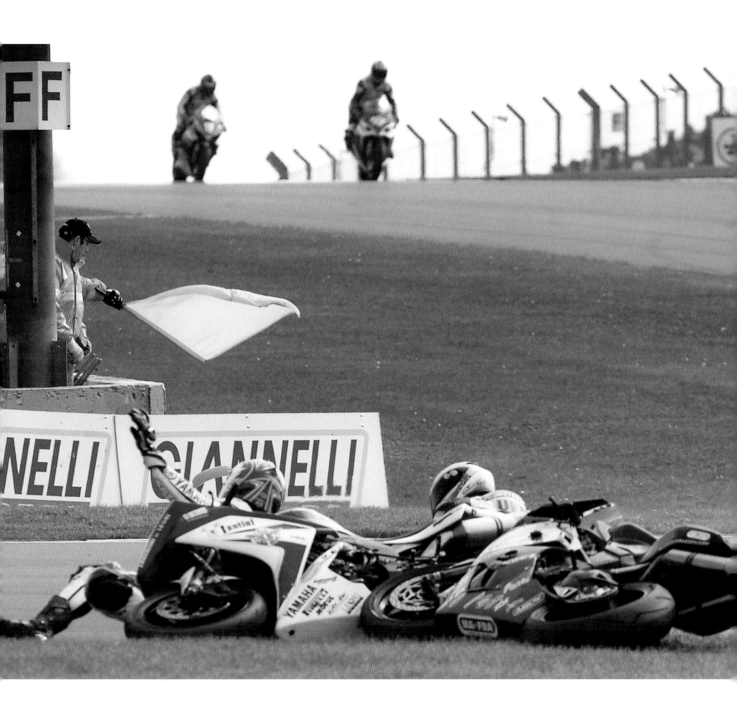

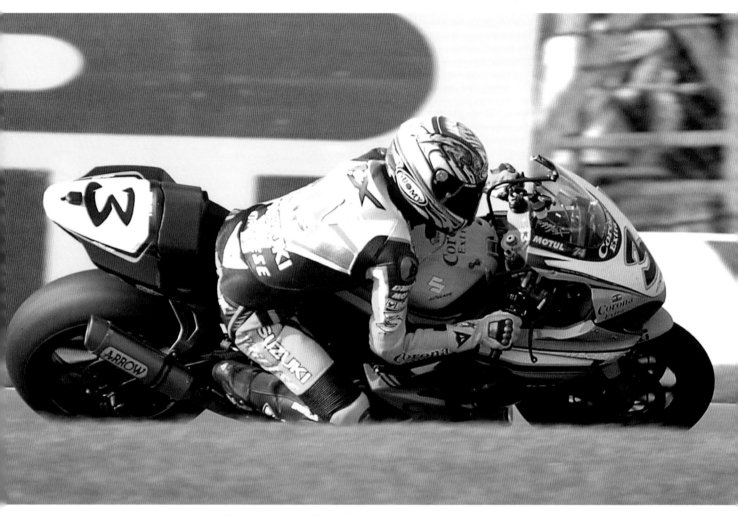

Italy's Max Biaggi in action
on his Alstare Suzuki GSX-
R1000 K7 during race two of
the British round of the World
Superbike Championship
at Donington Park, Derby.
He would go on to win the race.
1st April, 2007

Suzi Perry, presenter of Channel 5 television's *The Gadget Show*, launches the Vectrix, an emissions-free, rechargeable electric scooter that could have a major impact on urban commuting. The machine is capable of 62mph with a claimed operating cost of a penny per mile.
30th April, 2007

Sir Richard Branson (C) is joined by Ewan McGregor (L) and Charley Boorman as he delivers a batch of motorcycles to Nairobi, Kenya. The bikes had been bought by Virgin Atlantic for the Riders for Health charity project so that healthcare workers could reach remote African villages.

3rd June, 2007

PC Colin Chamberlain of Greater Manchester Police demonstrates the electric T3 personal mobility vehicle during the Association of Chief Police Officers annual conference at the Midland Hotel, Manchester. The trike has found widespread acceptance by police forces in North America, and the manufacturer was hoping to impress Britain's senior officers.

20th June, 2007

A Harley-Davidson FX STV 1500 Night Train, identical to the machine ridden by Gerry Tobin, a Hell's Angel who was killed by a single bullet to the head on the M40. The Harley was at Warwickshire Police headquarters, Warwick, where officers investigating the murder hoped it would help bring witnesses forward.
14th August, 2007

Facing page: Owners of Honda Step-Thru 50cc, 70cc and 90cc motorcycles take part in a world record attempt to become the biggest ever gathering of the machines, in Ballymahon, County Longford.
19th August, 2007

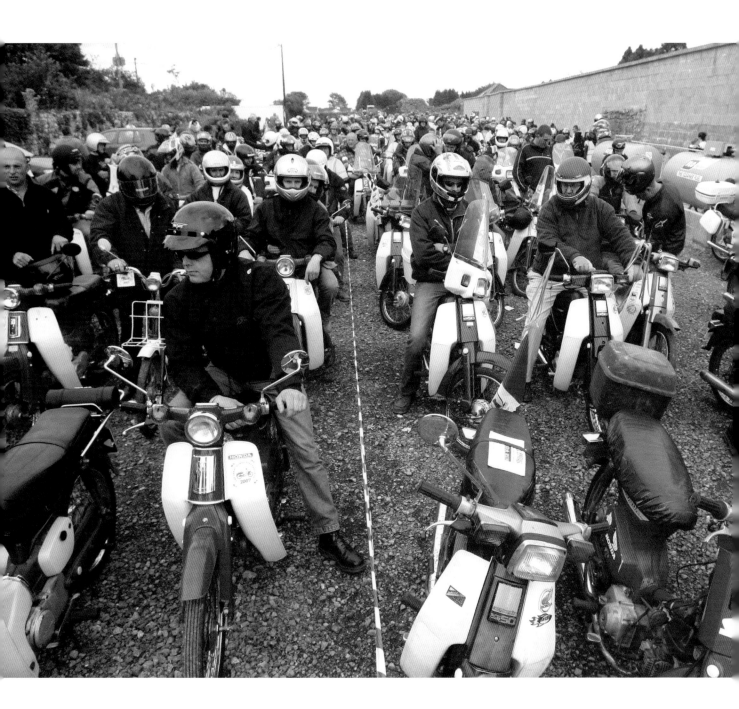

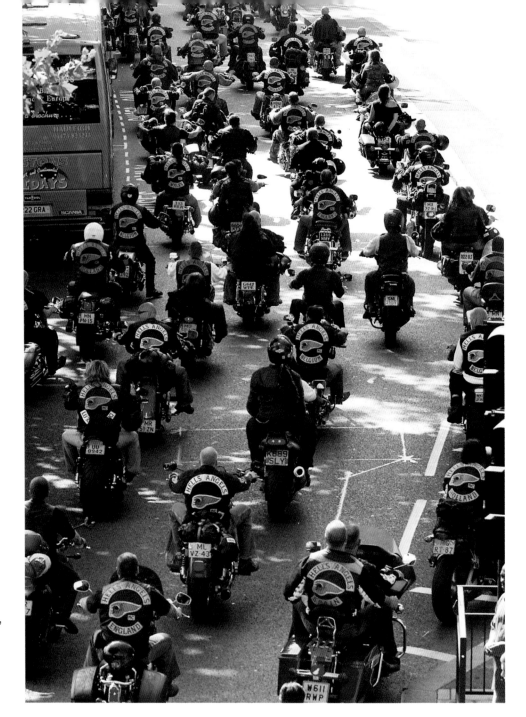

A long line of bikers formed the funeral cortege of Hell's Angel Gerry Tobin, which set off from the motorcycle club's London headquarters in Dawson Street, east London.

15th September, 2007

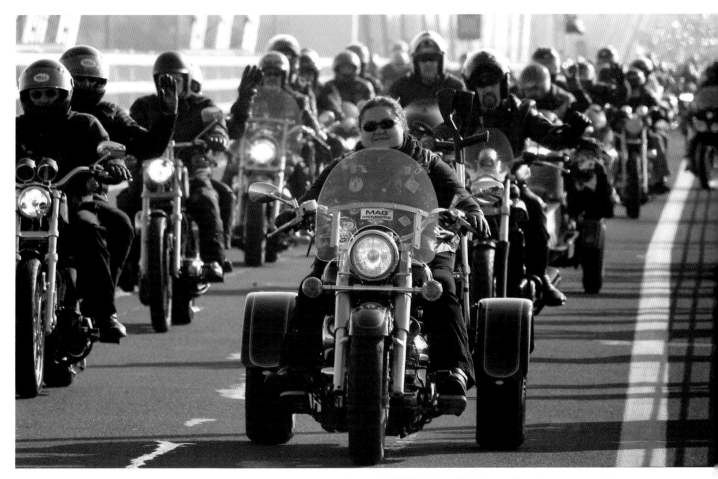

Around 3,000 Harley-Davidson riders from across Europe and the UK ride from Bristol to Chepstow across the Old Severn Bridge (M48) in aid of local charities. 'Hoggin' The Bridge' is an event organized by the Bridgwater Chapter of the Harley-Davidson Owners Group to benefit such charities as St Anne's Hospice, SARA, Secret World, The Air Ambulance and Yeovil Air Cadets. The event's name comes from the bikers' nickname for the Harley-Davidson, 'Hog'.

21st October, 2007

Facing page: Sitting astride his S&S Mobil 1 motorcycle, American television talk show host Jay Leno shows his support for writers picketing the Universal City Studios in Los Angeles in an attempt to obtain a better pay deal. The machine has a custom-built frame fitted with a Harley-Davidson X-wedge engine.
13th November, 2007

Black Sabbath singer Ozzy Osbourne's custom-painted scooter at a preview of a sale of property from the Osbournes' homes. The intricate paintwork, evoking Osbourne's 'Prince of Darkness' soubriquet, was completed with the aid of an airbrush, a miniature spray gun.
26th November, 2007

Ian Paisley Junior, a Junior Minister in the Northern Ireland Executive, tries a Ducati racing motorcycle for size at the launch of the North West 200 programme at the Waterfront Hall in Belfast. The annual race, which takes place in May, is run on public roads, where in places machines reach speeds of 200mph.

15th January, 2008

Spoils of war. While
on active service, Prince
Harry tries to push-start
an abandoned Honda CB125
motorcycle in the desert
in Helmand province,
Southern Afghanistan.
He succeeded in getting it
running and subsequently
rode it when off duty.
28th February, 2008

Thousands gather in Dublin's city centre for the annual St Patrick's Day Parade. One of the attractions of the parade was this giant riding a custom trike.
17th March, 2008

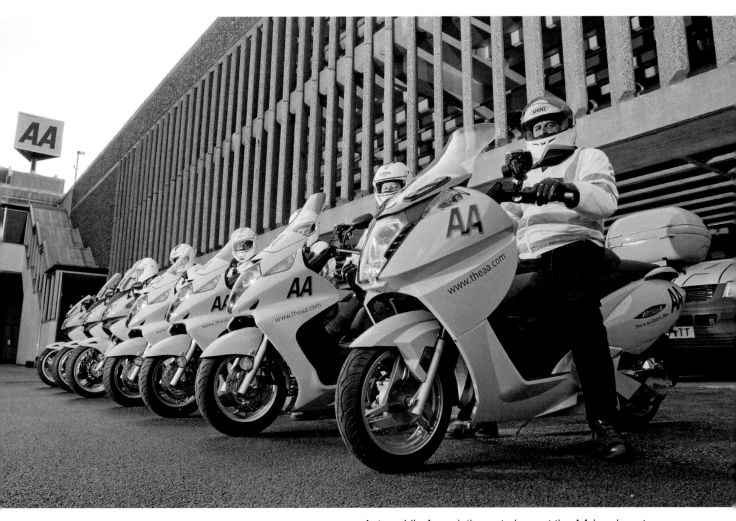

Automobile Association patrolmen at the AA headquarters, Basingstoke, Hampshire. The congestion in city centres has become so bad that the patrols have reverted to the use of scooters and motorcycles to get to breakdowns. The patrolman nearest the camera, Pepe Mongiovi, is mounted on a Vectrix electric scooter.
1st April, 2008

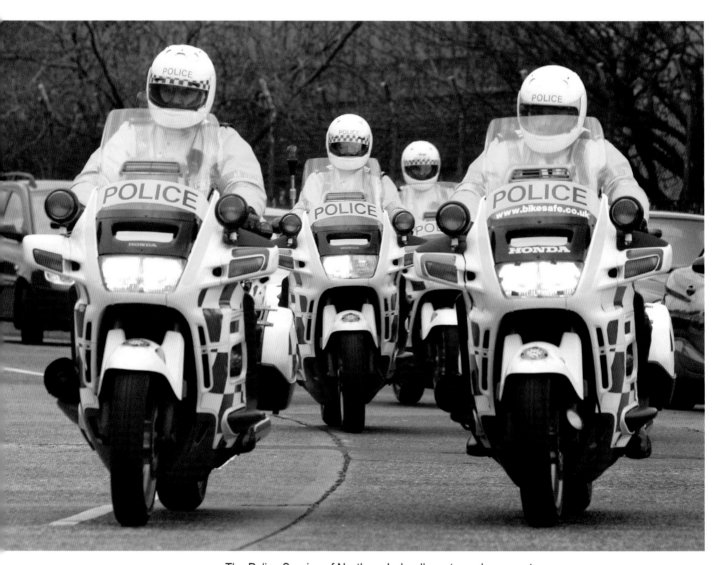

The Police Service of Northern Ireland's motorcycle support team is seen riding their Honda ST 1300A motorcycles at the team's launch in Belfast. Known as the Pan-European, the bike has a liquid-cooled V4 engine and fully-faired bodywork.
9th April, 2008

World record breaker
Nick Sanders prepares
to set off from the Meridian
Time Line in Greenwich,
London on his Yamaha R1
motorcycle. His aim was
to ride around the world
by taking the longest route
possible, travelling up and
down each continent. He
expected to cover a distance
of 55,000 miles in 120 days.
13th April, 2008

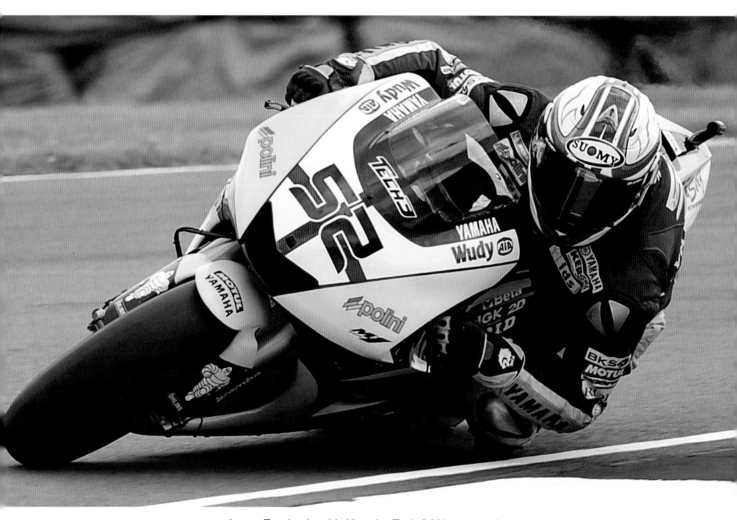

James Toseland on his Yamaha Tech 3 M1 motorcycle during practice for the British Grand Prix at Donington Park, Derby. In his rookie season in MotoGP, former World Superbike Champion Toseland hoped to impress his British fans after a lacklustre start to the year, but crashed out on the first lap. He remounted, but remained a lap down on the other riders.

20th June, 2008

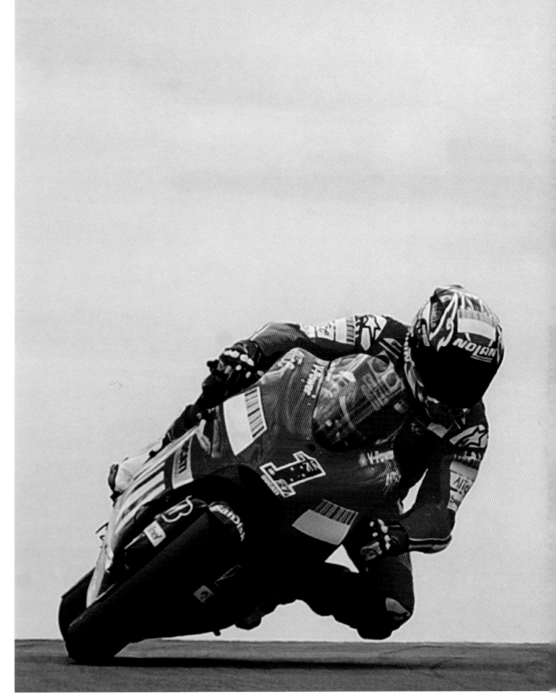

Eventual winner of the 2008 British Grand Prix, Australian Casey Stoner powers his 800cc Ducati Desmosedici through a corner during a practice session at Donington Park, Derby.
20th June, 2008

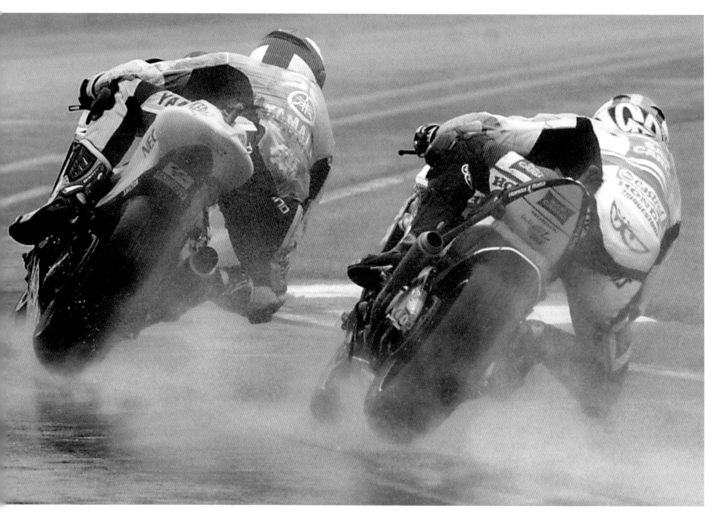

James Toseland (L), on his Yamaha Tech 3 M1, leads
Honda's Alex de Angelis, on an 800cc Honda RC212V,
during a wet free practice session for the British Grand Prix
at Donington Park, Derby.
21st June, 2008

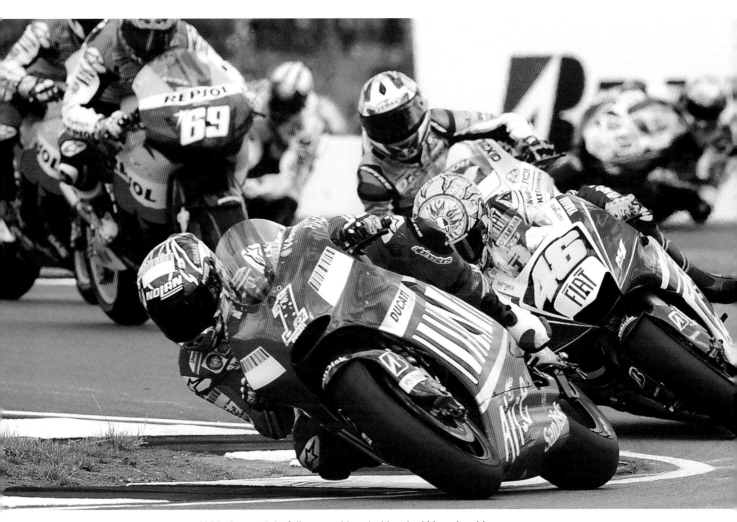

With the pack in full cry and harried by rival Yamaha rider
Valentino Rossi (46), Casey Stoner charges through a corner
on his Ducati Desmosedici during the British Grand Prix at
Donington Park, Derby.
22nd June, 2008

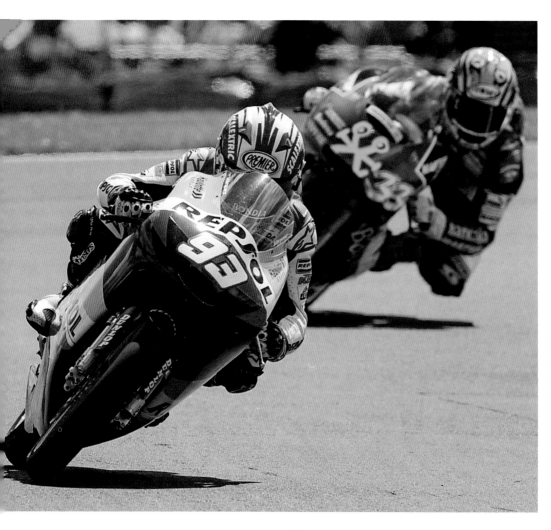

Repsol KTM's Marc Marquez (93) on a KTM 125 FRR during the 125cc Race at the British Grand Prix, Donington Park, Derby. He is chased by Sergio Gadea on a Bancaja Aspar Aprilia machine. Marquez came home in second place, while Gadea took third.
22nd June, 2008

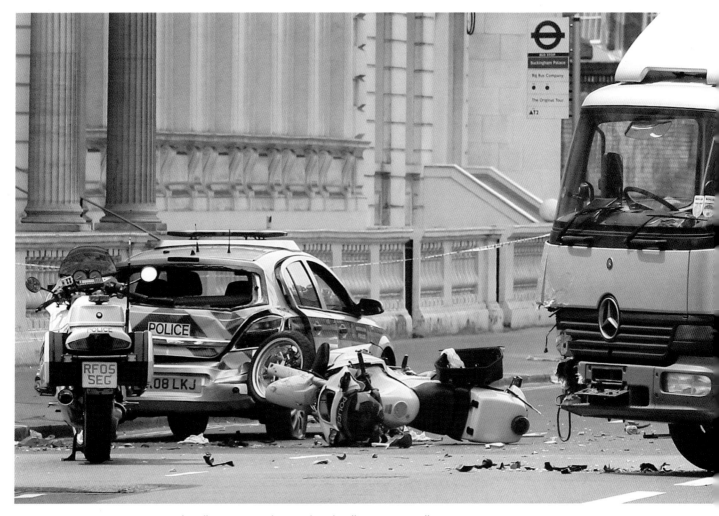

A police motorcycle patrol and police car, attending
an incident, were involved in this accident at Buckingham
Gate, central London. The bike had collided with the lorry
and then hit the back of the police car. Fortunately,
the rider's injuries were not fatal.
24th June, 2008

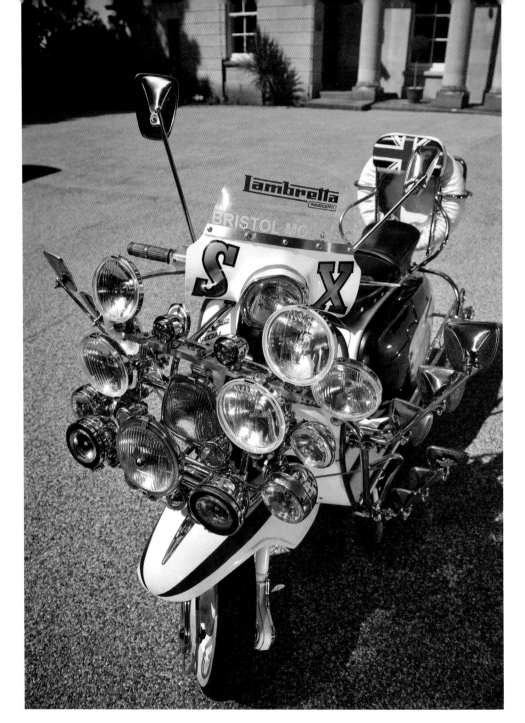

A Lambretta 200cc SX scooter fitted out in traditional Mod fashion with mirrors and masses of spotlights. Nostalgia for the music and fashions of the Mod period has led many enthusiasts to recreate the icons of that time.

15th July, 2008

Legendary motor racing driver Sir Stirling Moss, 79, leaving the Lanesborough Hotel in London on his three-wheeled canopy scooter after celebrating the 60th anniversary of Jaguar's XK range. Living in central London, Moss prefers the scooter to a car.

7th August, 2008

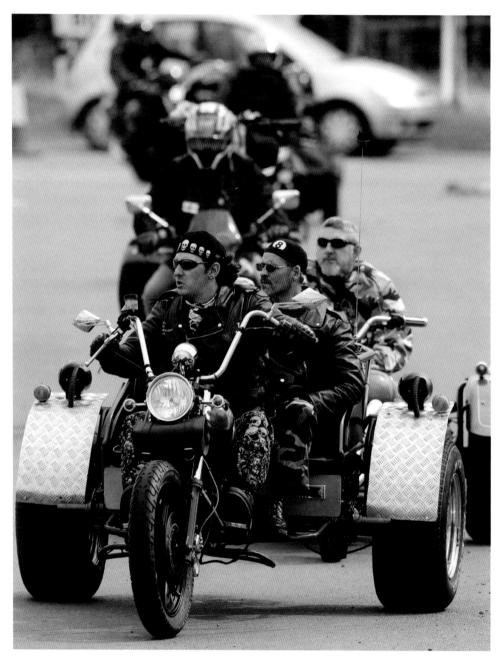

Facing page: Blowing in the wind. The ubiquitous leather jacket has been standard biker wear for decades. This rider's is adorned with fringes in the manner of North American Indian clothing, while the denim waistcoat provides a handy means of displaying his badges.
7th August, 2008

Bikers arrive for the Bulldog Bash motorcycle festival at Avon Park Raceway, Long Marston, Warwickshire. A strong police presence was evident and had been prompted by the death of Hell's Angel Gerry Tobin in 2007.
7th August, 2008

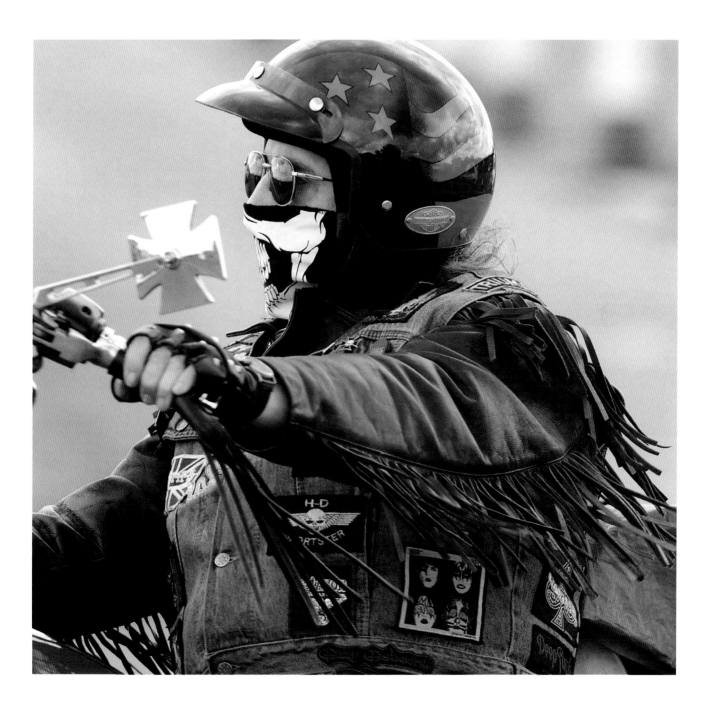

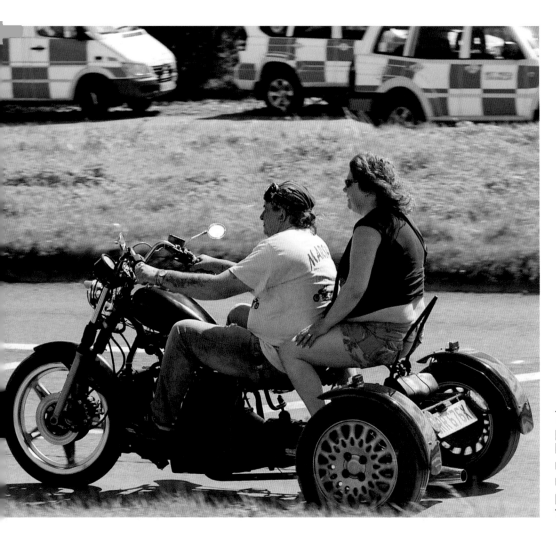

The trike has become a popular machine among bikers, since they are not required to wear helmets to ride one. This example is powered by a car engine.
7th August, 2008

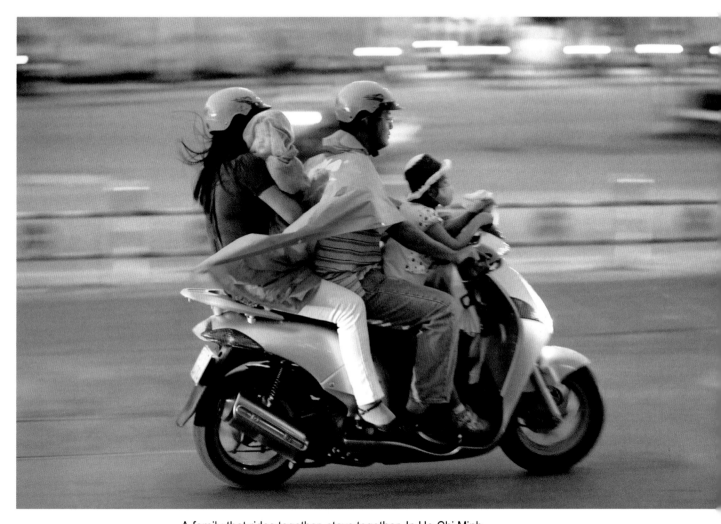

A family that rides together, stays together. In Ho Chi Minh
City, Vietnam these parents manage to cram themselves
and two children onto their scooter. In the West, such actions
would soon attract the attention of the police.
20th August, 2008

Remarkably, this man has managed to sleep on his
motorcycle in Ho Chi Minh City, Vietnam by stretching out on
the seat and hooking his legs over the handlebars. No doubt
he wasn't a restless sleeper.

21st August, 2008

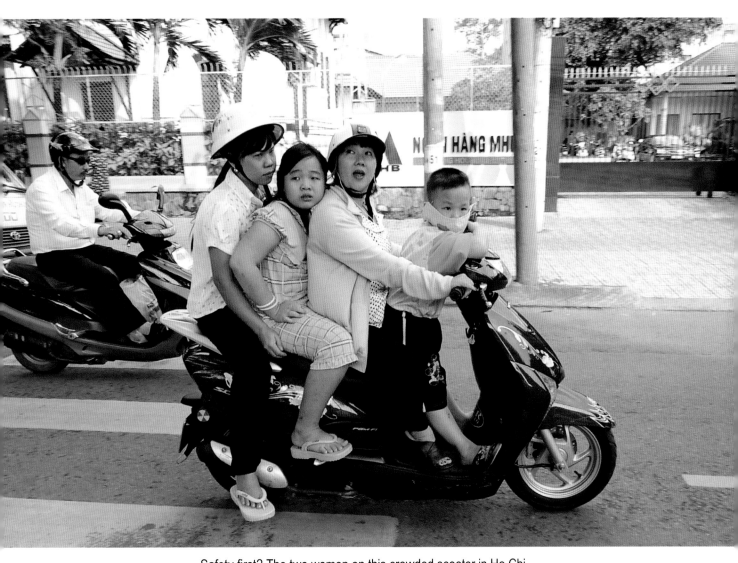

Safety first? The two women on this crowded scooter in Ho Chi Minh City, Vietnam are wearing safety helmets, but clearly they feel that the children have no need of such protection.

21st August, 2008

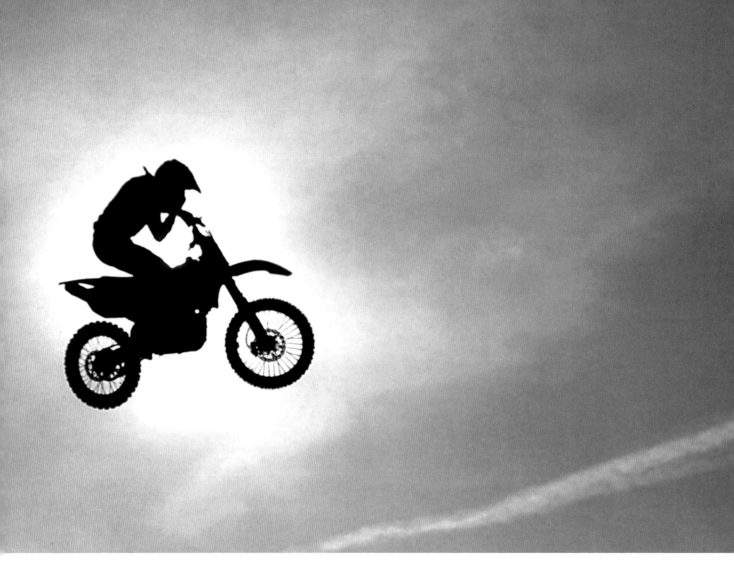

Heading for the wide blue
yonder. This rider launches
his bike skywards during
a practice session prior to
the Red Bull Motocross of
Nations race at Donington
Park, Derby.
27th September, 2008

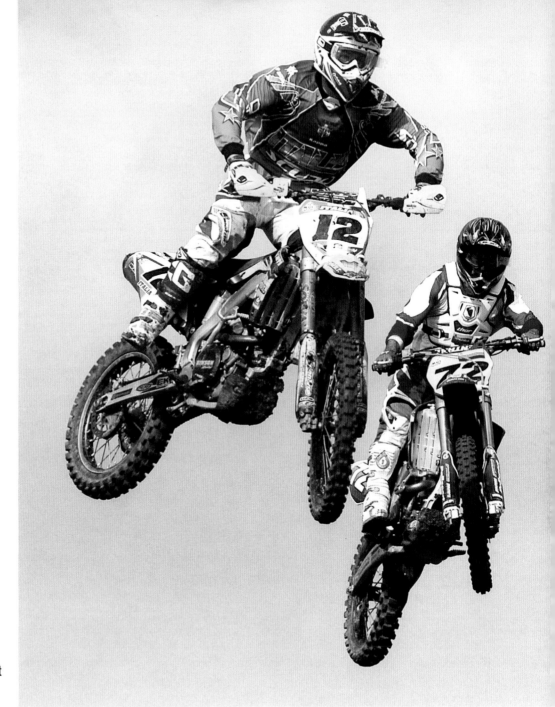

Flying in formation. Italy's Alex Salvini (L) and Venezuela's Fernando Macia get airborne during a practice for the Red Bull Motocross of Nations race at Donington Park, Derby.
27th September, 2008

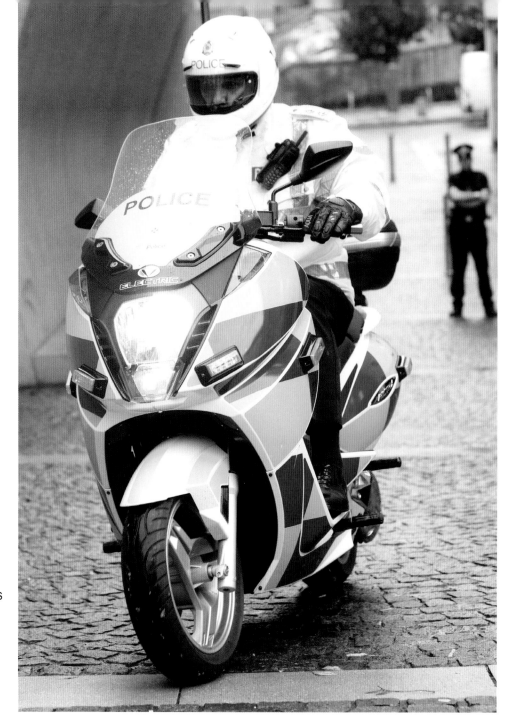

Inspector Alistair McIntyre riding a police Vectrix electric scooter near the Scottish Parliament buildings in Edinburgh. The scooter is seen as an efficient way of patrolling urban environments, allowing officers to cover large areas economically.
10th October, 2008

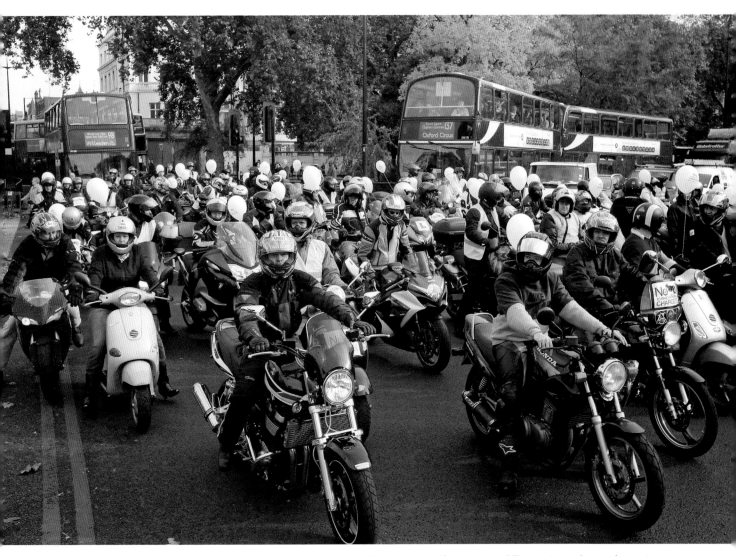

A large group of protesters riding motorcycles and scooters blocks traffic at the Marble Arch junction in London. They were protesting at Westminster Council's decision to introduce parking charges for bikes.

24th October, 2008

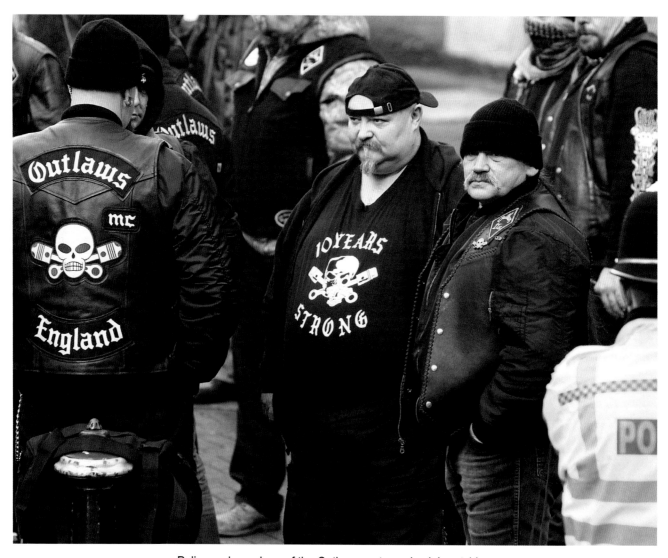

Police and members of the Outlaws motorcycle club outside Birmingham Crown Court, where seven members of the club were jailed for life for murdering Hell's Angel Gerry Tobin, 35, on the M40 in 2007.

28th November, 2008

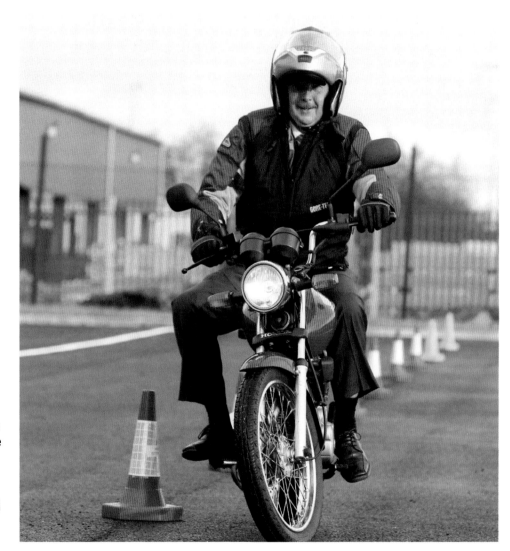

Right hand down a bit! Northern Ireland Environment Minister Sammy Wilson attempts the newly introduced motorcycle manoeuvring test in Belfast. The test was designed to ensure that novice motorcycle riders have good control of their machines.
4th December, 2008

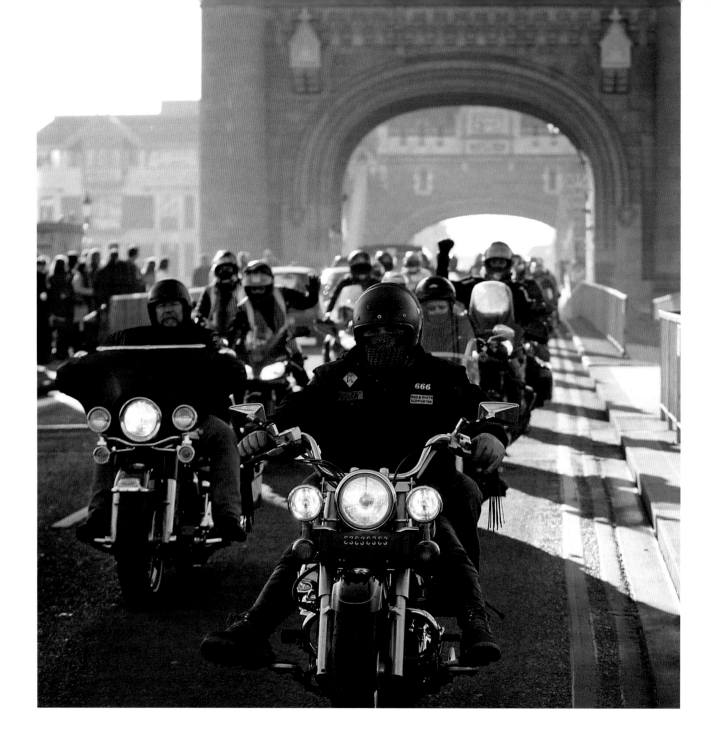

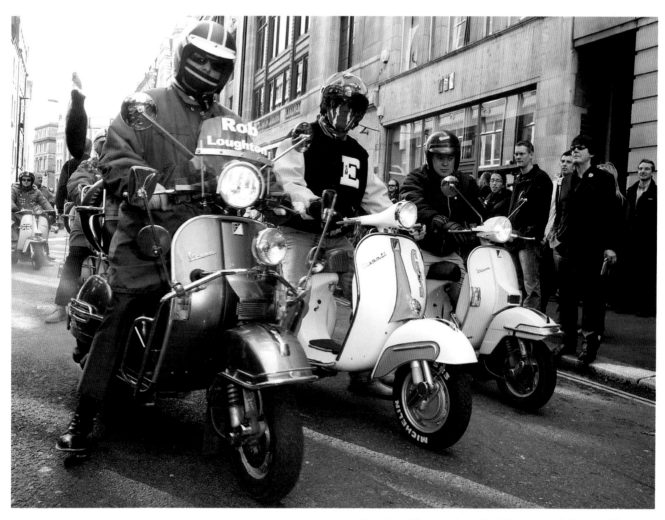

Scooter riding modern-day Mods attend the unveiling of a blue plaque in honour of Keith Moon, the legendary drummer of the band The Who, at 90 Wardour Street in central London.

8th March, 2009

Facing page: A convoy of motorcyclists, from the Ace Café in north London, rides over Tower Bridge to mark the release of the movie *HellBoy 2: The Golden Army* on DVD and Blu-Ray, and also to raise money for the road safety charity BRAKE.

7th December, 2008

The Publishers gratefully acknowledge Press Association Images, from whose extensive archives the photographs in this book have been selected. Personal copies of the photographs in this book, and many others, may be ordered online at www.prints.paphotos.com

PRESS
ASSOCIATION
Images

AMMONITE
PRESS

For more information, please contact:

Ammonite Press

AE Publications Ltd, 166 High Street, Lewes, East Sussex, BN7 1XU, United Kingdom
Tel: + 44 (0)1273 488006 Fax: + 44 (0)1273 472418
www.ammonitepress.com